The Complete Guide to
Drawing Manga

The Complete Guide to
Drawing Manga

Online Movie Book Guides

Sonia Leong

A QUARTO BOOK

First edition for North America
published in 2013 by Barron's
Educational Series, Inc.

All inquiries should be addressed to:
Barron's Educational Series, Inc.
250 Wireless Boulevard
Hauppauge, New York 11788
www.barronseduc.com

ISBN: 978-1-4380-0273-6

Library of Congress Control Number:
2013938349

QUAR.BGAD

Conceived, designed, and produced by
Quarto Publishing plc
The Old Brewery
6 Blundell Street
London N7 9BH

Project Editor: Victoria Lyle
Art Editor: Emma Clayton
Designer: Karin Skånberg
Copyeditor: Corinne Masciocchi
Proofreader: Caroline West
Indexer: Helen Snaith
Picture Researcher: Sarah Bell
Photographer: Simon Pask
Videographer: Simon Pask
Video editors: Mahina Drew
and Paul Carslake
Art Director: Caroline Guest

Creative Director: Moira Clinch
Publisher: Paul Carslake

Color separation by
Pica Digital Pte Ltd, Singapore
Printed by
1010 Printing International Ltd, China

9 8 7 6 5 4 3 2 1

Contents

v = video available online

About this book

★ **Chapter 1: Drawing figures, pages 10–79** Learn to draw characters based on real-life proportions and anatomy.

★ **Chapter 2: Creating characters, pages 80–111** Breathe life into your characters and bring them alive on the page.

★ **Chapter 3: Settings, pages 112–123** This section helps you draw your manga characters in different contexts.

★ **Chapter 4: Rendering techniques, pages 124–185** Bring your characters to life with different media and shading.

★ **Chapter 5: Character library, pages 186–215** Professional manga artists create a range of classic manga characters. Read about their methods.

★ **Chapter 6: Making manga, pages 216–249** How to lay out your panels and pages to tell your stories in an exciting way.

Special features

SEE SONIA DRAW!
There are QR links to videos that show Sonia in action while she talks through what she's doing. Scan the QR code for instant playback on your smartphone or type the URL address into your web browser to be taken to the relevant web page.

DRAWING HOW-TOS
Study the principles of anatomical drawing: see how the figure can be broken into primitive shapes and how to draw facial features, hands, feet, and physique.

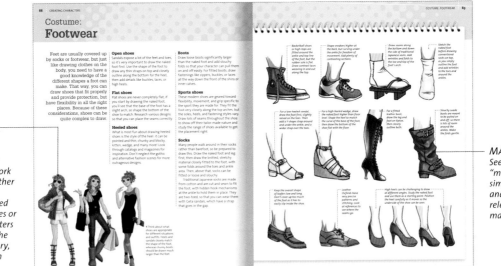

ARTISTS' PORTFOLIO PIECES
You don't only have Sonia's work to look at, as other manga artists have contributed individual pieces or created characters especially for the Character library, which starts on page 186.

MANGA WORLD
See how to "manga-ize" simple subjects and make them relevant to your manga characters.

STEP-BY-STEP SEQUENCES
See the evolution of a piece of artwork. Watch techniques being applied; learn how to hold and use particular tools.

The movies

Follow techniques on the move using your smartphone to access the online tutorials quickly via QR codes, or via the Internet on your laptop or netbook. It's like having your very own manga artist tutor sitting right next to you!

The techniques with an accompanying movie tutorial are marked in the Contents (pages 4–5); some complex subjects may have two or three movies. Throughout the book you'll find the QR code for scanning with your smartphone on the opening pages for the relevant technique; simply download a free app to scan. Alternatively, you may prefer to type the URL address into your web browser to link you to the relevant web page—all the URLs can be found on page 251. All the movies come with an expert commentary to guide you through the essential stages of the technique.

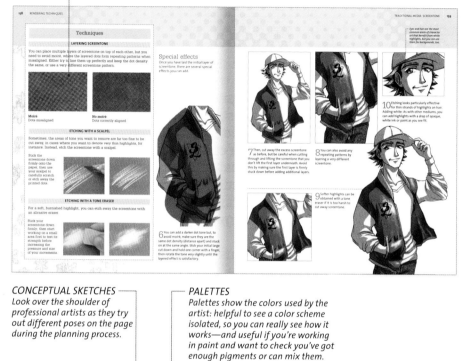

CONCEPTUAL SKETCHES
Look over the shoulder of professional artists as they try out different poses on the page during the planning process.

PALETTES
Palettes show the colors used by the artist: helpful to see a color scheme isolated, so you can really see how it works—and useful if you're working in paint and want to check you've got enough pigments or can mix them.

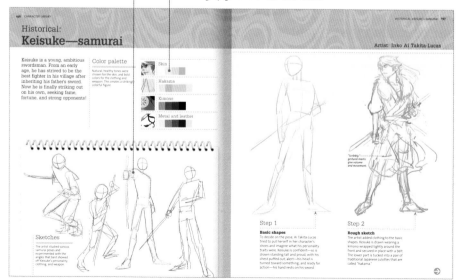

Browse the movie clips
Want to see a complete list of all movies, with live links to each? Then scan the code, right.

No QR scanner? No problem!
Want to view all the movies in this book on your laptop or desktop computer? Then go to: *www.barronsbooks.com/media/manga*

Hello!

A very warm welcome to you, dear reader!

If you have picked up this book, the chances are that I'm not that different from you. I've been a huge fan of manga since childhood and throughout my teenage years, watching anime on television, buying the comics and swapping them with friends. There was something about the look of manga that made it stand out from all the other forms of comics and cartooning I'd seen: the way it seemed so cool, so grown up, so unapologetic in its style, yet so well drawn and, at times, much more realistic. I felt like I could be those characters, that they looked like me, and dealt with issues that I needed to deal with. I wasn't being talked down to or babied in any way; I just got swept up in the awesome stories and character designs.

Naturally, I had a go trying to draw my own manga. And I was awful when I started. I made all the mistakes you could possibly think of: hiding ears with hair because I was scared of drawing them, tracing over images rather than coming up with my own poses or personal style, drawing a head and torso and then running out of space at the bottom of the paper, and squishing the legs into the picture but making them look short and dumpy in the process! The list goes on...

But the good news is that I got better! The more I drew, the more I improved. I started challenging myself to try to achieve the same professional standards as the products I bought. I tried to understand why something was drawn a certain way, rather than just copying. I pushed myself to draw the things I found difficult. And after many years of hard work, I'm now a professional creator, making manga for other readers to enjoy.

So I wrote this book to make the process easier for you. Back then, I didn't have anyone to teach me what worked and what didn't. If this book helps you get more things right and avoid bad habits or costly mistakes, then I will have succeeded.

I wish you all the best with your manga journey and I look forward to seeing your creations in the shops one day!

Sonia Leong

1

Drawing Figures

Learn to draw characters based on real-life proportions and anatomy. Includes: essential groundwork for drawing figures, from drawing faces and expressive features to keeping them consistent through different poses.

Head:
Front view

The basic structures for drawing the head and face are clearly introduced when drawing a front view. Look at real anatomy; then break it down into workable, simple, and customizable guidelines.

Guidelines

If you think of the head as separate sections, you can shift and stretch areas to match your style and suit the character. Visualize the different components of the human skull: there is a round part, with the face and jaw coming off the lower half of it. Use relative measurements to put down markers as needed.

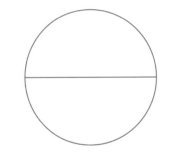

BROW LINE

1 Start by drawing a circle to represent the round section of the skull; then draw a horizontal line halfway down. This is the brow line.

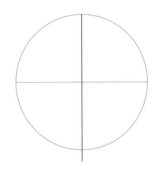

CENTER LINE

2 Divide the circle in half vertically and extend a little beyond the bottom of the circle. This is the center line, which cuts down the middle of the face, ending at the point of the chin.

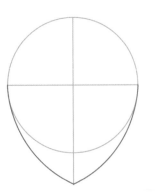

EGG SHAPE

3 Join the edges of the circle to the point of the chin so that you have an egg-like shape representing the entire front view of the head.

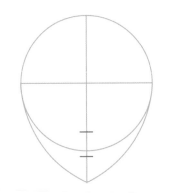

NOSE AND MOUTH MARKERS

4 If you look at a person's face in real life, the tip of their nose is usually halfway between their eyebrows and chin. So draw a nose marker on the center line, halfway between the brow line and the chin; then add a mouth marker by dividing that lower section in half again.

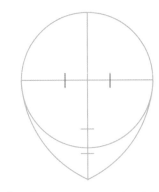

NECK MARKERS

5 In manga, necks can be drawn thinner or thicker than in real life. The minimum size you should use is one-third of the head's width, which you increase accordingly for realism and your character's muscle build. Mark out thirds along the brow line.

Drawing the face

You now have all the guidelines and markers in place for you to position the features.

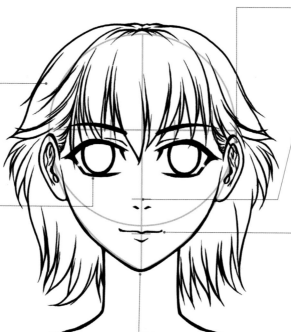

EARS
Roughly speaking, the tops of your ears line up with your eyebrows and the bottoms line up with your nostrils. Use the brow line and the nose marker to gauge the size and position of the ears.

HAIR
The outline of the head is the bald scalp, so when drawing hair ensure that you draw enough to cover the scalp and give the style the correct amount of volume.

NOSE
The nose marker represents the tip of the nose, so the nostrils should go slightly below.

EYES AND EYEBROWS
Position the eyes just underneath the brow line and on either side of the center line. Leave sufficient distance between them: one eye's worth or more. Eyebrows should sit directly on the brow line.

MOUTH
The mouth marker is roughly where the mouth opening is, so you can draw the main line of the mouth directly on it. If you are defining the shape of the lower lip, that goes below.

NECK
Use the neck markers to draw a neck that is at least one-third of the width of the head. Make your neck thicker if it suits your character.
The length of the neck varies depending on the style of the artist but, in real life, the vertical height along the side of the neck is roughly the same as the height from the eyes to the mouth.

JAW
Use the bottom half of the egg shape as a rough guide for where to draw the chin and jaw line, but edit as necessary so that it suits your character.

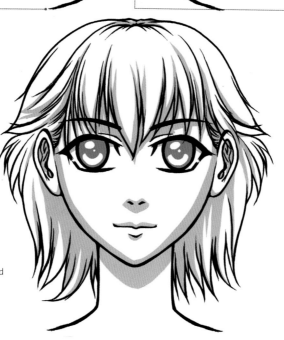

▶ Adding some basic shading and erasing the guidelines brings this simply constructed head to life.

Head:
Side view

Using the same logic as the front view, take the simple combination of the circular top section of the head with the pointed edge of the chin and rotate it to the side. Some features will no longer be visible, while others will become more pronounced.

Guidelines

Imagine putting the front guidelines shown on the previous page on your own face, then turning to the side. All vertical markers and measurements remain the same in theory, but the center line moves, taking the positioning of the facial features with it.

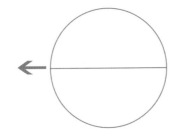

BROW LINE

1 Draw a circle to represent the round section of the skull. The character is looking straight ahead (in the direction of the arrow), not tilting up or down. So add the brow line, dividing the circle in half. The angle is horizontal, to match the arrow.

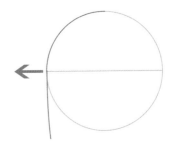

CENTER LINE

2 The character has shifted to the side so the center line moves to match, going down the side of the circle.

EGG SHAPE

3 Join the other edge of the circle to the point of the chin so that you have your egg shape—the sharpest point being the chin in the bottom left corner.

NOSE AND MOUTH MARKERS

4 The tip of the nose is halfway between the brows and the chin, and the mouth is halfway from the nose to the chin.

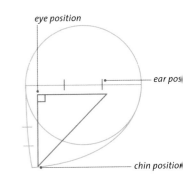

eye position

ear pos

chin position

NECK AND EAR MARKERS

5 On a real-life side profile, the distance from the eye down to the chin is the same as the distance from the eye to the center of the ear (shown by the right-angled triangle). Alternatively, mark out thirds on the brow line to help you position the ears and neck.

Drawing the face

Once you have all the guidelines and markers in place you can add the facial features.

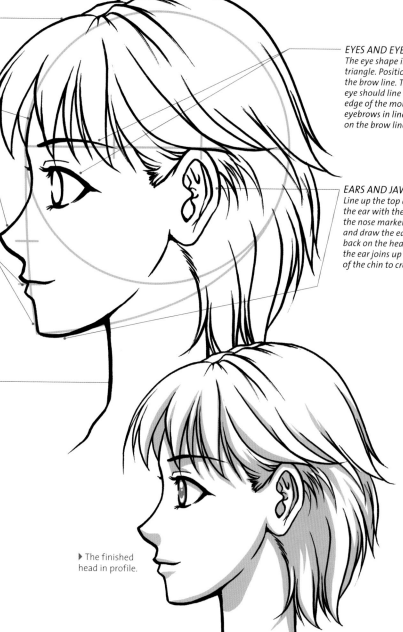

HAIR
Draw sufficient hair to match the curve of the circle guide, particularly toward the back of the head.

FOREHEAD AND NOSE
Draw the forehead by following the curve of the circle. At the brow line, dip inside the circle for the bridge of the nose, then bring it well beyond the outside of the circle, aligning the tip of the nose with the nose marker. Then draw the underside of the nose, moving back toward the center line.

MOUTH AND CHIN
From the underside of the nose, draw down with a slight slope outward to form the curve of the upper lip. Draw a curve for the bottom lip, then extend the line downward for the chin.

NECK
Draw a neck at least one-third of the width of the head. Make sure that the neck connects to the bottom of the circle guide in the middle so that it can realistically support the head.

EYES AND EYEBROWS
The eye shape in profile is a triangle. Position the eye below the brow line. The front of the eye should line up with the edge of the mouth below. Add eyebrows in line with the eyes on the brow line.

EARS AND JAW LINE
Line up the top and bottom of the ear with the brow line and the nose marker, respectively, and draw the ear two-thirds back on the head. The bottom of the ear joins up with the point of the chin to create the jaw line.

▶ The finished head in profile.

Head:
Other angles

This is where the real strengths of establishing a basic set of guidelines start to shine—they translate well into three-dimensional shapes, which can then be rotated as needed to help you draw heads at any angle and in any pose.

Three dimensions

Remember that the flat drawing on the paper is derived from a three-dimensional shape. If you draw a straight line all around an egg and then tilt the egg, the line will tilt and curve with the surface. Apply this logic to all the lines on the basic egg-shaped head template.

Because the head is a curved surface, when parts of it move farther away, they get distorted—narrower or closer together. That is where observation and practice come in—the guidelines give you a good idea of where to put everything, but you need to stretch and shrink the facial features to match the angle of the head.

Moving sideways

To draw a head moving sideways, start with the circle and brow line. Then, draw the center line in a curve, starting from the top and middle of the circle, and cutting across the brow line as needed before filling in the other guidelines. Bear the following in mind with regard to the facial features:

Eyes and eyebrows

As the face swivels more to the side, the width of the eye and eyebrow on the far side of the face is squeezed narrower until it is fully obscured by the nose.

Ears

The ear on the far side of the face will be obscured early on, but the nearside ear gradually moves from the edge of the head until its two-thirds back position in the side view. It takes practice and life observation to learn what looks correct, but in a standard three-quarter view, it looks good if the ear is just within the circle guideline.

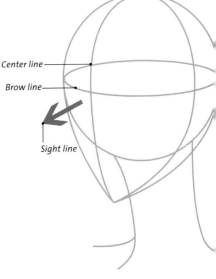

Center line

Brow line

Sight line

▲ An arrow pointing from inside the head out through the point at which the brow and center lines cross marks the sight line.

▶ This series of examples shows what happens when a character turns to the side and moves up and down. Observe the change in shape of and space between the features.

Off-center	Three-quarter	Nearly side

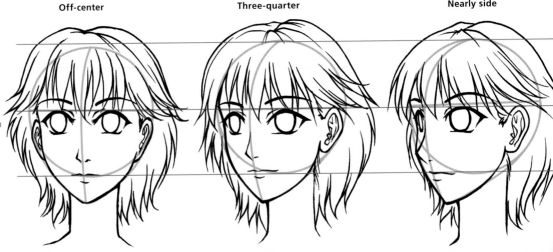

Three-quarter Looking up Looking down

Nose

The more to the side the face is, the more you can start defining the profile of the nose. The nose protrudes more as the character turns away. Remember that the origin point of the nose is along the center line, so make it look like the nose is really coming from that point by making your lines lead back to it.

Side of the face and jaw line

The sides of the face are generally smoother in views closer to the front. As the view gradually shifts to the side, the bone structure and muscle definition of the temples, cheeks, and jaw become stronger until they are obscured by the nose, lips, and the point of the chin.

Looking up and down

To draw a character looking up and down, start by drawing a circle, then draw the vertical center line straight down the middle from top to bottom. Remember that the brow line is strongly curved, starting from halfway down the circle as before, but curving and cutting the center line higher or lower as needed.

Eyes and eyebrows

That curved brow line is extremely important—follow it closely to make sure you place the eyes correctly. The eyes and eyebrows get squeezed flatter and are compressed closer together as the angle gets stronger. The top and bottom lash lines of the eye and the curve of the eyebrow are also affected by stronger tilts and will start to curve to match the brow line.

Ears

The most obvious indicator of showing an upward or downward view is the position of the ears relative to the eyes. In an upward view, by using the curved brow line, you would correctly place the ears lower than the eyes, and vice versa for a downward view. Like the eyes and eyebrows, you squeeze the height of the ear flatter in stronger angles.

Nose

The nostrils become higher and more elongated in upward angles. You will find that the tip of the nose sticks out in downward angles.

Chin and jaw line

Downward angles are mostly flatter, wider versions of a standard front view. Upward angles are more tricky—the chin and jaw resemble a flat line from the bottom of one ear to the other.

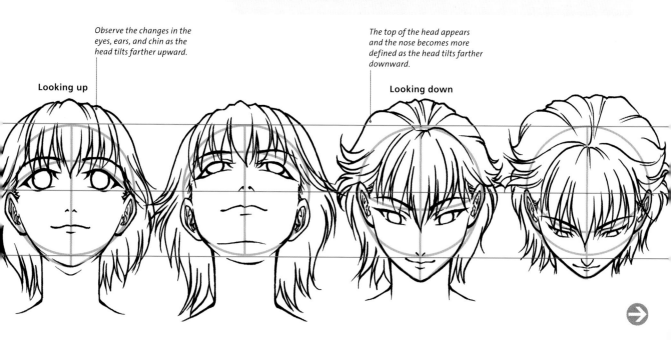

Observe the changes in the eyes, ears, and chin as the head tilts farther upward.

The top of the head appears and the nose becomes more defined as the head tilts farther downward.

Looking up

Looking down

Troublesome angles

There are a few other angles that are more difficult to capture from the basic guidelines. Some parts of the egg-shaped head template are still useful for gauging size and putting everything into context, so it is a good idea to still use them as a starting point.

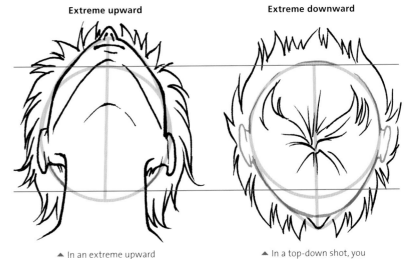

Extreme upward

Extreme downward

▲ In an extreme upward shot, you mostly see the underside of the chin. The nose sticks out and you can see the nostrils clearly.

▲ In a top-down shot, you see the hair and crown of the head, some of the forehead, and the nose. The parts of the head covered by hair are inked in gray.

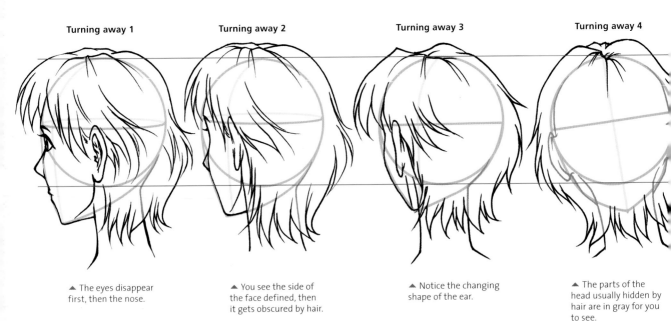

Turning away 1

Turning away 2

Turning away 3

Turning away 4

▲ The eyes disappear first, then the nose.

▲ You see the side of the face defined, then it gets obscured by hair.

▲ Notice the changing shape of the ear.

▲ The parts of the head usually hidden by hair are in gray for you to see.

Combinations

In real life and with manga pages that feature natural camera angles for good story-telling, people are rarely seen in perfectly straight or side-on level poses. Most of the time, you will need to draw characters facing slightly to the side and a little higher or lower than the camera. It takes practice to learn exactly how to subtly stretch or shrink parts of the face and head, but if you use the basic guidelines again and again as a template before you start drawing the final image, you are much more likely to get it right.

▶ This top-down view of the character twisting toward you can be tricky. Squish the eye that is farthest from you, make the chin appear smaller, and try to show more of the top of the head.

▲ The key to combination views is to picture the unseen guidelines at the back of the head (shown in pale blue in these examples) to get the curves correct and give yourself a clear context of the contours of the head at any point.

Head:
Other shapes, gender, and age

Using relative measurements within a basic set of guidelines enables you to stretch or shrink certain features so you can draw characters with many different facial shapes to match their age, gender, build, and bone structure. Your personal drawing style will also affect the types of faces you draw.

. .

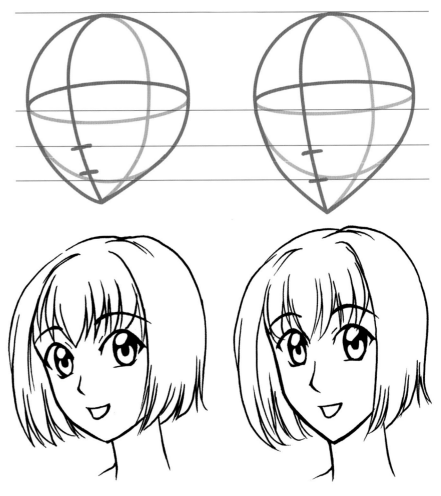

Length of the face
By making the center line longer or shorter you can dramatically alter the shape of a character's face while maintaining a good grasp of where to position the nose and mouth. This is because the markers are based on relative measurements, like the nose being the halfway point between the brow line to the chin, and so on. It is usually the first method used for defining the age of a character.

▲ Most children and younger characters tend to have rounder, chubbier faces, so a shorter center line, even one that barely goes beyond the circle guide, is appropriate for them.

▲ The same character drawn with a longer center line looks older. Note how the nose and mouth are automatically spaced farther apart as the halfway points shift.

Size and positioning of features

The brow line, nose marker, and mouth marker are approximate guides to placing the eyes, nose, and mouth, respectively. Just as in real life, people have subtle differences between them, particularly as they age. Perhaps your art style looks better with higher or lower placements.

You can also change the size of the facial features. Large eyes are associated with youth and cuteness. Large noses and mouths, however, are more mature looking, and the stronger shapes give a more masculine impression—this is also more appropriate when drawing in a more realistic style. If drawing more realistically, gender doesn't play as large

a part in editing the facial features as much as racial background and genetics. For example, a young Chinese woman is more likely to have smaller eyes than a mature Scandinavian man, despite her age and gender indicating otherwise.

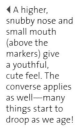

◀ A higher, snubby nose and small mouth (above the markers) give a youthful, cute feel. The converse applies as well—many things start to droop as we age!

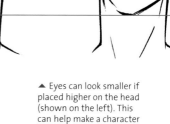

▲ Eyes can look smaller if placed higher on the head (shown on the left). This can help make a character look older, as the face and jaw appear longer and more developed.

◀ A realistic and a highly stylized drawing have different sizes and positions for the facial features. In the stylized drawing, the eyes were simplified and enlarged, and the nose, mouth, and chin were lowered.

Bone structure

Although subtle, there are many variations in bone structure in people's faces. Many factors such as age, gender, and race can be behind this, but while they can be indicative in the right combinations, few of these rules are completely exclusive. Manga can simplify these subtleties to an extent. Some aspects in manga are exaggerated, while others aren't shown at all—especially if the head is viewed from certain angles.

The forehead can be upright, bulging, or slanted and is most apparent from a side profile. The cheekbones are another strong feature you can play with—their height, fullness, and how they join with the cheeks. This is most easily seen in three-quarter views. Finally, the jaw line and chin can have the most variation of all, across nearly all viewing angles. The jaw can be rounded, angular, square, or flat. The chin could stick out a lot, drop away quickly, or it can be solid or cleft.

▶ Combining strong, angular features can make a character look older, leaner, or more masculine.

Muscle and build, folds and wrinkles

Muscle tone is linked to bone structure, as less muscle or bulk reveals more of the bonier parts of the face. While some areas can simply be widened or narrowed accordingly (such as the neck), it helps to show strong muscle definition or fleshy pockets by drawing folds and wrinkles in the right places. They have to line up with the main muscle groups and follow the natural movement of the face.

Some lines will only show with certain expressions, like the dimples in the cheeks with a wide smile. Others show with age, as the skin loses its elasticity and starts to droop, or furrows become permanent from years of frowning. There are folds of flesh that become apparent with a chubby character, and there are hollows that will show if someone is very skinny.

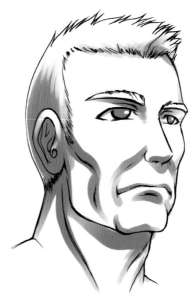

▲ An imposing, heavily muscled man has no excess fat on his face; he has strong muscle definition in the cheek pockets around the mouth. His neck is also very thick, with a prominent sternocleidomastoid muscle in the neck running from below his ear.

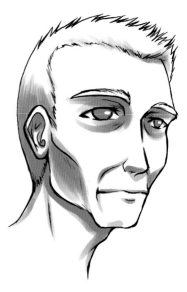

▲ If your character is very skinny, show much more of the bone structure: The brow is pulled sharply into deeply hollowed-out eye sockets and the cheek pockets curve well into the underside of the cheekbones, looking gaunt. The neck also appears thinner.

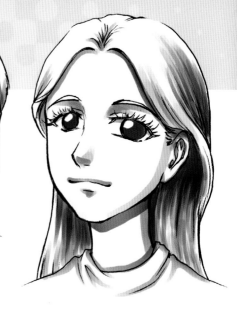

▲ A character appears younger, delicate, fleshed-out, or more feminine if the curves of the face and jaw are drawn with a softer, more rounded shape.

▲ To show a strong familial resemblance between a father and daughter, as shown here, focus on features that carry through well like the nose, chin, and jawline.

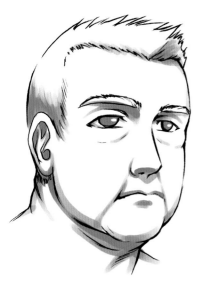

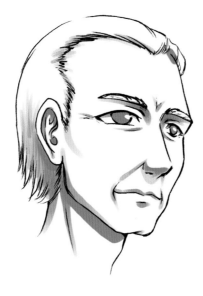

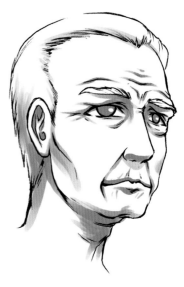

▲ An overweight character will have soft flesh on their face, with fat deposits under the eyes and in the cheeks and jawline. The neck is also wide, but not muscled, and it links softly to the chin.

▲ As a character ages, wrinkles appear first in the parts of the face that are subject to the most movement and tension through our lives: the forehead and between the eyebrows, at the outer edges of the eyes, and the lines from the nose to the mouth.

▲ In old age, wrinkles are combined with loose skin folds, particularly around the mouth, jowls, and chin. There may also be folds of skin around the eyes.

Head:
Eyes and eyebrows

Eyes and eyebrows

The strongest defining features of the face are the eyes, accompanied by expressive eyebrows. They are often the signature of the artist, as they are so personal and can be interpreted in many ways. Even if drawn by the same person, they can have many variations to match the character.

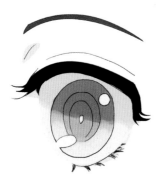

Drawing the eye
Manga eyes are important to get right. Practice the basics and then adapt these to create a signature style.

1 The fundamental building blocks of an eye consist of the following three things: the upper lash line, the circular iris, and the lower lash line. The eyebrow is an additional line on top. Draw all of these basic shapes.

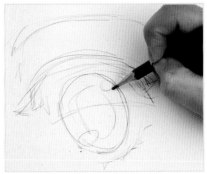

2 Turn the geometric shapes into organic ones by filling in the details. Manga eyes showcase lots of shine—mark out the highlight to match the light source first so you know to leave this area of paper white.

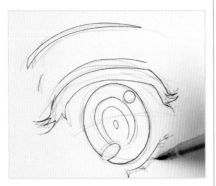

3 Trace the pencil lines carefully with ink. More eyelashes have been added to give an extra feminine appearance. A few more circles have been added to the iris to create a translucent, gradient effect—this is because the iris reflects light subtly.

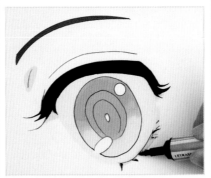

4 Add gray tones. A small patch between the eyelid and the eyebrow is added to give a three-dimensional feel to the eye socket. A bright gray is used on the white part of the eye to make the light reflections stand out.

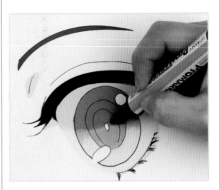

5 Apply a darker gray to the shaded part of the eye to create a dramatic look.

▶ These sparkly eyes are the focal point of this image. They are highly embellished with highlights and iris patterns.

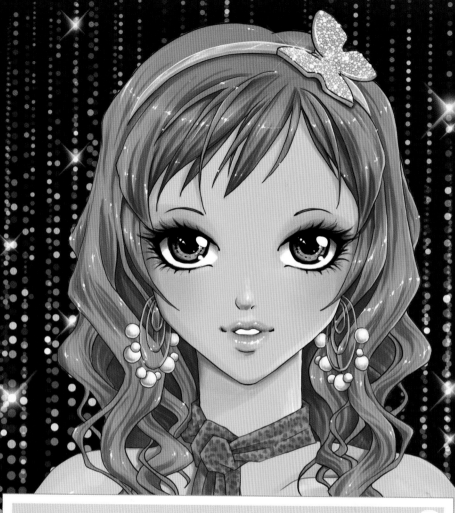

Eyes can be drawn in many different ways. More realistic eyes are not necessarily better—basic eyes convey the visual information the reader needs.

This eye is very basic, consisting of little more than the fundamental building blocks (iris, upper and lower lash, eyebrow) plus a single highlight and some shading.

Little details, such as the sharpening of the edges of the eye and the addition of the lines for the eyelid, make this more realistic than the basic eye.

This realistic eye is very detailed with individual eyelashes, eyebrow hairs, and a complex iris pattern.

Eyelashes

You can choose whether to add eyelashes to your character or not. If drawing in a simple style, it is okay to leave out such detail and just make the upper lash line a bit thicker, or extend it a little to the side with a flick. If drawing individual lashes, however, you need to follow the angles they would take in real life: they radiate out from the center of the eye, like the rays of the sun. Don't feel as if eyelashes can only be used for female characters: if your style is detailed and delicate, it's appropriate to draw eyelashes on your male characters as well.

▼ You can draw many styles of eyelash, from none at all, to a simple side-flick, through to complicated individual curves.

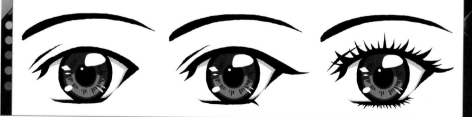

Eyebrows

You can render eyebrows in different ways: a solid line, an outline which is colored in, or detailed outlines that hint at a hairy texture. Consider the overall shape, height, and thickness of the eyebrow on a person whose face is relaxed. Eyebrows can add "femininity" or "masculinity" to a character's face. Thinner, curved eyebrows placed higher up are considered more feminine, due to their delicate appearance. Thicker, straighter, yet angled eyebrows that are closer and lower to the eye are seen as more masculine, as men tend to have stronger features and more pronounced brow bones, with deeper-set eyes. But this is why eyebrows can be fun—why not give thicker eyebrows to a girl, or thinner eyebrows to a boy if it suits their personality or the rest of their appearance, or to add an androgynous feel? For more on eyebrows, see Expressions, pages 34–37.

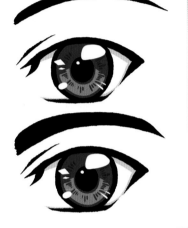

▶ The height and thickness of an eyebrow affects the viewer's impression of the same eye. Here, the top eye feels delicate, while the bottom one feels bold.

Character eye shapes

You can change the size and position of the eyes, but it is far more interesting to try different shapes and angles. It also makes it much easier for the reader to distinguish between characters in closeup shots. Choose eye shapes that match the character's physical appearance and personality: If you give an older character round eyes it implies that they are young at heart, whereas narrow eyes on a younger person may mean they are precocious or mature for their age.

That said, someone who looks innocent and good could later turn out to be an evil mastermind, so mix up these shapes and use their connotations to make your characters richer.

Eyes at different angles and poses

The examples used so far have dealt with front views, but eyes change in appearance as the character moves and rotates their head. Sometimes they are obscured by other parts of the face, like the nose or the cheekbones in the more extreme angles. The side profile is completely different—the eye shape becomes a triangle.

▲ A round eye, looking youthful and innocent.

▲ An upwardly angled, red eye, looking cat-like and sneaky.

▲ A triangular-shaped eye shows single-mindedness and grim determination.

▲ An eye angled downward with heavy lids, giving a sleepy and laid-back vibe.

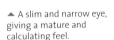

▲ A slim and narrow eye, giving a mature and calculating feel.

Before tackling subtle angles, like tilting only slightly upward or turning partly sideways, observe how your eye shape changes when you look at yourself in the mirror in such poses.

You must combine two variables. The first is simple transformation and perspective: If you draw an eye on a flat sheet of paper, then tilt the paper in different directions, you're almost there. The second concerns facial contours—the face is not a flat sheet of paper. Our cheekbones and brow bones stick out, but our eyes are in the hollows of the eye sockets. The curves of our lash lines will change, as well as the curve and position of the eyebrow.

This diagram shows how the eye shape changes when a character tilts their face in different directions.

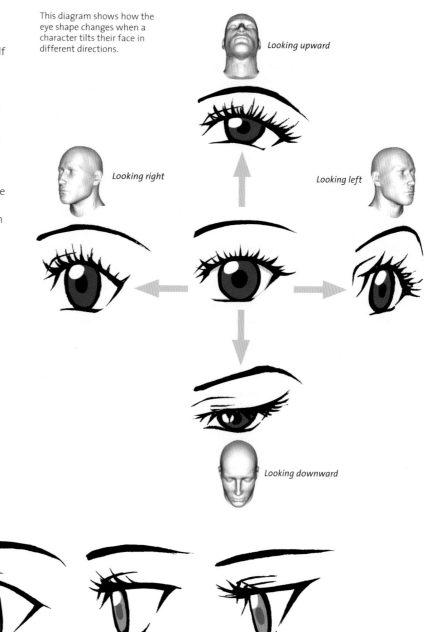

Looking upward

Looking right

Looking left

Looking downward

▶ All eyes in side profile have a triangular shape to them, with a sharp point at the outer corner. The eye can tilt down or up, or even have a slight trapezium element to it. Keep the width compact to match the perspective.

Head:
Noses

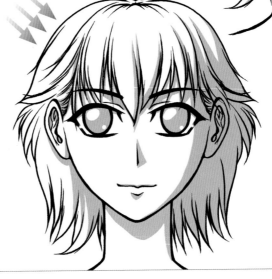

Manga noses have a reputation for being relatively small and sharp in appearance. As manga is predominantly minimalist and uses simplified versions of real life and clean lines, small and sharp noses fit well with this train of thought. But don't feel restricted—there is a lot of variation in levels of realism and character design.

Focus on the front

The front view of the nose is notoriously difficult for artists working in any style of art. This is because the shape of the nose is really only defined in the side profile. It sticks out toward you, in a three-dimensional triangular shape, like the corner of a pyramid. The main visual cues would be the dark holes of the nostrils and other shadows cast by the nose's shape. Lighting plays a key role in depicting the front view. Think carefully about the shape of the shadows and where you place them. This is also affected by the level of realism you use— some lines are left out or merged if you draw in a very simplified style.

▲ The nostrils are defined in ink and the nose is shaded as if the lighting is coming from above.

◀ The lighting is coming from the side, so the length of the nose is inked along one side of a triangular shadow, matching the shape of the nose.

Showing width

If you want to add more realism and character differentiation to your work, it can be helpful to practice changing the width of the nose. This is most obvious in a front view. Define the curves on the sides of the nose just above the nostrils with lines, shadows, or a combination of both. Vary the size and shape of the nostrils so that it feels appropriate for the nose's width. You may also change the width of the philtrum, the cleft just under the nose leading to the cupid's bow of the top lip.

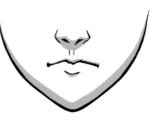

▲ A narrow nose has small, individual nostrils defined by sharp angles.

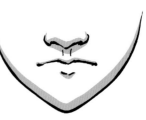

▲ The nostrils of a wide nose are drawn with long, shallow curves. You'll find that the philtrum is also wide.

Side profile of the nose

The side view is where you can truly appreciate the nose's actual shape and play around with variations. Even if you are drawing a character in a front view, if you are going to do any complicated or realistic shading, it will help to have a good idea of the side view so that you get everything right.

Popular shapes

The most popular manga series and advertising mascots are those aimed at older children and young adults. The characters are often idealized and attractive young men and women. Men are portrayed with elegance and a sense of "cool," so their noses appear quite long, sharp, and angular. Women are portrayed as pretty and cute, with smaller noses that have a more delicate curve and tip.

More variety

It can get boring using a stereotypical hero/heroine's nose shape. You can give some individuality to your characters by working with more shapes found in real life. Many factors can affect nose shape: Younger characters have snubby noses whereas a warrior may have a broken or crooked nose bridge from getting into fights. Someone who becomes overweight can also develop a nose with a more fleshy, bulbous tip.

▶ The angles, sizing, and position of the bridge, the nose, the tip, and the underside are different for the profile of an idealized male (left) and female (right).

◀ Here are different nose shapes. See how some have a very distinct underlying bone structure, while others look more fleshed out.

| Snubby | Upturned | Broad | Angular | Broken | Straight |

Head:
Mouths

When asked to draw a mouth for the first time, many beginner artists draw too much. They tend to give too much emphasis to the shape of the lips, making their subject matter look like they're wearing lip liner or dark lipstick. This can look even more pronounced when working in manga, due to its minimalist aesthetic.

Closed mouths

The most simple mouth to draw is one that is closed in a neutral position or slight smile. Most manga styles simplify mouths so that, unless your character is wearing lipstick or lip liner, there is no need to outline the shape of the lips explicitly. Just like the tricky front view of the nose, focus on the darkest shadows that the mouth casts. This usually means drawing the line where the mouth itself opens or closes, as well as the swell of the bottom lip as it casts a subtle shadow onto the chin in most lighting conditions.

If your character is wearing lipstick, again, it is not always necessary, and sometimes it's too much to outline the lip shape fully. A small "U" shape defining the top of the cupid's bow of the upper lip is often the only concession, with some coloring or screentone to tint the area of the lips. If you do choose to outline the lips, keep the lines thin and subtle, unless you want a very strong, cartoonish feel to the character. Try to tint the upper lip slightly darker than the lower lip, to match the lighting conditions, as the upper lip is usually in shadow. Conversely, highlights can be seen on glossy lower lips.

▲ The main lines of a closed mouth are the mouth itself and a small line underneath to define the lower lip.

▶ Although this woman is wearing lipstick, just two main black lines are used to define her lips.

Open mouths

When drawing the mouth open, stick to drawing the outline of the mouth opening itself, with more definition of the lower lip against the chin. Consider whether your character's teeth will show in the expression or sound they are making—a mouth shape that is wide open may show the top row of teeth, sometimes the bottom, and the tongue inside as well.

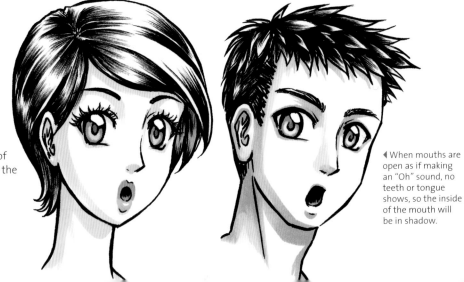

◀ When mouths are open as if making an "Oh" sound, no teeth or tongue shows, so the inside of the mouth will be in shadow.

Side views of mouths

The shape of the lips is easily seen in the side view as the lips bulge slightly outward. You must shade the top lip darker than the bottom if the character wears lipstick—the surface of the top lip faces downward, hence it is in shadow, whereas the bottom lip surface faces upward toward light, and can have

highlights. It is also important to remember that when the character's mouth is wide open, there isn't just empty space below the teeth—you will see the inner cheek inside the mouth. Keep the mouth width under control as the mouth isn't as wide as in front views.

▼ Make an effort to define the shape of the lips when drawing the mouth in a side view.

Grins and teeth

A wide grin or even a small one will show both rows of teeth closed against each other. Keep it simple unless you are doing a major closeup and your style of drawing is very detailed. Even if you choose to define each separate tooth, draw each individual shape only toward the ends of the teeth, avoiding detail in the gums.

In most camera shots and zooms, it looks effective if you use a fairly straight line to divide the top row of teeth from the bottom, perhaps with a gap in the lines to suggest a gentle over-bite. Use shading to help define the rows of teeth.

▼ In manga, a wide toothy grin is simplified so that only the biting ends of the teeth are defined. Note the canines, a popular feature to highlight, particularly on feisty characters.

◀ When mouths are open as if making an "Ah" sound, the teeth and tongue show and should be drawn appropriately.

▲ A typical camera shot of characters when they are grinning will not be close enough to see the full details of the teeth. Just a line to separate the top row from the bottom is drawn.

Head:
Ears

It's surprising how intimidating ears can be to the budding manga artist—many choose to cover them up completely with a fluffy hair style rather than try to tackle them! But you will be doing yourself no favors if you can't draw characters with ears showing. They demonstrate technical ability and confidence, which can raise the level of your artwork.

The basics of drawing ears

Ears are vertically positioned between your eyebrows and your nose. They are also slightly farther back than halfway on the sides of your head. It's important to keep their position on the head consistent over different views and angles. You must also be careful not to draw them too small. In manga, your character can actually look better if you err on the side of large ears that stick out, as it endears them, and fluffy hair can balance it out.

Ears are roughly oval in shape, usually with more of a bulge in the top half of the ear and shallower at the bottom. There are various markings and patterns of curved ear cartilage on the ear, the most distinctive being the dark spot of the ear canal near the bottom where the ear connects to the head, and the thick border all along the outer edge of the ear known as the helix. Within the ear is a "Y" shape: this is the antihelix. You have to flip the patterns and slant depending on whether you're drawing left or right ears. Try to memorize these features to save yourself time when drawing characters.

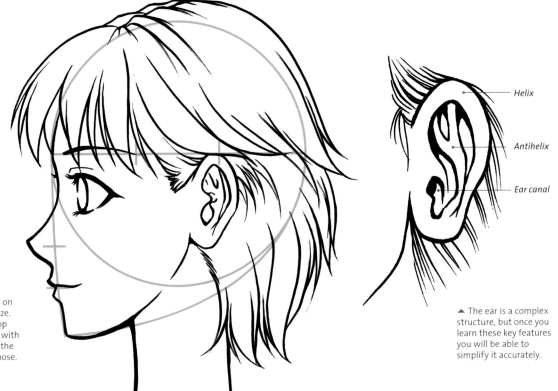

▶ Take note of the position of the ear on the head and its size. Look at how the top of the ear lines up with the eyebrows and the bottom with the nose.

Helix

Antihelix

Ear canal

▲ The ear is a complex structure, but once you learn these key features you will be able to simplify it accurately.

Variations in ears

In real life, ears vary significantly from person to person, with traits passed down through families, but the effect is relatively subtle when used in manga's simplified style. The overall shape may skew in a different direction, or be more rounded. The position and contours of the antihelix can change a lot, appearing wider or deeper. These variations are most likely to be used if the style you are drawing in is fairly realistic.

The ear lobe is larger.

The lobe is shallow and the overall ear shape is very round.

The top of the ear is angled farther back.

Ear has shallower contours.

Simplified ears

There are many occasions when a manga artist draws characters in a simpler style, particularly if their artwork is aimed at younger audiences. If the face, hair, and body are drawn simply, then drawing the full pattern of cartilage on the ear will look inappropriate and too busy. You should simplify the ear. It looks fine if you just draw one line defining the outer helix and leave out other details.

▼ These two examples show characters drawn in a simpler style, so the ears are also drawn without too much detail.

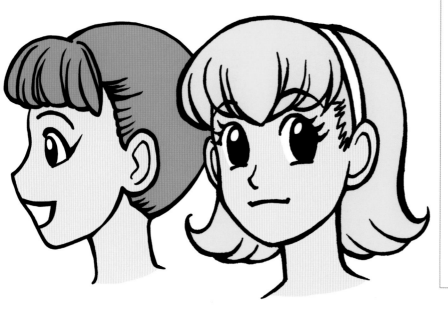

Decorating the ear

The curves of the ear cartilage lend themselves well to distinct forms of decoration—there are so many surfaces to hook onto or pierce through. Even if the jewelry is kept very basic you can add a lot of personality to your character.

▶ This ear has three pieces of jewelry added: a basic ear lobe piercing at the bottom, an ear cuff which hooks onto the outer helix, and an industrial or scaffold bar going through the ear in two places at the top.

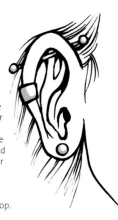

Head:
Expressions

Much of the appeal of manga is in the wonderfully varied and expressive characters. No matter how realistic or stylistic, exaggerated or subtle, the reader is rarely left in the dark about what the character is thinking or feeling at any moment. Practice different combinations of shapes, angles, and muscle tension with facial features to discover the full range of expressions.

Start with basics

The range of expressions used to reflect the complexities of human emotion may seem infinite and overwhelming, but distilling their essence and using basic combinations of differently shaped eyes, brows, and mouths will serve as a useful starting point, which you can then adapt and expand on.

Happiness

Happiness is associated with a smile or grin. The mouth can be open or closed, but will give a happy impression so long as the ends curve up. The eyes and brows can be drawn in various shapes and angles. Variations are used to give nuances to the type of happiness the character is expressing and how strong it is: A face showing pleasant surprise would have calmer, more subtle shapes in the features than one that is ecstatic.

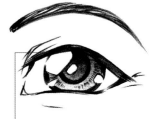

When someone smiles, the muscles of their cheeks will push up into the eye, making the eye crinkle. Draw both the top lash line and bottom lash line curving upward and an eyebrow that curves upward as well.

 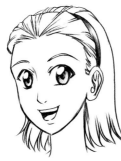

▲ Simple drawing showing a basic happy face. The eyes and brows are in a neutral position, and the mouth is upturned at the ends.

▲ A happy-go-lucky character. Her eyes are large, wide, and bright and her open mouth expresses her joy.

▲ A quiet and reserved type of happiness. Her eyes are bright, as if they are smiling along with her mouth and her brows are tilted upward making her look earnest.

▲ A confident male teenager with a wide grin. His brows angle downward in a mischievous fashion.

▲ A side view of a character smiling in happy relief, like a weight has been lifted off her mind. The tilt of the brow hints that she feels relaxed and content.

▶ The forlorn princess has tears in her eyes and eyebrows that tilt upward in the center, as well as a mouth shape that is wider at the bottom.

Sadness

The downturned mouth is the most obvious indicator of a sad expression, but it must be combined sensitively and appropriately with the other features or it may get drowned out. As in real life, most characters do not universally show sadness plainly on their faces; many people prefer to exercise restraint and stoicism, keeping their face relatively neutral. Keep things subtle: a slightly downturned mouth or even a resigned smile can do the trick. Only a very emotional or open character would express the more obvious and exaggerated features of sadness, including tears.

▼ Closeup of a tearful eye clearly showing the underlying facial muscles pushing and pulling at the brow. These emphatic lines better communicate the emotion.

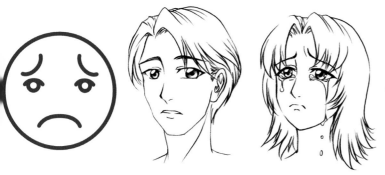

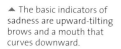

▲ The basic indicators of sadness are upward-tilting brows and a mouth that curves downward.

▲ Keeping a sad expression subtle will create a more nuanced emotion. This man is displaying concern or disappointment. His brows are only slightly tilted and his mouth only slightly downturned.

▲ A very distressed woman. Her brows are strongly tilted upward, her eyes are crinkled and squinted, and her mouth is tightly closed in a small downward curve.

▲ In a side profile, you can really emphasize the shape of the lips. In this case, not only is his mouth tilted downward, but his lower lip is pushed up strongly.

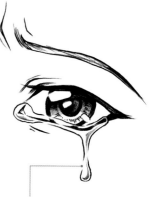

Tears are tricky to get right—keep their outline thin and apply highlights to make them look transparent. Highlights used on the eye itself gives a bright, wet appearance.

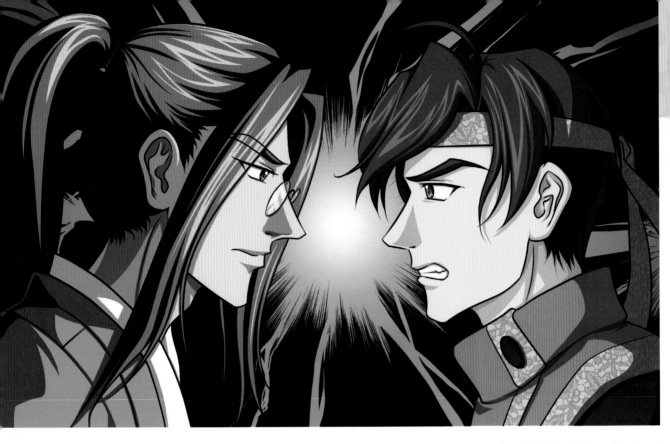

Anger

Strong furrowed brows that tilt downward in a frown are the main focus of an angry face. A mouth that is either straight or curving downward is another key part of the expression. You can vary the intensity of the anger by using more extreme angles for the brows and mouth.

▲ Both characters have downturned mouths and eyebrows that tilt downward in the middle. The man on the right is showing more aggression by baring his teeth.

▲ Basic drawing of an angry face highlighting the frowning eyebrows and the downturned mouth.

▲ A determined and fired-up woman who looks like she is shouting defiantly at someone. Her brows tilt downward in the middle, her eyes are slightly narrowed, and her shouting mouth has a definite bottom-heavy trapezium shape to it, giving a downturned impression.

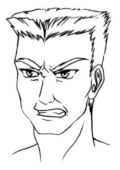

▲ A man seething with fury. Notice how wrinkles collect at the bridge of the nose. His eyes are narrowed and muscles beneath them push up from the cheek. He has set his jaw in a grimace, baring his teeth.

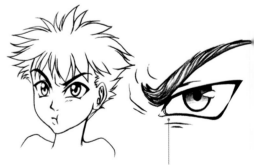

▲ A young child throwing a tantrum. His large eyes have a slight squint, his cheeks are puffed up, and he is pouting, twisting his lips to the side.

It really pays off to exaggerate the shape of the eye and angle of the brow. Here the brow tilts down so low that it touches the eyelid and leaves skin folds and wrinkles around it.

Visual grammar

Manga artists conventionally add little symbols near or on a character's face to highlight or draw attention to an emotion. This is known as visual grammar. Like punctuation marks, they facilitate understanding. For example, if a character is in love, you may wish to draw a heart shape above their head. In Western comics, one of the best-known examples is a light bulb to represent a bright idea. These symbols are particularly useful in short comic strips or one-page gags as they act as a form of shorthand to confirm what the character is really thinking or feeling. There are many examples used around the world, and some are country-specific. Do your research and see which ones appeal to you.

▲ If you use a heart symbol, there can be no doubt that your character is in love.

▲ The sweatdrop symbol is used to indicate embarrassment, nervousness, or awkwardness. This is because when we are uncomfortable, we sweat more.

▲ If someone is really angry, blood vessels and veins start to protrude from the skin as the blood starts pumping and they tense up. This is represented with a stress mark, like a pinch of skin.

Expressing complex emotions

You can approach most emotions from the basic trio of happiness, sadness, and anger. Embarrassment is a combination of happy mouth and sad brows, whereas mischief is a mixture of angry brows and happy mouth. But if you are having difficulty figuring out a starting point for a character's expression, it is a good idea to put yourself in their situation. Try to imagine you are going through what they are dealing with and say the dialog like they would say it; act your character's part, then look in the mirror or take a quick picture of yourself as reference to draw from.

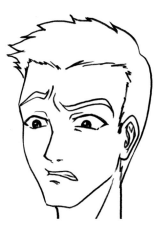

▲ A man whose brows tilt in different directions, giving an impression of curiosity and incredulity, like he is suspicious of something. His eyes are squinted as if he is uncomfortable and tense, and his mouth is twisted downward with a grimace to one side.

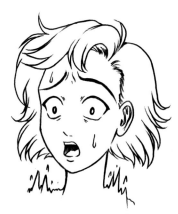

▲ A girl who has clearly been frightened by something. Note the movement in her hair (like she's flinching back in shock) and the shivers on her shoulders. Her brows are high and tilted upward, her eyes are wide and open, and her pupils are very small, leaving lots of white in the eye. The sweat on her forehead and cheek hints at nervousness.

Hair:
Basic principles

Hair is a tricky subject at first, due to its complex, moveable nature and the variety of ways in which it can be rendered. But all hair styles are derived from a few simple rules, so it's not as hard as you might think. Minimalism is key—reducing the hair style down to basic shapes.

Pigtails, short, spiky

Bob, braid, ringlets

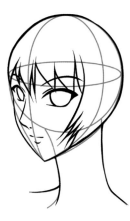

◄ If you draw hair only up to the guideline, it will look like you're painting hair on a bald head!

▶ Aim for hair that goes above and beyond the head template.

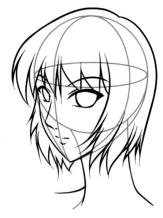

Coverage

The first and most important thing is ensuring that the hair covers the head correctly. A common mistake by beginners is to concentrate on drawing a beautiful face without a sense of the skull shape and size, so when they throw some hair on top, the character appears to have a flat head. Art teachers call this "Neanderthal syndrome." If you've used guidelines as outlined in previous sections, your head template shows your character with a bald head. Adding hair is simply a matter of putting a wig on top. But you must remember—hair has volume! No matter what the texture, the length, or the style, it has to grow out from the scalp.

Origin points

Another consideration is where the hair is coming from or going to. In general, hair grows from the surface of the scalp, but there are common patterns to where it collects or radiates from.

▼ Most people have hair that grows out in a circular pattern (or whorl) from the crown of the head.

▼ When drawing bangs, make it obvious where they start on the head.

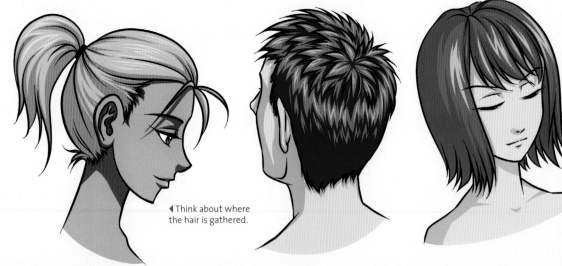

◄ Think about where the hair is gathered.

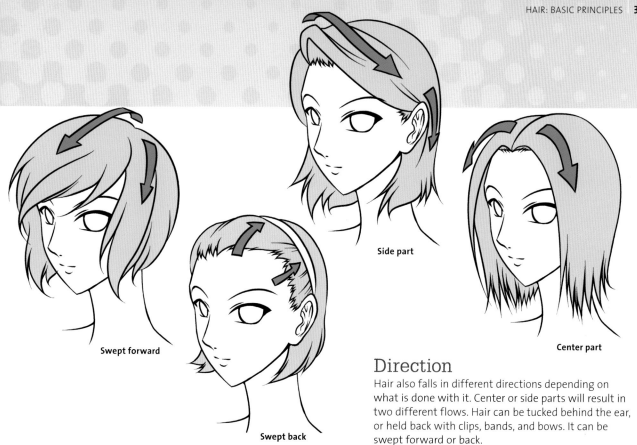

Side part

Swept forward

Swept back

Center part

Direction

Hair also falls in different directions depending on what is done with it. Center or side parts will result in two different flows. Hair can be tucked behind the ear, or held back with clips, bands, and bows. It can be swept forward or back.

Grouping

Finally, try to give an impression of the overall hair style without drawing every single strand. Outline the key shapes and groupings; hair naturally forms in clumps or locks of varying size and thickness, with a few loose strands.

▼ The loose strands in this short, spiky hairstyle give it vivacity and character.

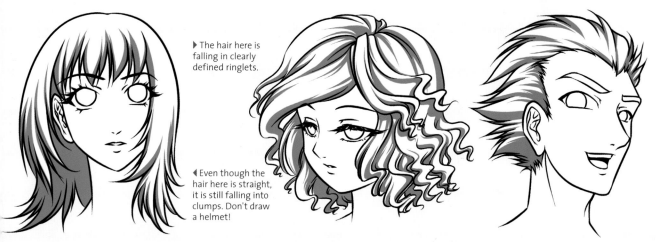

▶ The hair here is falling in clearly defined ringlets.

◀ Even though the hair here is straight, it is still falling into clumps. Don't draw a helmet!

Hair:
Textures

Things can get dull if you always draw characters with straight hair. Even though straight hair is most popular among beginners because it's relatively simple to draw compared with other types of hair, it still has to have subtleties if you want to achieve a professional-looking finish. Having a variety of hair textures is really important for differentiating your characters from one another.

Straight hair
The key skill to focus on is achieving long, smooth strokes with your lines. Make sure that you draw multiple lines almost parallel to each other to give the texture of many strands of hair all flowing in the same direction. Straight hair isn't particularly voluminous, so it should follow the contours of the head or body that it falls over.

Wavy hair
Wavy hair is best achieved by using gentle, undulating lines. Waves only really start becoming obvious once past shoulder-length, where they are free from the head to curl at the ends. The longer the hair, the more wavy it will become.

Curly hair
Curly hair is probably one of the most time-consuming of hair textures to draw, especially if the hair needs to be fully shaded. Corkscrew curls spiral out from the scalp and follow gravity thereafter. This type of hair also tends to look full and thick, so be sure to draw a generous amount, even if the hair is quite short.

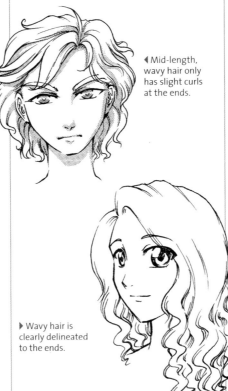

◀ Mid-length, wavy hair only has slight curls at the ends.

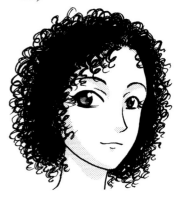

◀ Draw this shape repeatedly with your pen or pencil to build up volume and give the impression of multiple strands of hair.

▲ Shoulder-length, straight hair with a center part. The straight parallel lines give an impression of sleekness.

▶ Wavy hair is clearly delineated to the ends.

▲ Here, dark curls form a sort of halo around the character's head as they spring out evenly from the scalp. Fill the main shape of the hair in black, then embellish with curls.

Afro-textured hair

With Afro-textured hair, you can't see each curl defined clearly so treat it as a single textured shape. Whether it's neatly sculpted or left wild, start with a basic outline of the overall hairstyle. Use a large or small motion with your pen or pencil to match the tightness of the curl; just remember to be consistent. It isn't necessary to fill in the entire hairstyle; just use the same scribble to shade parts of it as required to reinforce the texture visually. If adding screentone or shading digitally, use something with a textured pattern, similar to leaves in the distance on trees.

Dreadlocks

Dreadlocks—long tubes of tightly matted hair—are not dissimilar to Afro-textured hair, in that the method used to draw them is almost the same, except broken down even more. Just like Afro-textured hair, the texture is drawn with scribbles to give a matted impression. Roughly draw each dreadlock, then outline with a scribble and shade slightly with more scribbles where needed to give volume.

Styled curls

Dramatic barrel curls are popular in manga for high-class or aspiring characters who can afford the time and luxury of having their hair done in this style. It looks complicated to draw and keep track of, but it really is just like drawing a drill bit or a screw. Concentrate on the sections in front first (diamond shapes all in a column). Then connect them by filling in the sections at the back (diamond shapes going in the opposite direction). Add texture and shading as you see fit. These curls can be drawn very tight and close to each other, in which case the back sections are barely seen at all and the front section looks like one long sausage shape (hence the name "sausage curls").

◄ The theory of drawing a screw shape: Draw diamonds sloping down in one direction, then connect them going in the other direction.

▲ A large 1970s Afro hairstyle is neatly rounded at all angles. A little bit of shading can be added with a pen before using a textured screentone.

▲ Dreadlocks can be drawn from the hairline, or covered with a bandana. Start with drawing guides for each dreadlock as long, flexible cylinders. Then outline with scribbly lines before filling in with more scribbles to add volume. Keep the size of the scribble texture small and consistent.

▲ Draw diamond shapes as a rough guide before outlining with more organic, curved strokes and vary the width between the lines of hair strands.

Hair:
Lengths

Much like varying the textures of your characters' hairstyles, you should consider different hair lengths to help your readers distinguish one person from the other. In manga, it is fairly common to see males sporting just as much variety as females in terms of hair length, even in contemporary settings.

Short hair

Short hair can be surprisingly difficult to draw. That is because you have very little room for error. The hairline is also hard to come to grips with for beginners. Just remember to get your anatomy basics absolutely right before drawing short hair. Make sure the size of the head is correct and the right proportion is allocated to the face and scalp. As a rough guide, if your character looks correct bald, then you're good to draw short hair. Very short hair follows the shape of the head closely. Think about whether your want the hair to point downward or upward from the hairline.

Mid-length hair

Mid-length hair covers any length and style from around the ears and chin to the shoulders. This length tends to look voluminous on the scalp section, where the hair is at its healthiest and thickest before it starts to thin out from growing too long. Mid-length hair is often the most fun to draw, as it is flattering on most faces and allows you to have more fun with design without worrying about getting the details of a short hairline or fiddly long strands absolutely perfect.

▲ Draw short strokes of hair keeping the direction consistent with their origin at the top and back of the head for a pixie cut.

▲ For a swept-up style with hair gel, draw hair strands going up from the roots and hairline, keeping the shorter hair at the back neat.

▲ Draw lots of fluffy strands, clumps, and long spike shapes coming from the top and back of the head. Make the ends stick out.

▲ For a more controlled style, draw the strands of hair and clumps coming from a center part where it rises up slightly before sweeping past the character's temples.

Long hair

Hair that is shoulder-length and longer is seen as a sign of vitality. Long hair can be left loose, tied-up, or fashioned in any way for looks and practicality. Its appearance can tell you a lot about the character: Messy and straggly hair may point to a more relaxed and liberal character, whereas tied up hair may indicate someone more conservative or stict. The main concern with long hair is making sure you get smooth lines with your inking. Practice drawing long, slightly curved strokes with pencils, then pens. Draw big to get it smoother—don't just direct the pen with your fingers; use your wrist and your elbow if you need to. Long hair never looks good if drawn with shaky, hesitant, or broken lines.

Ends of the hair

There are many ways to finish off the ends of your character's hair, whatever the length. An uneven, choppy look can be really dynamic on both male and female characters, while a neat, even trim hints at a well-groomed type. The latter style requires a great deal of maintenance, so think about the type of person that would be willing to do this. Would your character go to the hairdresser at least once a month? Round off the ends for a neat trim, and sharply square them off for a severe cut.

▼ Longer hair needs even longer, continuous, parallel lines before ending in more tapered spikes. Add lots of individual, loose strands in between the clumps.

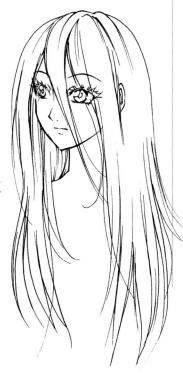

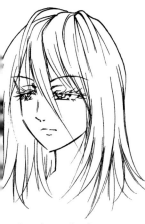

▲ Draw long spikes from the back of the head, thinning out at the ends to create sharp points. Remember to vary the width of each clump.

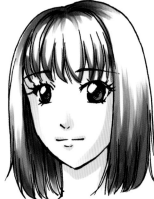

▲ The clumped spikes of hair on this character's bangs are rounded inward to give the impression of the hair being roughly the same length.

▲ A very sharp, chin-length bob, with a sheared undercut to the back of the head brings the hairline in close. Use straight lines to draw the bottom of the hair to give the impression of a very sharp cut.

Hair:
Shading

All artists have their own style and way of doing things, but hair presents a particularly difficult challenge due to its shiny nature, unique textures, and the fact that it is formed of so many individual strands. How you choose to shade and color it is up to you. It basically comes down to figuring out how much detail you need to define in your chosen medium, as well as the strength of the lighting conditions.

▼ Manga hair is often typified by its strong highlights. Notice how the color, placement, and shape changes for different hair types.

Shading hair

Look at how artists you admire shade the hair of their characters and experiment with different styles, before refining your technique and making it your own. Here, an unusual, two-tone shading style is used.

1 Pencil in the basic shapes of the head, neck, shoulders, and then the hair. One of the most important aspects of drawing hair is its flow. Here, the figure is turning her head and her hair is caught in a slight breeze—this is captured with some loose, but characterful curved lines.

2 Work out the composition of the different sections of hair—here, the bangs, the roots, and the ponytail. Block in their shape and fill in a few details.

3 Ink in the image. Use long, flowing lines that follow the shape and flow of the hair. Be careful not to over-ink the hair—a few lines create a light impression, whereas too many lines can make the hair look solid.

4 Use markers to add the first layer of color. You can choose naturalistic or unnaturalistic colors—you can even, as here, choose two colors, blended together in the middle. Here, shading has also been added to the eyelashes.

Correction fluid

5 Use darker shades of your main color to add shadows. Don't use too many colors or the hair will start to look heavy. Add highlights using correction fluid.

Hair:
Complex styling

You can have as much fun as you want experimenting with hair lengths, textures, volume, color, and accessories. But it can be difficult to figure out where to start when trying to invent a complicated updo or similar styles. Try experimenting, but make sure that you learn the basics before combining several techniques when creating something unique.

Ponytail variations

Instead of sticking to the single ponytail at the nape of the neck or high on the head, try two or more. Twin tails are very popular in manga because of how cute and youthful they look. Always shade the hair going into and out of the hair tie or fastening.

Braids

The basic braid is a three-strand braid. When drawing the three-strand braid, think of which sections of hair go over and which go under. Start with a strand curving from one side, then draw a strand crossing over it. Then from underneath the first strand, the last remaining strand comes out and crosses the braid again.

If you are dealing with long braids that are very thin, or if you are drawing a character with a long braid that is far away in the distance, or if you are going for a very simple style, you don't have to go into as much detail. Draw a line to represent where the braid is going to go in your picture, then draw little blobs, heart shapes, or ovals all the way along it.

▲ The twin tails that trail behind this character add personality and movement to the dynamic pose. Draw the hair split down the center and pulled into ties before using diamond shapes to outline the spiral curls.

◀ Two ponytails tied low down create a wild, dishevelled look. Draw the hair bunched up and rounded at the hair ties, then surround with lots of loose strands.

▲ A simplified version of drawing a long braid, which sticks to the main outline it makes, rather like heart shapes.

▶ This male character has a long, three-strand braid, drawn using the diagram above, but with added texture and loose strands to suggest movement.

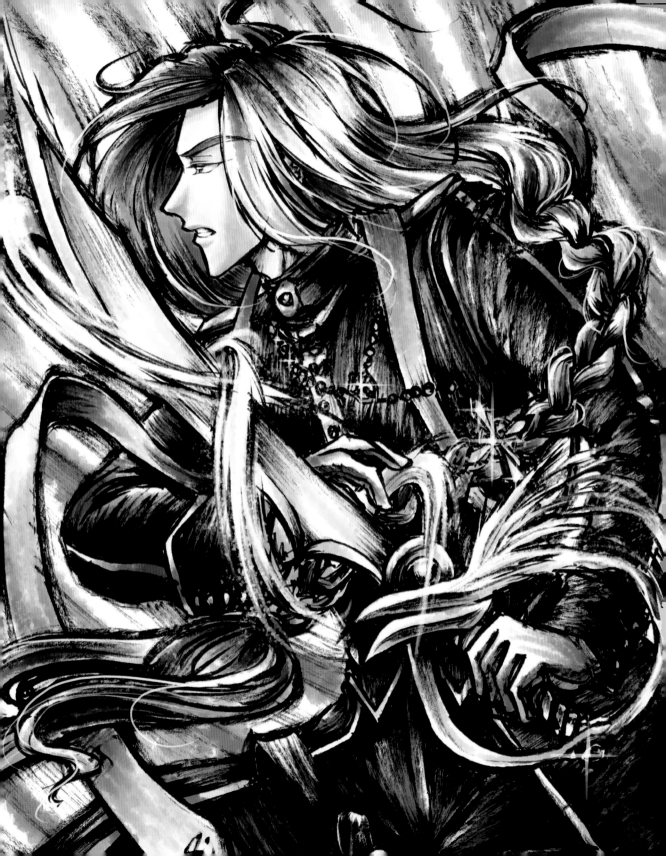

Buns and updos

You might decide to put your character's hair up and collect it into a bun. For a conservative, clean, and polished look, the ends of hair should be pinned underneath the bun. For a messier look, draw lots of hair strands coming out from the bun; a popular look in contemporary manga art.

▲ Break complex hairstyles down into sections. Here, the front section was drawn first, then some diamond and screw shapes were roughed out as a guide for the full length of the character's hair, before outlining the spiral curls.

◀ To draw buns effectively, think about the direction of the strands of hair and indicate this with a few fine lines.

Embellishments

The real fun begins when you start putting combinations together and adding extra little touches like jewelry and hair accessories. Don't feel as if you must put all of the hair together. Try dividing the hair into separate parts and doing different things with each. Start by roughing the outlines of each group of hair and build up the complexity gradually. When working on the final inks, it helps to stay on track if you focus on one thing at a time—draw the top of the hair first, then any sections in front or on top of anything else.

Tying it all together

By now you should be aware of good practices to use and pitfalls to avoid when drawing all types of hairstyles. Now you need to work on the different ways that hair can be altered by circumstance and style.

Movement

The only time hair is still is when we are still and somewhere without wind. In those cases, gravity (and gravity-defying hair products) take charge. But at all other times, hair moves. If we are moving forward, then it flows behind us; if we are falling, it will flow up. If hair is being moved by something else, such as air or water currents, it matches the flow of the current. Not all movements are the same, however. The stronger the movement or current, the more the hair is shifted from its normal state. A small breeze will stir the hair slightly, with only the outer strands lifting; a gale will blow all of the hair sideways, taut from the face.

▶ This mermaid is moving to the right, so her hair flows behind her toward the left.

▶ This mermaid is slowly descending in the water, so her hair flows up as she travels downward.

Angles

When designing a hairstyle on a character for a manga or anime series, you need to understand exactly how the hairstyle is constructed so that you can build a three-dimensional model of it in your head. That way, you'll be able to reproduce it from all angles. A hairstyle can look very different from the back of the head. Some parts can only be seen in one view and not the other. It is even harder to keep track of what goes where if the style is asymmetric. Make an effort to draw your character from different views and angles and keep your work as a reference.

◀ The same character is seen from three different views. Note the way the twist in her bun and the loose ends at the top are expressed.

Body:
Head-to-body proportions

We know some people are taller than others and that children are smaller than adults, but you need to observe everyone around you to build up a rough structure in your mind about their overall proportions.

The theory

Aside from the progression of infancy into childhood, the head does not increase in size exponentially as we grow. As such, comparing the size of the head to the size of the body is a useful way to manage drawing people of all heights as it provides you with a basic reference point. Use the top-to-bottom length of the head to count all the way down the body to give yourself the number of head-lengths required.

Children

Over the age of three and until roughly 12 years old, children's bodies are relatively short and small in comparison to the size of the head. They vary between four to six head-lengths tall, depending on whether they are naturally shorter or taller, but the number will vary according to the style in which you draw.

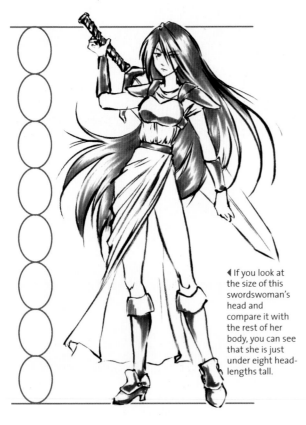

◀ If you look at the size of this swordswoman's head and compare it with the rest of her body, you can see that she is just under eight head-lengths tall.

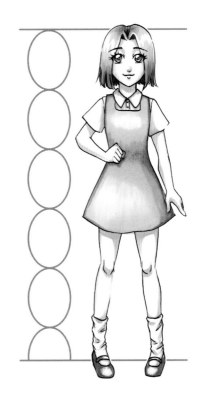

◀ This little girl is about nine years old. She is only five-and-a-half head-lengths tall.

Teenagers

Teenagers are the most inconsistent of age groups to draw in height and build. Even a difference of just two years is enough for the same character to transform and grow dramatically. Teenagers go through many changes—some have their growth spurt earlier or later, others barely have any at all—so just because a person is taller, it doesn't mean they are older. They can range from around five head-lengths tall, through to a towering nine head-lengths.

Adults

Similar to teenagers in that they can be many different heights, the only main difference is that adults will not grow any further. Err on the side of drawing adults taller (i.e. more head-lengths) than the normal real-life examples. Manga is a dynamic-looking art form that is very visual. Just like in the fashion industry, certain heights and head-to-body ratios look more impressive, particularly if your character is whirling around in an action scene, guns blazing and cloak flying. Depending on your drawing style and whether they are naturally short or tall, adults range between five-and-a-half to ten head-lengths.

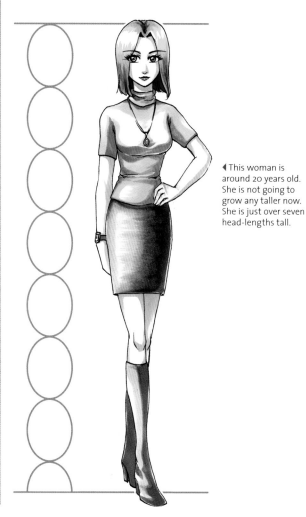

◀ This woman is around 20 years old. She is not going to grow any taller now. She is just over seven head-lengths tall.

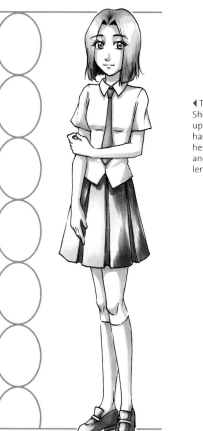

◀ This girl is around 14. She's started shooting up in height, but hasn't reached her full height yet. She is six-and-a-half head-lengths tall.

Body:
Limb proportions

Once you know the overall height and head-to-body ratio of your character, you need to understand and memorize roughly how long the limbs are as well as where all the main joints are. What is great about the human body is that, barring a few exceptions and subtle variations between people, everything can be measured and divided into easy ratios and relative sizing.

Proportions

The number one pitfall of every artist when they first begin to draw full body shots of characters is making the legs too short. Even if the artist has tried to learn and practice from looking at themselves in the mirror or their own photographs for reference, they can still make errors. This is because our point of view is also flawed. Typical photographs, normal-sized mirrors in small rooms, and the fact that when we look at someone face-to-face we actually look down at an angle to see their legs, all add up to give us a misleading impression that our legs are shorter than they are.

In truth, most legs take up roughly half the entire height of a person, or at the very least, half of the height from the shoulder to the floor. In manga, legs appear relatively long, so once you have drawn an outline for the head and figured out how many head-lengths you want your character to be to get their full height, don't be afraid to cut that height in half to split it into legs and torso. There are also aesthetic differences between men and women on the leg/torso split: it is more masculine to have a long, powerful-looking torso, and more feminine to have long, graceful legs.

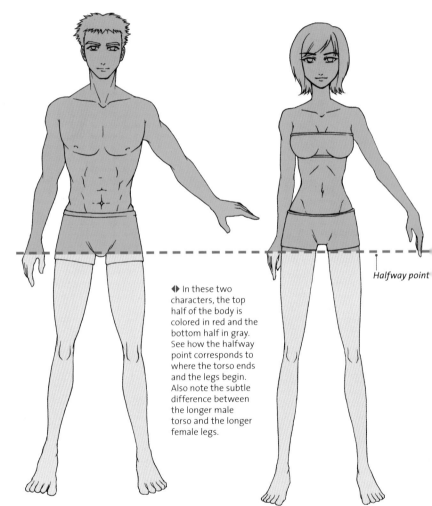

Halfway point

◀▶ In these two characters, the top half of the body is colored in red and the bottom half in gray. See how the halfway point corresponds to where the torso ends and the legs begin. Also note the subtle difference between the longer male torso and the longer female legs.

Arms and hands

Having allocated the right amount of space to go toward the legs, what is left has to make up the torso, minus the neck. If you have the size of the upper body, you can use that to figure out how long to make the arms. The torso height matches the distance between the shoulders and the wrists, so the main length of the arm is the same as the length of the torso. Hands extend beyond this, from the wrist—this is why you are able to sit on your hands. To place the elbow joint, take the length of only the arm without the hands (the distance from the shoulder to the wrist) and divide that in half.

Waist and hips

There are some basic differences between men and women in the placement of the waist. The waist is slightly lower than halfway down the torso, but women generally have a higher waist than men, even if they are of the same height. The effect is made even more obvious because of the typically longer male torso, and also because of less waist definition. In both cases, in regular male and female bodies of all ages past childhood, the waist is narrower than the hips. In mature females, the difference between the waist and hips is more pronounced.

Legs and feet

Just like the placement of the elbows, look at the main length of the limb, minus its extremities, and divide in half for the knees. The legs join onto the bottom of the torso at the hips. At the bottom of the legs are the ankles and feet. Take the distance from the hips to the ankles and divide that in half to place the knees correctly. Another tip to consider is the length of the feet: it will match the distance from the elbow to the wrist. Check it out on yourself!

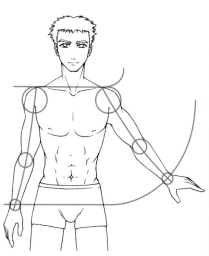

▲ The joints and relative lengths along the arm have been marked out in red. Even if the arm is extended or bent, try to use the same measuring principles to ensure the correct length and placement of joints.

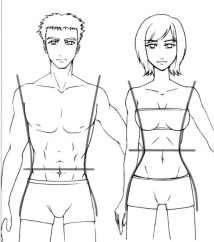

▲ The waistline should be slightly lower than halfway down the torso. Notice how the female waist appears higher than that of the male. Also note the difference in curvature—the female has a curvier silhouette and a more defined waist than the male.

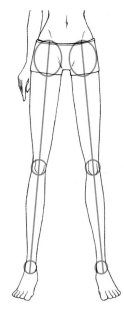

▲ The placement of the hips, knees, and ankles have been marked out in red. Be sure to place the knees halfway between the hips and ankles, not the hips and the feet. Feet extend out from the ankles, just as hands extend out from the wrists.

Body:
Flesh and muscles

Although manga is a relatively simple style that often leaves out details of wrinkles and muscles, you need to have a good overall knowledge of key muscle groups, so that when you are drawing, you can at least hint at the muscles underneath the skin.

General advice

In most manga storylines, there is at least one muscle-bound character. They are favorites in comics with lots of action and brawling, so in such stories there may be several, each getting even bigger than the last. In romances or thrillers, characters may not be as bulky, but still have lean, wiry muscles.

Muscles are more prominent on male characters as they naturally have less body fat than females, so they are easier to sculpt. But if you have a physically strong female character, don't be afraid to add some muscle to her—it is more appropriate than leaving her looking too thin and skinny.

The main muscles and major bones of the body often mirror each other in basic shape. Where a bone juts out it may be emphasized or framed by muscle on either side; other times, a muscle that covers a bone may become so built-up that it sits over and on top of the bone, adding bulk.

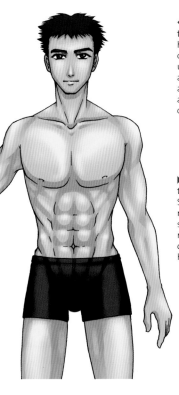

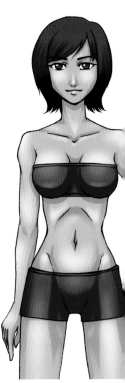

◄ A front view of a male torso, with shading to highlight the muscles. You can clearly see the pectorals, upper abdominal six-pack, and lower abdominals going all the way down the front, and the obliques and laterals on the sides of the ribs.

▶ A front view of a female torso with added shading. She is not as built up as the male character, so you mainly see the overall shape of the ribcage and the gentle swell of the belly with the hipbones slightly protruding.

Torso

The swell of muscles leading from the base of the neck to the collarbone are the trapezius muscles, or "traps." The main chest muscles are the pectorals—they appear as large bulges on men if they have exercised them regularly; on women, they are flatter as a whole, but the swell of the breast tissue sits on top of them. Below these are the muscles covering the ribcage. Most women and slender men will have a more obvious ribcage swell than muscles, but if built-up, the abdominal muscles will show in the central area below the chest, covering the belly and leading to the top of the hips. The set of six muscles in two columns leading from the chest to the belly button is known famously as a "six-pack." Below the belly button are two longer lower abdominal muscles leading to the groin. Along the sides, the muscles hugging the ribs just under the armpits are called the laterals. Underneath these, surrounding the sides of the waist and ending at the top of the hips, are muscles called the obliques.

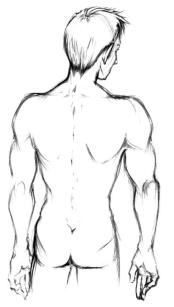

▲ The back of the torso shows the traps more clearly. The spine itself doesn't stick out unless the character bends forward, but you will see indents along it all the way down to the top of the buttocks.

Arms and shoulders

The arms and shoulders are likely to be showcased in manga art as clothing is often short-sleeved, tight-fitting, or is made of thin, clingy material on the sleeves. The swell over the shoulder is called the deltoid; there is a bulge on the upper arm for the bicep; the underside of the upper arm has the tricep muscle, which is usually less defined. The muscles slim down as they connect with the area that pulls on the elbow joints. There is a bony bulge for the elbow, then a swell of muscles for the forearm, which again slims down as it approaches the wrist.

Legs

The quadriceps, or "quads," are the main front group of muscles between the hips and the knees. One of these muscles runs along the inner thigh up to the groin and can be visually distinct at the top of the thigh. The knees always protrude, regardless of the build of the character, and there are no muscles along the front of the shins. But the calf muscles can be built up. These are split into two—the ones on the outer edges tend to bulge more.

◀ There is very little muscle in the lower back. The buttock muscles are known as glutes and tend to be smaller and indented in males, but larger and more plump or peachy in females, as shown here.

▶ Make an effort to memorize the main swells of the muscles and where they slim down to show more bone. Note how defined the bicep and tricep muscles are in this pencil drawing.

▶ Make sure that you show off the protruding quads and calves when the leg is tensed up, as shown in these pencil sketches.

Body:
Weighting and action lines

It is usually the mark of an experienced professional when you look at a piece of artwork and feel as if the character could come to life and walk around you or throw a punch or a kick with real force and movement. That is because all aspects of movement, balance, and weight have come together in harmony to give a believable, but dynamic, pose.

Roughing

Before committing the time to drawing in all the details of the face, body, and costume on a character, it is good practice to draw a rough outline in simple stick figures first. You should be able to see from this outline whether a pose could actually work in real life. You will also be able to spot any major mistakes.

Draw a quick egg-shape for the head, then use a series of lines, balls, ovals, and cylinders (whatever you feel comfortable with) to get a rough outline for your character in your chosen pose. While the basic lines marking the key start and end points of the skeleton won't change too much between characters of the same height, the volumes of the shapes you use to flesh them out will, due to differences in gender and body shape.

Line of action

A line of action is a line that goes through either the whole body or parts of the body to sum up the overall pose of the character. It can be mostly straight for static positions. For active poses where the body bends or curls, the line will curve and twist.

Bodies

Imagine a line going down through the head and spine of a character, and then going out through the tail bone. It is rarely completely vertical in reality, particularly if you take into account views from all sides. Even a basic, upright,

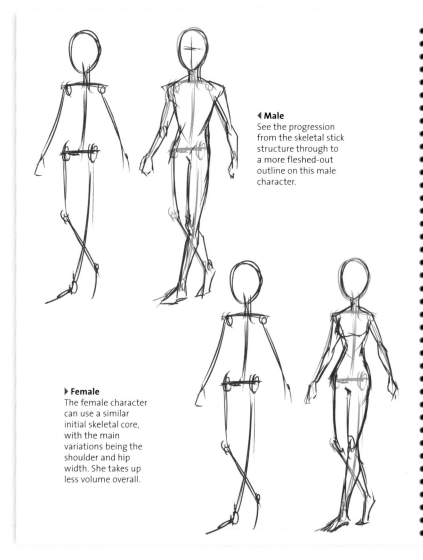

◀ **Male**
See the progression from the skeletal stick structure through to a more fleshed-out outline on this male character.

▶ **Female**
The female character can use a similar initial skeletal core, with the main variations being the shoulder and hip width. She takes up less volume overall.

▶ Someone receives a knockout punch! Action lines are important, even on the character receiving the punch. Here, they are marked out on the spines and the limbs on all of the characters.

standing position may look vertical from the front or back, but will have some curvature to the spine from the sides. Understanding the natural curve of the spine and its limits will play a huge part in making your characters stand and move realistically.

Limbs

You can use action lines to help guide the placement of limbs for active poses. This is especially useful for drawing arms and hands, as the joints are close together, so they can be more curved and expressive than the legs, where there are long, straight sections and the joints are placed farther apart. The key thing to remember is that action lines for limbs are best employed when you are drawing a long, extended position. Throwing a punch or kick, flinging arms back, leaping high—all of these actions require a limb to be extended in a slight curve. Think of this line going through the shoulder to the wrist, or the hip to the ankle. The elbows and knees do not have to be strictly on this line, but should be close.

▼ Some drawings of front and side views of a female with the spine marked out. The spine curves most obviously from the side view.

▼ These basic stick figures show a female pulling dramatic action poses, with the action lines marked out for the spine and the limbs.

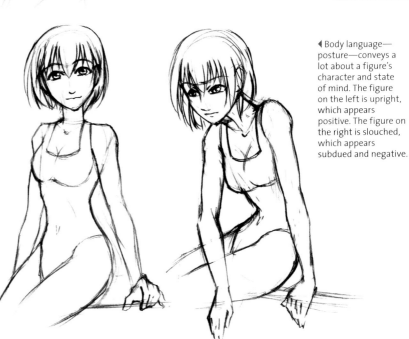

◀ Like a guardian angel, the man unfurls his wings to protect the girl from danger. His upright posture leans into the wind, ready to take the brunt of an attack. In contrast, she is hunched over into his chest, showing that she is scared and startled.

Posture

You can tell a lot about a character from the way in which they hold themselves and how they stand. All of us stand and sit in different ways, and this can be affected by both health and frame of mind. Make full use of the action line through the spine to show a proudly puffed-up chest or a tired and despondent slouch. Observe people around you to learn their body language. If someone is interested in something, they have a more forward and open position. A relaxed character leans back more, but still keeps an opened position. But a posture that angles backward with tightly closed legs or folded arms shows the character is uncomfortable or dissatisfied.

◀ Body language— posture—conveys a lot about a figure's character and state of mind. The figure on the left is upright, which appears positive. The figure on the right is slouched, which appears subdued and negative.

Balance and heaviness

When drawing characters that are supporting themselves on their own two feet, you have to take into account their balance and where their weight is supported. It is rare to plant both feet shoulder-width apart and stand with your weight evenly distributed. Shifting weight from one foot to another when we are relaxed is far more natural and our bodies and hips will tilt accordingly.

When moving—be it walking, running, or jumping, or to be able to stop without falling over—our legs and body position have to be in balance. A good way to check this is to draw an action line through the spine, then draw another line from the groin to a spot halfway between the feet. If both lines tilt in the same direction (unless your character is halfway through a running stride), they are going to fall over.

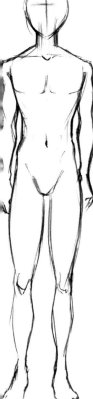

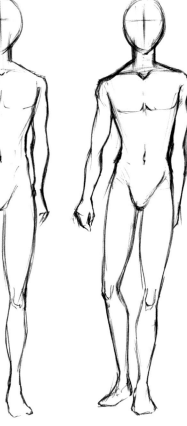

▲ The figure has its weight evenly distributed on each leg. However, the pose looks rigid and unnatural.

▲ This figure is standing in a natural-looking pose, with its weight resting slightly more on one leg.

▲ The action lines show that although the body of this figure is bending one way, his legs are tilting the other way, so the weight is balanced.

▶ This woman is breaking forward into a run. Everything tilts forward, but she has one leg raised and bent ready to put down in front of her when she takes her next stride.

Body:
Perspective and foreshortening

Part of what makes all forms of comics so exciting is the use of dramatic shots that really show off the action. Having a character look like they are leaping out at you or reaching toward you requires you to stretch yourself beyond simply drawing poses. You'll need to get a good grasp on drawing your characters showing perspective and foreshortening.

Basic theory

When something is closer to you, it appears larger. When it is farther away, it appears smaller. So if a character is in the foreground, they should be drawn larger than one at mid-distance, and much larger than one who is in the background. But it's not just about drawing characters larger or smaller—you also have to practice drawing parts of the character larger or smaller as well.

Using boxes

When dealing with a tricky perspective shot, be it of the character's entire body or just one of the limbs, you may find that using boxes and grids can be very helpful—not just to get yourself in the frame of mind to visualize how your character is getting distorted, but also as a guide for helping yourself place key body parts in the correct positions. As so much of the human body is divided into sections using relative measurements, it becomes fairly straightforward if you also divide up any box in the same way.

Halfway point

◀ A normal front view of a character. She is enclosed in a long rectangular box, with the halfway point marked out for where her body ends and her legs start.

— *Halfway point*

▲ In this example, the view point is at a lower angle. The box clearly shows how strong the perspective is. Notice the halfway point has been marked out again, making it easier to gauge the size of her legs and body.

▶ This is an ancient Egyptian-inspired character, drawn in a semi-chibi style. The viewpoint is high above her, so note how her raised, gloved hand and head look very large compared with the ungloved hand, legs, and feet farther down below.

◀▶ There is very little foreshortening in this side view of a man holding his hand out. When viewing the same pose from the front, foreshortening occurs. Notice how large the hand looks. Emphasize the curves and swells of the muscles in his arm; these muscles help to ground the hand and convince the viewer that the arm is extending out.

Placement and degree

Foreshortening is a visual effect used to enhance the feeling that the character is coming toward you, where the size is slightly exaggerated to shorten the distance. In most comics and manga, foreshortening is very dramatic, with a fair amount of exaggeration above and beyond the scope of actual increase in size when looking at the same pose in real life. The main difficulties arise in gauging how much to increase the size of the close object, but also how to account for what it obscures and the distortion on what the object is attached to. Look at the way many artists have chosen to display this in their comics to gauge what is right for your style.

▶ This fox warrior brandishes a dagger in front of her. Keep the length of her arms compact and visualize them as a cylinder coming toward you. Then draw her hands and dagger very large in size for a three-dimensional look.

Body:
Hands

Palm and
back of hand Fist and
peace sign

Hands are incredibly complex to represent, not only because of the difficulties in drawing their physical structure, but because they are so agile and dexterous; they can shape themselves into many different forms, grips, and gestures. If you tilt a hand one way, add length to some parts and shorten others, you can change the overall feel of the character and give them personality.

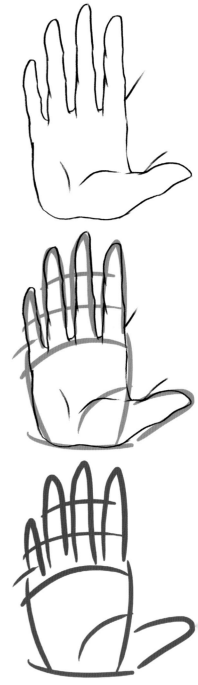

Basic structure and measurements

Before diving into complex hand poses, you need to know the key shapes and measurements of a hand, distilled down to the very basics. Looking at your own hand is very helpful, but you need to observe others as well. If you can understand and depict the following important features, you may not draw the best hand in the world, but it will be, unmistakably, a believable hand.

Palm

The palm is roughly a square shape. Rounded off at the edges, sloped more toward the little finger, it sticks out more where the thumb connects to it.

Thumb

It is absolutely vital that the thumb joins onto the lower half of the square, on the

side. Once you place the thumb correctly in relation to the rest of the other fingers, it becomes a hand.

Fingers

The fingers join onto the top of the palm, with gaps in between them. The longest finger is the middle one, and its length should be no longer than the height of the palm. There are two joints per finger.

Pinky

The pinkies shouldn't be longer than the final joint of the other fingers.

Mound of the thumb

A form of shorthand for comic artists everywhere, drawing a curved line for the mound of the thumb is a way to indicate when a palm is facing you.

▶ Breaking the hand down into basic shapes and following the guidelines outlined above makes them simple to draw.

Adding detail

If you want to showcase a slightly more realistic style, you can incorporate some definition to the most prominent joints and knuckles by adding slight swells to your lines and a few strokes on the places which would cast the most shadow. But, if you use too many lines, your character will look like they have lots of deep wrinkles in their hand. Rather than adding too much detail with outlines, use shading to give the hand volume and to define folds.

Accentuate the lines in the palm with a little shadowing.

When a hand is relaxed, it curls slightly.

Note how shading is used to highlight the knuckles and joints.

Trailing shadows on the top of the hand show the tendons that connect them.

Fists

Even if you aren't drawing an action manga, you will have to draw fisted hands at some point. The main things you have to remember are that the fingers curl tightly at their two joints until the nails touch the palm; you will mainly see the knuckles and joints. Furthermore, in most cases, the thumb curls over the fingers on their outside.

Note how the ends of the fingers are curled in and the thumb is tucked around the middle and index fingers.

You don't see the ends of the fingers at all as they are obscured from view by the last joints. The knuckles form the top line.

The curled index finger and part of the thumb can be seen in this view, but the rest of the fingers are obscured.

Reaching

The most difficult of hand poses to draw is when the hand reaches back or forward. Try not to be daunted; use the swells of each finger joint to help define the volume of the fingers and reposition the lines and mounds on the palm to match the perspective. Shading also helps immensely.

The wrist and thumb mound are in front, so they are drawn prominently. The rest of the palm looks smaller. Take your time with the fingers as their angles and lengths are tricky when perspective is mixed in.

When a hand reaches forward, the grasping fingers become most obvious and splay out in dramatically different angles.

Body:
Feet

Front and back view — With shoes

Feet are not as changeable or easily poseable as hands are, but it would be wrong to think that they are boring or simple—they can be incredibly expressive.

Basic structure and measurements

Feet can be broken down into basic shapes to help you visualize them at all angles. Shoes can also provide a valuable resource if you need to get a rough idea of how everything is positioned at different angles; look for designs that are molded closely to the foot's actual shape.

Ankle

The muscles of the leg gradually slim down to the ankle joints. It is very important to draw these in all angles, as they are not only prominent in real life, but they are a key visual indication of where the foot is joined onto the leg. The outer side of the ankle is slightly lower than the inner side.

Spade shape

When you look down at your own feet, you will notice a triangular, spade-like shape. The foot starts off narrow and rounded at the heel, then widens and spreads as it progresses to the toes. From the side, the triangle is reversed—the toes are the sharp point of the triangle, and the height of the foot at the back from ankle to heel is the thick part.

Heel and ball

These two features form the sole, the underside of the foot. The heel is the very back of the foot, just under the ankle. It is very round, so try to flesh it out with a circle shape. The ball is the padded section at the front of foot, where we would put our weight if we stood on tiptoes. There are two main fleshy areas here, so use two circles next to each other for shaping and adding volume.

Toes

The number of joints on the toes are built on the same model as hands; one big one for the big toe, then two very small, close ones for the rest of the toes. But the last section on the ends of our toes usually stays in line with the middle section, unless the toes are curled very tightly. They can bend a lot from the toe knuckles where they join onto the foot.

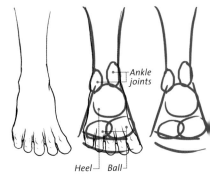

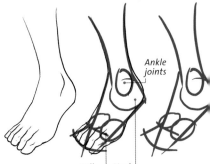

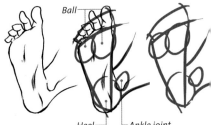

▲ Simple line drawings of feet with guidelines have been overlapped and shown separately in order to demonstrate the key shapes you should take note of.

Adding detail

If you want to showcase a slightly more realistic style, create definition on the most prominent joints and knuckles by adding variations to your lines and a few strokes on the places which would cast the most shadow. Use shading where possible to give volume and to define folds. Focus on the ankle, the knuckles, and the first joint on the toes.

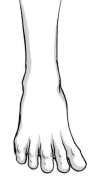

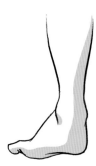

▲ In this front view, shading has been used to emphasize the tendons leading into the toe knuckles and the primary joint on the toes themselves.

▲ A side view of a foot, with toes spread slightly. This view allows you to really highlight the bend of the toe from the knuckle at the primary joint.

▲ This ankle shape is rounded when viewed from this angle. Use lines to define where the sole starts on the side of the foot, and also for the heel and ball of the foot.

▲ This view is from the back of the foot. The heel takes precedence; make it very round at the bottom. The arch of the sole is moderate in most cases. Most of the toes would be obscured.

▶ The progression of the foot going through a step from a three-quarter view. Here we see the foot rising onto the ball of the foot (left), showing strong angles at the ankle and the toe knuckles (center), and the primary joints visibly bending back (right).

Movement

Understanding how the foot moves is essential. Our muscles and balance have developed so that our motion is smooth and practiced, and while there are many gaits and ways of walking, the most common way is to roll the sole of the foot gradually on and off the floor. We put our feet down mostly beginning with the heel, before rolling through the sole onto the ball of the foot. Then, when pushing off the floor for the next step, we raise ourselves onto the ball of the foot and push off with the toes. This is used with minor variations for walking, jogging, and running. The two main areas where the foot bends to take the strain are the ankle and the toe knuckles. It shouldn't really bend anywhere else!

▲ When drawing a foot in motion from the back view, the main sections you have to emphasize are the rounded bottom of the heel (left) and the details of the ball farther along the sole (center). Toes will only be visible once the foot has pushed off the floor and is pointing downward (right).

Body:
Chibi proportions

A much-loved feature of almost all forms of anime and manga artwork, chibis are cute, mini versions of normal-sized characters. Chibi means "little one" or "shortie" in colloquial Japanese. Another way to think of it is to consider the letters "C" and "B" standing for "child body" because that is, in effect, what you draw when creating a character in this style.

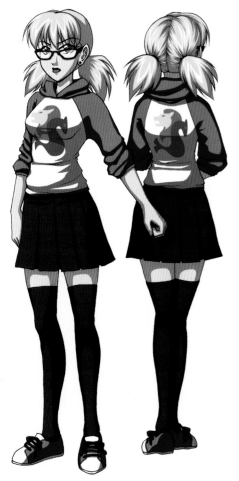

Basic theory

When drawing a chibi, you limit the height of the character to between three to four head-lengths tall, as if you were drawing a very young child or toddler. The body is then drawn using the same guidelines as usual, although the legs are relatively shorter. Take the distance from the shoulder to the floor and divide it in half to get the point where the body ends and the legs begin. Aside from that, the lengths of the limbs and placement of joints are the same. Another thing you need to take into account is to use childlike proportions—thicker, chubbier limbs are very common.

▲ Front and back view of a character in normal proportions, about six head-lengths tall.

▲ This is a chibi-proportioned version of the character to the left. Note the length of the legs—half the height from the shoulder to the floor.

▲ Looking at the chibi silhouette, you can see the height is just over three head-lengths tall.

Subtle styling

There are some important changes you need to take into account when drawing chibis as opposed to normal-sized people:

Face shape

Even if a character usually has a long face, the chibi version must be rounded and cuter. Don't extend the chin much beyond the basic circle of the head shape. Many chibis have even shorter and wider heads than a circle.

Facial features

The eyes become much larger, like those of a child, and the nose will almost disappear.

Neck

The length and width of the neck are important. Use the absolute minimum width that is appropriate for the character type. One-third of the width of the head is perfectly acceptable for all but the most muscle-bound characters. Never draw a long neck on a chibi. Keep the neck very short; sometimes, it's barely there at all.

Body shape

Regardless of whether the character is male or female or any size and build, chibis tend to be drawn quite blob-like and bottom-heavy. The shoulders are not too wide, the waist is not as narrow or pinched-in, and the hips are widened.

If the original character has any extreme proportions, such as being really muscle-bound and top heavy, or is very voluptuous and curvy, you should reduce those measurements slightly, according to those principles.

Hands and feet

Aside from using shorter, stubbier proportions, it is up to you if you want to draw them relatively smaller to match the shorter limb lengths, or larger to match the larger head size. Whatever the case, pick small or large for both hands and feet; don't draw the hands small and the feet large, or vice versa!

▲ It is important to get the joints and weighting in the right places to give your chibis life and attitude.

▲ The eyes and face shape of these two chibis are quite distinct from one another, demonstrating that it is possible to individualize your characters when working in the chibi style.

▲ Male manga characters are usually drawn with wide shoulders and narrow hips, but on chibi males these tend to be the same width.

Body:
Other art styles

It can sometimes be difficult to describe manga to newcomers because there are actually so many different styles within the format. While it is most important for you to develop your own style, it really helps your flexibility and improves your general knowledge if you know a little more about the key principles behind the most popular looks.

Role-Playing Game style

Many artists like to represent their characters in a proportion set that appears cute, without being too exaggerated, small in stature, or chubby. Chibi style is very stylized, so, instead of shrinking down to as much as three to four head-lengths, characters of all ages are represented between five to six head-lengths, even full-grown adults.

There are multiple reasons why this proportion set is used over other variations. This semi-chibi look is very popular for video games, particularly Role-Playing Games or RPGs. These games last for many hours and feature many characters aside from the main player. This style of artwork is expressive and exaggerated for easy viewing on a limited screen size; you want to be able to see their expressions and poses, and the main details of their clothing and weaponry either on a small hand-held console screen or when seated far away from the television. Video games have influenced anime and manga artwork, so you will find characters in this style even when they aren't originally linked with a video game.

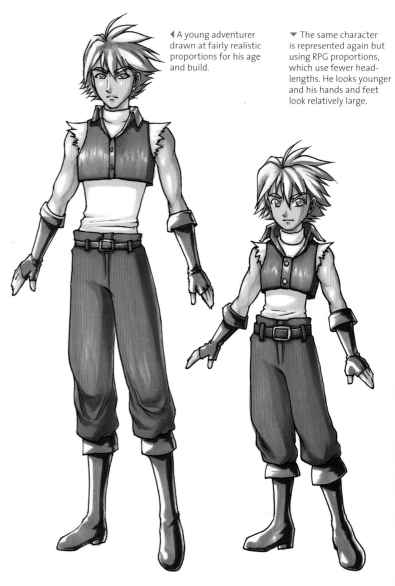

◄ A young adventurer drawn at fairly realistic proportions for his age and build.

▼ The same character is represented again but using RPG proportions, which use fewer head-lengths. He looks younger and his hands and feet look relatively large.

▶ Cute characters with animal mascots are often featured in video games. To keep the art clear and easy to see, not only do the costumes have to be bold and simply designed, but the proportion set is often reduced so that they are shorter than in real life.

▼ A swordsman drawn in RPG proportions. He is only five head-lengths tall, but he looks like an adult drawn in this style, rather than just a drawing of a child. Make sure you give him an adult's confidence and stance.

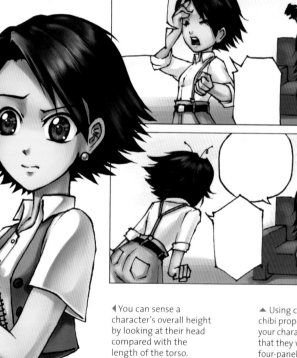

◀ You can sense a character's overall height by looking at their head compared with the length of the torso.

▲ Using chibi or semi-chibi proportions for your characters means that they will fit into four-panel gag strips (see page 238).

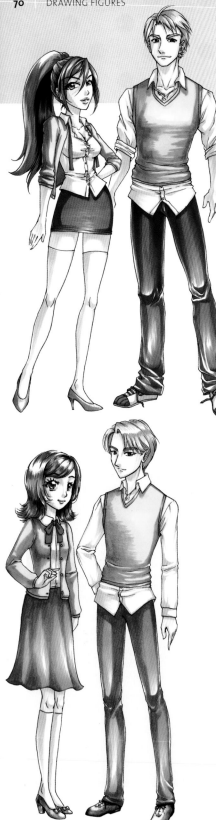

Shounen style

The word "shounen" is Japanese for "boy" and when used in the context of art style, it refers to manga and anime aimed at young boys and teens. While the main features have much more to do with the storyline and the way it is told, there are some popular character types and styles that feature very strongly across the majority of shounen manga.

As the focus is often on the action (particularly fighting and special moves), characters are frequently drawn quite tall, sometimes taller than real life. This makes them look more powerful, giving them stature and presence. It also makes a great backdrop for costumes with cloaks and chains or large weapons. Taller characters look more dynamic in action scenes. Longer limbs can also help to emphasize the action.

The male protagonist will often grow more powerful throughout the course of the series. He may or may not be very large, but even if he is lean, he will have defined muscles. Female protagonists are usually either old friends with strong attitude or someone newly met and timid that needs to be protected. Regardless of their personality, they tend to have a lot of sex appeal; even if modestly dressed, they have idealized, curvy figures.

◄ Shounen males are muscular and almost nine head-lengths tall. Females are curvaceous and nearly eight head-lengths tall.

Shoujo style

"Shoujo" is Japanese for "girl" and is used to describe any series in anime or manga aimed at girls. Again, the most obvious differences will be seen in the story itself and the way it is presented, but characters tend to be drawn very differently to the style that is used in shounen comics.

Shoujo manga tends to focus on relationships. Even if there is action and fighting, there is a lot of emotional build-up and deconstruction afterward.

As such, it is vitally important to have lots of closeups of people's faces so that you can clearly see their expressions and what they are feeling throughout any scene. Characters are also drawn very daintily, with a beautiful finish and flair. This means that heads tend to be on the larger side, with bodies drawn in a slender style.

A female protagonist is usually the point-of-view character for the reader, and she is drawn in a very feminine, slim style: delicate and pretty, with a cute, round face that has large eyes. It is rare for shoujo heroines to be excessively sexy or voluptuous. Male characters are typical "bishounen" or "beautiful boys"; they are drawn so prettily that at times they may look androgynous to newcomers to the style.

◄ Shoujo females have large eyes and their bodies are slender and dainty; they are six head-lengths tall. Males are seven head-lengths tall and they are drawn slim with little muscle definition.

Other styles

Shounen and shoujo are the most well-known and popular styles because they cater to the largest market and are visually the most striking. But manga has a long history of catering to many different audiences. If sticking to gender and age, "seinen" means "young man" and is a subset of manga that caters to males aged roughly between 18 and 30 years old, although there are many older fans. "Josei" means "feminine" and is the female counterpart to seinen, as it caters to more mature ladies. Neither seinen nor josei are necessarily "adult" in the sense of being sexually explicit, but the storylines are more developed and less idealized than their younger equivalents.

Instead of fantasy action or school romance, you would find historical accounts, intense political thrillers, or real-life drama and infidelity. Hand-in-hand with this is a development of the art style; namely, there is less demand for presenting perfectly polished, stylish pieces in favor of individual style and flair with original ways of presentation to tell a more mature story. Characters can be drawn realistic or stylized.

▲ There's no need to stick to just one drawing style: Here, a mixture of chibi and semi-realistic styles have been used. The head is large, rounded, and cute but the body is slender and more realistically proportioned. This look is popular with both fashion and beauty publications.

Styling the face

While the first step to nailing different styles of artwork is to think about the proportion sets and number of head-lengths you need to use, you must not neglect the subtle variations required in styling the face.

▲ An RPG-style face is drawn in a very simple, childish style.

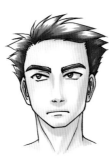

▲ A shounen-style male hero should look masculine and have a strong jaw and a determined expression.

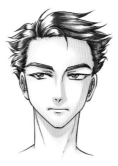

▲ A shoujo-style male hero should look beautiful, elegant and aloof, with pointed features.

Body:
Different body types

Regardless of your own personal style, it is incredibly important for an artist to have flexibility in the types of characters they can draw. It can get boring and monotonous for a reader to see characters that all look the same, let alone the difficulty it can cause telling them apart.

Gender

Some of the differences between male and female characters have been touched on already, but here is a summary of the key features:

Height

Once matured, males tend to be taller than female characters. However, just like in real life, there are tall women and short men, so don't be afraid to mix things up a little, particularly if it adds to fun interaction and dialog between your characters.

Leg to body ratio

Generally, the ideal male showcases a longer, toned torso and shorter, powerful legs. In contrast, the ideal female has a compact and curvy body, with long, elegant legs. Whatever the case, the difference is subtle and optional; the point at which the body ends and the legs begin should be either half of the whole height of the character, or at its lowest, half the height from the shoulder to the floor.

Shoulders and hips

Men tend to have broader shoulders and narrower hips. Women tend to have broader hips, with shoulders around the same width or narrower. Part of this is also due to muscular build-up; men find it easier to define and shape muscle than women, so even with similar amounts of exercise, the upper torso and the shoulders have a lot of potential muscle to develop, which will show more quickly and obviously on men.

Waist

There are various body types for men and women that affect exactly how wide the waist is in relation to other parts of the torso but, overall, women tend to have a more defined waist than men. Most women within a healthy weight range can find and measure their waistline fairly easily as the narrowest point of their torso, but healthy men will have more of a straight-up-and-down section just above their hips. Women also tend to have higher waists than men, partly due to the shorter torso.

Chest

Men have pectoral muscles on their chests which will have a smooth, gentle bulge if they work out. The chest is flat if they don't, or can be shaped more like women's breasts if they are overweight. This is due to fat accumulation. Women have the same muscles as men, but their breasts sit on top of all of the muscle, which is made from both breast tissue and fat tissue. This means that even muscular women will still have breast

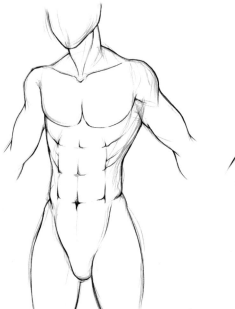
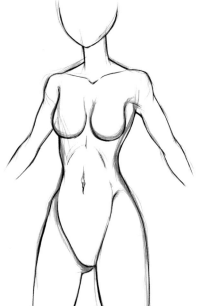

◀ Comparing the male and female torso side-by-side, you can observe the common differences. Men have long, inverted triangle-shaped torsos with clear muscle definition. Women have shorter, hourglass-shaped torsos and fewer muscles.

◀ Female breasts come in different shapes and sizes. Think about how they are positioned, their firmness, and heaviness.

▼ Elderly male characters tend to be thin with little muscle definition but a slight paunch at the belly. Females tend to carry a little bit more weight.

mounds on their chest, except for the most extreme body builders. Female breasts are a special case in point and can come in many shapes and sizes.

Curves versus angles

A stylistic consideration is the use of more curved lines for females and sharper, more angular shapes for male characters. Males tend to exhibit a stronger, sharper bone structure and more muscle definition than females. Curves give females a softer and more delicate appearance, which can look more feminine.

Age

Getting the correct height and proportions for a particular age is just the start. Our body shape also changes as we age.

Childhood

Very little separates the silhouette and body shape of young boys from young girls. As bodies lengthen, there is a little bit of difference with regard to the waist height and position, but shoulders, waist width, and hips are all fairly tube-like.

Adolescence

Once we hit puberty, our bodies start to take on aspects of male and female maturation. The classic differences

▶ Young children have no obvious curves and there is no real difference between the widths of male and female torsos.

between male and female bodies will show, but only slightly at the start and more fully as we develop.

Maturity

In adulthood, the bodies can show the highly contrasted extremes of male and female appearance. It is also when muscle definition should be at its peak.

Old age

When elderly, there are still obvious differences between men and women, but the muscles lose their condition and skin starts to droop. People tend to either put on or lose weight; the lucky few who

don't will lose some tone in their muscle. Posture changes as well; we start to stoop and slouch a little more and our spine compresses over the years, so we may also be a little shorter, too.

Weight

A person can lose or gain weight in different ways. Weight can be either in the form of muscle or fat. It will sit differently on a person's frame depending on what it is and the type of body the character has.

Bony areas (like the wrists, hands, feet, and hips) should not increase in size; there are no muscles there that can grow.

Fat sits below the skin and can be distributed anywhere, so previously bony areas can appear rounded and fleshy. Fat accumulates in particular areas to match with gravity, such as the throat and jowls, the chest, the undersides of the arms, the belly, and the thighs.

The key thing to remember is that there are limits to how much the skeleton can change; all weight has to be taken away from or added to it, so use the skeleton as your starting point.

Body shape

Even when perfectly healthy and fit, everyone has a different body shape. It is not as common to see some of these shapes in idealized Shoujo or Shounen manga aimed at teenage readers, but variations of these body types will be simplified and exaggerated in children's manga, or depicted very realistically in manga aimed at more mature readers. Showing different body types consistently between characters can really add credibility to your work.

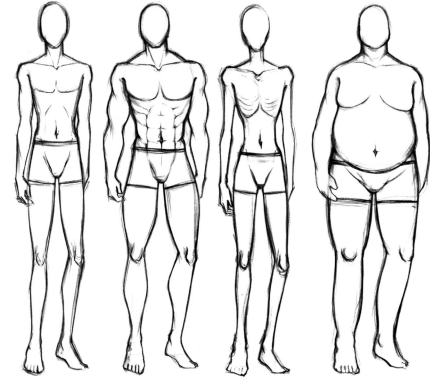

▼ A girl with an hourglass body, narrow at the waist with large breasts and hips.

▲ A lean body, neither skinny, nor fat, nor overly muscular. These are the default type in manga art.

▲ In a character that has been bodybuilding you can increase the swells upward with strong angles in the areas where the muscles should be.

▲ In a very skinny, emaciated character, you can see many of the bones as there is no fat and very little muscle covering them.

▲ The muscles of an obese figure will be hidden under thick layers of fat.

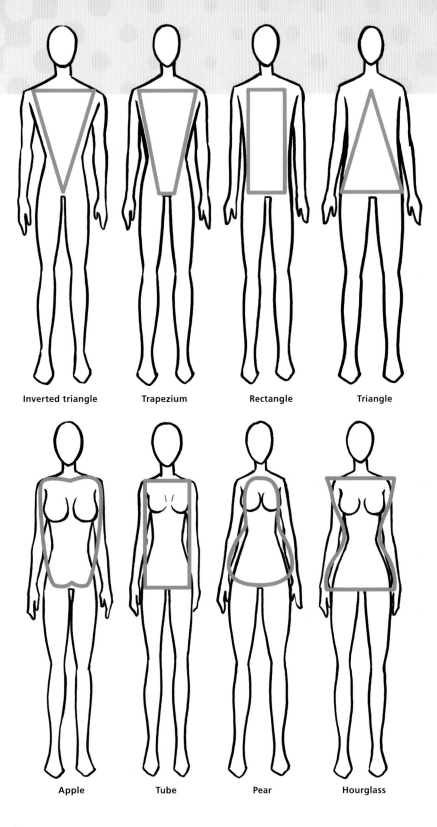

▶ Basic shapes showing different male body types. The most common types in manga are the inverted triangle and the trapezium.

Inverted triangle **Trapezium** **Rectangle** **Triangle**

▼ A girl with a tube-type body—tall and thin throughout.

▶ Basic shapes showing different female body types. The most common types in manga are the tube and the hourglass.

Apple **Tube** **Pear** **Hourglass**

Body:
Multiple figures

Manga really comes into its own when it showcases the relationships and interaction between multiple characters. It can be very tricky to master close contact between characters at first; don't give up and keep practicing.

Characters of different sizes

Remember how easy it is to gauge height and overall body proportions by looking at the size of the head? The head is very useful when drawing characters together or distanced farther apart because it gives a common base to start from. There are variations in head size between people, but these are relatively minor compared with the other more obvious differences in overall height, build, hair, and more. So, if you keep the head size roughly the same, it makes it a lot easier to draw characters near each other without worrying about whether you are drawing one too large or too small.

▲ You cannot see the full bodies of the two characters meeting in this image, but you can see that the one in white on the left is taller, larger, and more heavily built than the one in black on the right. The head sizes are mostly the same, but the size of the hands and the thickness of the neck are all indicators.

◀ Two characters of different heights walking next to each other. By keeping the size of the heads the same, it is easy to show the differences in height if they are in line with one another, by using a line on the floor.

▶ The multiple characters in the foreground, middle ground, and background of this abstract image are not strictly standing on a floor. But the head sizes (and body sizes in general, regardless of each individual's height) have increased for characters that are closer and decreased for those farther away.

Distance

Similar to the theories and techniques regarding perspective and foreshortening, you can use perspective and vanishing points to help you gauge where to position your characters and how large or small to draw them. It is very important to have a good idea of where the horizon line is, as it can be affected by the position and angle of the camera. Once you have established a vanishing point to refer to, use it to mark out the top and bottom of a character. Then you can use those points in conjunction with floor markings to position your characters farther or closer and keep the sizes consistent. If the characters are not set in a rigid background, you don't have to worry as much about positioning, but try to use the head size as a way of keeping track of who is in front of the other and draw them larger or smaller as required.

Vanishing point

◀ The vanishing point is marked out where the green lines join, along with the horizon line or floor in blue. The green lines extend out from the vanishing point to the top of the head and the feet of the character. The character is reduced in size and placed correctly to match the vanishing point.

Characters interacting closely

This is probably the hardest skill to perfect. Of course, you may have characters who look very similar or very different, but if they are holding each other or twisting around each other, it can be very difficult not only to account for their poses, but also to keep their sizing, perspective, and foreshortening correct. You have to build up complex poses gradually. Start with a very quick rough or stick figure of what they are doing. Look at stock photos or try out the pose with a friend if you have trouble visualizing it; there is no sense in trying to draw a pose that can't actually work in practice. Then draw the head sizes. Add flesh and length to the bodies and limbs, and adjust the positioning as you go. Try to focus on the main torso of one of the characters first before adding the other character to their pose. The torso will determine the central starting point and overall line of action to the image. Limbs can be added, shifted, and curved much more easily.

◀ In this pose, there is the impression that the girl is smaller and shorter than the boy because of the length of their bodies and limbs. Notice, however, that they still have roughly the same head size.

▶ When dealing with a more complex pose, draw the rough outline of the body for both characters, even if certain parts will not be seen in the final drawing. The pose on the right is a particularly challenging interactive pose, with one character giving the other a piggyback. It involves knowledge of anatomy, differences in body size, natural lines of movement and weighting, along with foreshortening and perspective.

▶ When drawing
multiple figures
closely interacting,
draw the character in
the middle first, then
the other figures in
front of and behind
him. Keep the heads,
torsos, and limbs
roughly the same
size and length.

2

Creating Characters

Breathe life into your characters and bring them alive on the page: Design and draw appropriate costumes for them, then give them a prop to hold or a weapon to brandish.

Costume:
Coverage and layering

Many beginner manga artists try to learn by copying finished pictures of characters in various poses that are already clothed. This can lead to bad habits and learning how to draw people and clothing by memory, without understanding how much the body underneath can affect the clothes on top. The very first stage in drawing clothed characters is drawing them without clothes!

Tight or loose clothing

Tight clothing clings to the body and stretches around the largest parts. For most natural textiles, there will also be stretch marks and thin gathers of material where the body has bends and folds. On the other hand, very stretchy, synthetic materials will have fewer gathers because they mold to the body better.

Some artists mistakenly think that if a character wears loose clothing, there is no need to worry about the body underneath. While this can be true to some extent, it is still essential to draw the body and limbs where the clothing is likely to hang off or drape from. For example, a floor-length, full skirt covers the legs underneath completely but if the character has a leg outstretched, the skirt hangs from the leg.

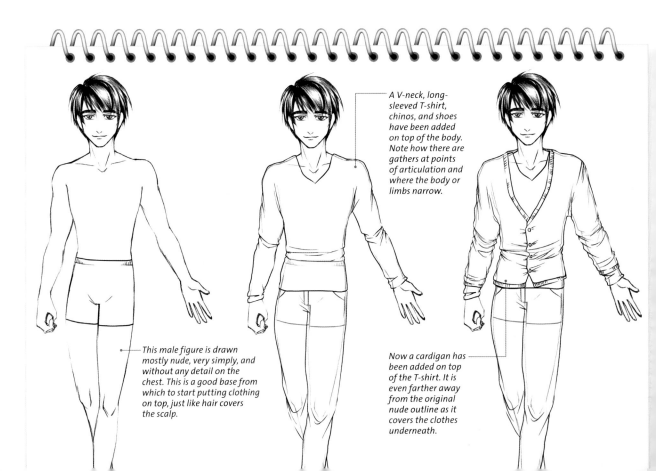

A V-neck, long-sleeved T-shirt, chinos, and shoes have been added on top of the body. Note how there are gathers at points of articulation and where the body or limbs narrow.

This male figure is drawn mostly nude, very simply, and without any detail on the chest. This is a good base from which to start putting clothing on top, just like hair covers the scalp.

Now a cardigan has been added on top of the T-shirt. It is even farther away from the original nude outline as it covers the clothes underneath.

▲ This female figure wears underwear that is skintight and molded to her shape.

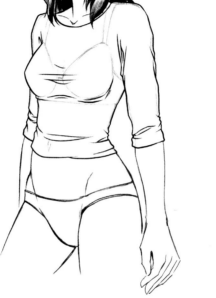

▲ When she wears a tight T-shirt, the cloth will cling closely to her body, but there will be areas of stress and stretch (such as at the bust), and gathers where there are bends (such as the armpits, elbows, and waist).

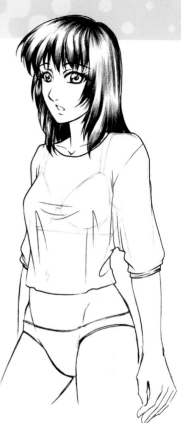

▲ Now she is wearing a loose, bat-winged shirt. There is no stretch at the bust; instead the material drapes as it falls from it. There are a few gathers at the armpits, but the impression is that of excess material rather than tight stretching around the limbs.

It is always good practice to start with a rough body outline, particularly to help you with clothing on the top half of the body (where the cloth is likely to hang from), if the character is in an active pose (where movement or gravity makes the cloth drape), or if the character is affected by the environment (such as wind blowing the cloth close to some parts of the body). Just as hair covers the head, clothing covers the body, and the thicker the material, the farther away you have to draw it from the skin. If the material is very thin or very tightly fitted, then it can be drawn literally skintight.

Layering

When designing a character and their clothing, start off with a quick nude sketch to get a good idea of the proportion set, the build and bulkiness of the flesh, and the pose you want to put them in. You need to have a clear picture of where the swells of the muscles are and where there are any bends in the body or limbs, as this affects how the clothing sits on top of flesh, how it hangs, and also where the folds and gathers go.

If you are drawing more than one item of clothing on top of another, then you have to take into account both the body and the thickness of the clothing underneath before adding it. There is a little bit of leeway as you can flatten the clothing underneath slightly.

Costume:
Folds and draping

Once you have drawn a quick sketch of the nude body, it helps to position and shape the clothes realistically. The body also gives you plenty of clues when it comes to drawing realistic folds in the cloth.

Identify key areas

Unless a material is absolutely skintight and fully stretchy, clothing will always have folds and gathers where there are changes in the shapes underneath. This means that cloth is under tension and stretches where parts of the body stick out; this could be around the breasts or hips, for example. There will be folds of loose cloth where the body gets smaller, such as the waist, wrists, and ankles. Then, where there is most bending and movement, cloth will stretch and strain over any bulges (such as the elbows and knees when bent) and fold in the recesses (such as in the insides of the elbows and the back of the knees). Think about how clothing interacts with the body and other pieces of clothing. If the character is reaching high up, his shirt will be pulled up by this action, so there will be gathers at the shoulders and the hem will finish higher on the hips or waist.

Materials

Different types of material and finishes affect the number of creases and folds that appear in clothing. The weight and stiffness of different materials become apparent when worn: Thicker materials, such as those used to make a suit, wool coat, or chunky knitted sweater, do not crease as much as a crisp cotton shirt, for instance. If there are any creases, they will be large folds and gentle swells rather than fine, thin gathers. That said, thickness isn't the only factor to affect creasing; some types of cotton jersey are slouchy and clingy, and drape from the body without making

sharp folds. Study lots of photographs of people wearing different types of clothes to learn about how fabric drapes.

Draping

Folds appear even in loose clothing because of the way the material drapes over the body. Identify where the cloth is centered and where the flow of the fabric comes from, then draw several folds coming from it. Where parts of the body stick out, there will be flat areas of cloth with gathers at the edges.

▼ If the character is moving or if their clothing is affected by wind, cloth will billow out away from the direction of movement, or where the wind is coming from. This causes tautness on one side of the body, with multiple fold lines as the cloth dramatically drapes away at an angle.

▲ Drawing gathers is a matter of drawing lines and curves from the points of tension, with the lines becoming wider and softer as you get farther away.

Pipe fold

The pipe fold is the most straightforward form of drape. The fold occurs from one point of suspension, or when pulled between two tension points. It is usually dictated by gravity, having a more or less smooth, consistent pattern.

Note how the cylindrical shape features in the lower part of the fold.

Zigzag fold

This fold refers to the pattern when a pipe fold is bent and the zigzag fold is created on the slack side of the bend. The zigzag fold goes in alternating directions.

The type of fabric determines the fold. The more rigid the fabric, the more prominent the fold.

Concertina fold

This fold is commonly found wrapped around a tubular form. Sleeves and pant legs are good examples of the concertina fold.

A well-drawn concertina fold will change direction and follow the form beneath it.

Diaper fold

The diaper fold occurs at the break or turn of the cloth. The top of the curve is usually sharp, and the lower side of the fold is relaxed.

As the points of support vary, the angle of the dip changes.

Half-lock fold

The half-lock fold occurs when tubular or flat pieces of cloth change direction. The fold generally occurs on the slack side of the form.

The arrows show three half-lock folds, where the fabric changes direction.

Drop fold

From a point of suspension, the drop fold twists and turns. It will contain zigzags, concertinas, and half-locks, but they all contribute to the drop of the cloth.

A drop fold will be uneven and irregular.

Costume:
Fastenings and embellishments

Have fun adding stylistic flair to the clothing of your characters—make choices about the cut, colors, patterns, and fancy details of what they wear.

◀ To draw a French maid's outfit, start with the basic shapes of the dress, apron, and stockings, then add the outlines of lace or ruffles along all of the edges. Take time adding lots of gathers and holes for the lace.

Fastenings

Fastenings play a key part in the overall appearance of a costume, so ensure you add them to clothes and spend some time drawing the details correctly.

Lacing

Either along a seam or two separate pieces of cloth, sketch a line of holes running down its length. Keep the distances and size of the holes consistent. Draw laces through the holes and be careful to make sure they overlap and go into the holes and above or under the cloth correctly. Add border reinforcements for the holes; these also add a flash of metal contrast to the design.

Buttons

Remember to draw buttons evenly spaced and consistent in size, going down one side of the fabric, and draw holes, slits, or button loops going down the other to match up with the button positions. Position them on the right side of a shirt in menswear and on the left side in womenswear.

Zippers

Some zippers are sewn in an invisible style, so you can simply draw a thin line down the back of a dress or skirt, and a subtle zipper pull at the top. Chunky, flashy zippers have their teeth clearly on display. If the zipper is closed up, draw one long column down the cloth and then add a tooth pattern or zigzag down the middle.

Embellishments

For as long as we have worn clothing, we've sought to decorate it. Even with a basic T-shirt, we choose one with a particular cut, color, or pattern. Your characters should do the same!

Decorating

For some style and individuality, clothes can be made from printed fabric. Alternatively, a dress can be made from plain fabric and then decorated with embroidery or shapes in appliqué. Draw the basic clothing first, then add the decorations on top, taking into account the contours and folds of the cloth.

Edges and hems

Embellishing hems is a great way to add interest to an item of clothing. Having a fancy cut, piping, or some other eye-catching trimming sewn onto the edges is effective. Try adding some simple borders by outlining the edges of your clothes with a thin line.

Ruffles and gathers

Ruffles, gathers, and drapes can be simply but effectively conveyed on plain-colored fabric. It can be tricky to have such embellishments on patterned fabric, as you have to take into account how the pattern is affected by the folds.

Draw the toggles first, angled vertically. Then draw loops that are long enough to slip over the toggles. Cover the areas where they join onto the cloth with an appliqué shape.

Draw the basic button shape and add a stitch or two. Then draw the button holes on the other side, in line with the buttons. Draw a border around the holes for reinforcement.

When drawing a lace-up fastening, keep the number of holes consistent and keep track of where the laces go—under, over, or through the holes.

Lace is not easy to draw. Try to keep the patterns consistent.

There is usually no need to go into this amount of detail on a zipper unless it is oversized or you are drawing a closeup, but, if required, make sure the teeth align and that the pull is wide enough to fit over both sets of teeth.

To draw epaulettes, first draw the rectangular, almost flat bar on the shoulder. Then add lots of lines from the base of the bar for the fringing underneath and close the bottoms of the lines to finish.

To depict ruffles, first draw a winding hemline at the bottom. Then, using the hem as a guide, start from the bottom and draw the folds of fabric going up into the gather.

To draw an embellished shirt, first sketch the basic shape of the garment, then draw U-shapes along the hems to give a scalloped effect. Outline along the hems to add piping. Then draw little circles along the neckline for pearls. Keep the flowers on the bust simple so they have the feel of embroidery.

Costume:
Footwear

Feet are usually covered up by socks or footwear, but just like drawing clothes on the body, you need to have a good knowledge of the different shapes a foot can make. That way, you can draw shoes that fit properly and provide protection, but have flexibility in all the right places. Because of these considerations, shoes can be quite complex to draw.

Open shoes

Sandals expose a lot of the feet and toes, so it's very important to draw the naked foot first. Use the shape of the foot to draw any thin straps on top and closely outline along the bottom for the heel, then add details like buckles, laces, or high heels.

Flat shoes

Flat shoes are never completely flat; if you start by drawing the naked foot, you'll see that the base of the foot has a slight arch, so shape the bottom of the shoe to match. Research various designs so that you can place the seams correctly.

Heeled shoes

What is most fun about drawing heeled shoes is the style of the heel: it can be pointed and thin, chunky and blocky, kitten, wedge, and many more! Look through catalogs and magazines for inspiration. Don't neglect the gothic and alternative fashion scenes for more outrageous designs.

Boots

Draw loose boots significantly larger than the naked foot and add slouchy folds so that your character can pull them on and off easily. For fitted boots, draw fastenings like zippers, buckles, or laces all the way down the front of the shins or inner calves.

Sports shoes

These modern shoes are geared toward flexibility, movement, and grip specific to the sport they are made for. They fit the foot very closely along the top arches, but the soles, heels, and fastening styles vary. Draw lots of seams throughout the shoe to show off their tailor-made nature and study the range of shoes available to get the placement right.

Socks

Many people walk around in their socks rather than barefoot, so be prepared to draw this. Draw the naked foot and leg first, then draw the knitted, stretchy material closely fitted to the foot, with some folds around the toes and ankle area. Then, above that, socks can be fitted or loose and slouchy.

Traditional Japanese socks are made from cotton and are cut and sewn to fit the foot, with hidden hook mechanisms at the ankle to hold them in place. They are two-toed, so that you can wear them with Geta sandals, which have a strap that goes in the gap.

◀ Think about what shoes are appropriate for different situations and outfits. Heels and sandals closely match the shape of the foot, whereas chunky boots should be drawn much larger than the feet.

Basketball shoes or high-tops are fitted around the ankle and top line of the foot, but the rubber sole is flat. Draw contrast laces weaving in and out along the top.

Shape sneakers higher at the back, but curving under the ankle for freedom of movement. Add plenty of contrasting sections.

Draw seams along the bottom and down the side of traditional Japanese socks. Add wrinkles and folds to the toe and top of the foot's arch.

Sketch the naked foot before drawing conventional socks on top, as you simply outline the foot and add wrinkles to the toes and around the ankles.

For a low-heeled sandal, draw the foot first, slightly raised on the toes. Then add a Y-shape strap around and under the ankle, and a wider strap over the toes.

For a high-heeled wedge, draw the naked foot higher than floor level. Shape the heel to match the curve of the base of the foot, then draw the bottom of the shoe flat with the floor.

For a fitted leather boot, draw the leg and foot on tiptoe, then closely outline both.

Slouchy suede boots are meant to be pulled on and off, so there is lots of room around the ankles. Make the folds gentle.

Keep the overall shape of loafers low and long. Don't cover up too much of the foot as it has to easily slip inside the shoe.

Leather Oxfords have very precise patterns and stitching. Look at references to see where the seams go.

High heels can be challenging to draw at different angles. Study the naked foot and use them as a starting point. Position the heel carefully as it moves so the underside of the shoe can be seen.

Costume:
Accessories and props

A character's accessories and props can speak volumes about his/her personality, job, hobbies, and style. It is a great way to add realism and individuality to your character.

◀ What kind of character might wear this exotic ring and bracelet and in what situation?

Jewelry

There is a wide range of ladies' jewelry and it can be delicate or chunky, simple or elaborate. Men's jewelry tends to be simple and more streamlined, but generally larger. It is definitely worth studying your own or your friends' collections so that you know how the fastenings, links, settings, and clasps work.

Eyewear

Eyeglasses can convey a lot of personality, particularly if they are strongly designed. They also offer opportunities for characterful poses, such as a man who needs to constantly push them up his nose.

Environment

You can tell the reader a lot about a character's environment with accessories. If it is hot, they might be wearing a wide-brimmed hat to cool off from the sun. If it is cold, they may wear scarves, woolly caps, and gloves to stay warm. It's not just weather you need protecting from either; elbow pads and knee pads are important if you're into rollerskating or mountain biking.

Occupations

There are some accessories that are necessary for certain occupations because they fulfill a functional purpose. If you're a doctor, you will probably often wear a stethoscope around your neck; if you're a gardener, you may carry a watering can around, along with a rake or shovel. If you think carefully about what your character does for a living, you should get plenty of ideas about what objects and items they may use.

Hobbies are another great way to add interest, depth, and personality to your character. Many hobbies require the right kind of prop and can can contribute greatly to the bigger picture. Even if you don't see a character actually in the middle of surfing the ocean waves, you can infer it by depicting him walking around with a big surfboard. You can spot a guitarist in the crowd if she has a guitar case on her back.

Props can add context by showing what a character does or likes. Some props are so embedded in particular situations that they become symbolic—they are representative of someone and designate a specific type of character.

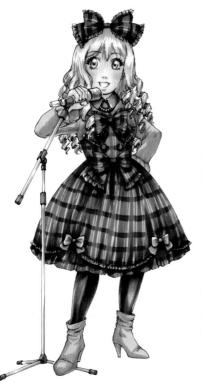

◀ Think about the ways in which your characters interact with their props. This Lolita singer is positioning the microphone on a stand, but she could be grabbing it with both hands, lifting it up, and so on.

▶ With different props and accessories, it is clear that the same character, who is wearing the same clothes, has taken on a different persona.

◀ Glasses can be used to draw attention to the eyes or emphasize expressions—here, a stern look is given gravitas, as the eyes look directly over the rim of the glasses at the viewer.

▶ A matching set of jewelry will have common design elements in each—the metal color and gemstones being the most obvious.

▼ Consider how to convey different textured clothing. Add depth and volume to the knitted fabric by drawing contoured lines for the rows. Leather gloves have a slight sheen to them.

◀ Give the impression of glass in sunglasses by shading in neat streaks and highlights.

▶ Commonly understood accessories—such as a witch's black pointed hat and broom—can be a useful visual shorthand.

Costume:
Genres

The genre of manga you draw will affect the type of character you design, their costume, and their accessories. Here are some considerations you should take into account.

Science fiction
Science fiction is rooted in modernity—it looks forward to the future. It explores technology and where it is going. It looks at the unknown and outer space. When designing human characters and their environment in this genre, it is important to link all visuals to current science and logical progression for it to be plausible. If set in the future, designs should expand on what is considered cutting-edge technology now. Always try to come up with rational or physics-based reasons for why something is designed the way it is.

Steampunk
Steampunk is similar to science fiction in that it is based on our knowledge of technology and science, but the knowledge base is from the 19th century and the Wild West or Victorian eras. So one should imagine an alternate world history without electricity or digital technology. Steam power and its resulting mechanical inventions feature very strongly, as well as traditional period costume designs.

Horror
Whether historical or contemporary, there are horror stories in every culture, which have given rise to thousands of popular monster designs. It can be lots of fun to research the many types of ghost out there, as traditional literature often describes their terrifying features in great detail. Urban legends abound on the Internet, too. If you get bored with the ghost stories of your own country, look to others for inspiration. Many designs include traditional costume, animal features, and, of course, blood and gore.

Fantasy
Fantasy is an extremely popular genre for manga artists. The main premise is that of a magical world. It often draws from medieval history, folklore, myths, and legends. You can take inspiration from the stories that are already out there. Fantasy does not have to be limited to the ancient past; you can incorporate magic into modern history, the present, or even the future. But make sure to avoid anachronisms (unless time travel

▲ If you are brave enough, draw on your own fears to create modern horror characters. Here, a hooded man has no face and instead emits dozens of spindly, clawed arms.

is actually involved). When designing characters and their accompanying props and environment, think about what level of technology is appropriate. It can help to pick a real historical time period as a starting point so that you can keep everything consistent. Research the costumes, buildings, and so on to build up a picture of what looks right.

STEAMPUNK: Mechanical wings are typical of steampunk—they are futuristic, yet rely on old-fashioned technology.

HORROR: Vampires traditionally look pale and gaunt, so draw pointed features and use cool tones. Werewolves are muscular, but cover them with a layer of fur and concentrate on the head. Give witches a pointy hat and dress them in monochrome.

SCIENCE FICTION: A reptilian alien wears a battle suit. Keep the alien feel by drawing non-human legs. It needs life-support tubes and many mounted guns.

SCIENCE FICTION: A space mercenary needs tightly fitted armor in a modular system for flexibility— match the shapes to his muscles. Tie in the whole outfit by limiting the color palette.

FANTASY: Add insect features like butterfly antennae and wings to create fairies. Give the wings a transparent feel with lots of color for maximum effect.

Props:
Weapons

Whether the theme is action, thriller, fantasy, or sci-fi, many manga series will have exciting fight scenes with characters wielding all sorts of weapons. There are many types of real weapon, let alone the modifications you can make for more fantastical settings, so it can be difficult to know where to begin.

Melee weapons

There are various weapon types that are used in close combat. Familiarize yourself with historical designs and learn how they work so that you are able to design your own.

Swords

Every culture has its own take on swords, which come in many different shapes and sizes. You can make the blade straight or curved, narrow or thick, single or double-edged. Other areas to customize include the guard, grip, pommel (end of the handle), and scabbard or sheath.

Knives

Knives can be very simple or extremely ornate. Draw the main shape of the blade first, but remember to make the grip proportionately much larger than if you were drawing a sword.

Miscellaneous

There are many weapons used for hand-to-hand combat. Axes, maces, and clubs are used for blunt attacks and bludgeoning. Draw the main stem and handle for grip, then customize the other end with bladed edges, spikes, or a chunky hammer shape. For longer-reach weapons like spears, staves, or lances, use a ruler to draw their long, thin shapes correctly.

Projectile weapons

Characters sometimes need to attack from a distance! Think carefully about what weapon is appropriate for the setting; visualize how your character would hold and carry it, and how the ammunition is used and stored.

Throwing

Stones, bolas (string with weighted ends), darts, and ninja stars are all examples of throwing weapons. When drawing them, the emphasis is not so much on the weapon itself as on the way the character launches them, so think about balance, weight, and action lines (see pages 56–59) . Look at photographs of hands holding darts or other specific throwing weapons in order to get an authentic pose.

Bows and crossbows

Draw the long, curved piece of wood in a C-shape, then join the ends together with string. Make the curve more pronounced when the string is pulled back to launch an arrow or bolt. A bow is held vertically in one hand, with the arrow and string pulled back and released by the other. A crossbow is held horizontally by both hands, supporting the front and the back of the weapon. Research the designs made by different cultures for inspiration.

▲ This figure holds a sword and ninja star. Study how to draw them by holding similar-shaped objects and looking in the mirror so you can get a natural pose.

Guns

Gun designs can be customized to suit many different purposes and characters. All guns have some form of handle or grip for one or two hands, a trigger to fire with the index finger, a place to insert ammunition, and a barrel through which the ammunition is shot. Guns can be difficult to create from scratch if you haven't had experience drawing them before, so you should look at historical designs to get a feel for how the essential parts fit together into a compact design. It's easiest to start with the barrel and the handle of the gun so you can get the pose of the character correct from the start. Then add more details on top of this basic frame.

Gun Sword

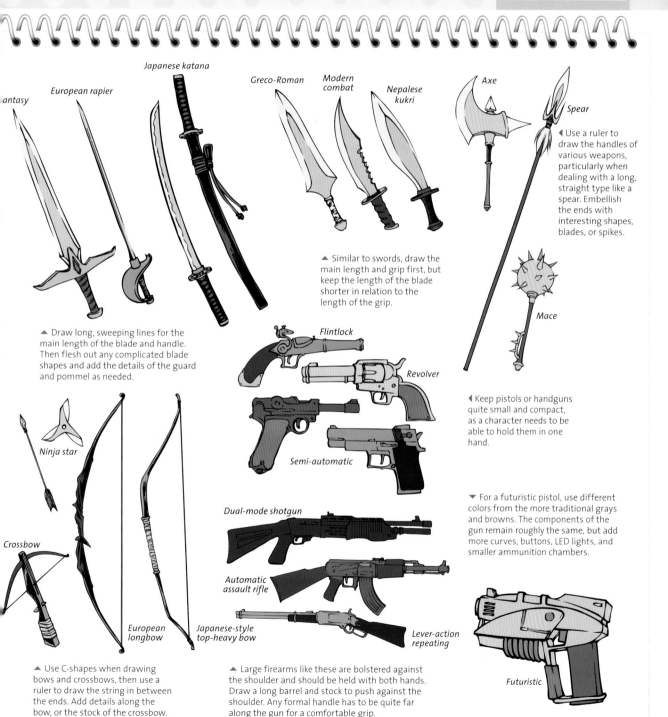

Fantasy

European rapier

Japanese katana

Greco-Roman

Modern combat

Nepalese kukri

Axe

Spear

◄ Use a ruler to draw the handles of various weapons, particularly when dealing with a long, straight type like a spear. Embellish the ends with interesting shapes, blades, or spikes.

▲ Similar to swords, draw the main length and grip first, but keep the length of the blade shorter in relation to the length of the grip.

▲ Draw long, sweeping lines for the main length of the blade and handle. Then flesh out any complicated blade shapes and add the details of the guard and pommel as needed.

Mace

Flintlock

Revolver

◄ Keep pistols or handguns quite small and compact, as a character needs to be able to hold them in one hand.

Semi-automatic

Ninja star

▼ For a futuristic pistol, use different colors from the more traditional grays and browns. The components of the gun remain roughly the same, but add more curves, buttons, LED lights, and smaller ammunition chambers.

Crossbow

Dual-mode shotgun

Automatic assault rifle

European longbow

Japanese-style top-heavy bow

Lever-action repeating

▲ Use C-shapes when drawing bows and crossbows, then use a ruler to draw the string in between the ends. Add details along the bow, or the stock of the crossbow.

▲ Large firearms like these are bolstered against the shoulder and should be held with both hands. Draw a long barrel and stock to push against the shoulder. Any formal handle has to be quite far along the gun for a comfortable grip.

Futuristic

Holding weapons

Once you get over the hurdle of drawing plausible weapons, a vital part in showing them off and making it obvious to the reader how they are used is to make sure that your characters know how to hold them correctly.

If possible, pick up a toy weapon and play with it. Hold it and pose in front of the mirror. Try to imitate some of the stances and holds that you see in movies. Better yet, get a friend to do it for you and take some reference photographs. It can be beneficial if you can find someone who is trained in martial arts or shooting and actually knows how to use the weapon in question. You may find that the reality of holding certain weapons is very different from what you might have imagined. The center of balance, the weight of the weapon, how you guard against recoil—these issues can change the hand positions significantly. Obvious mistakes will be immediately spotted by any enthusiast, so be precise.

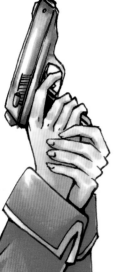

◀ This closeup shows how to hold a modern handgun with both hands: One hand holds the grip with a finger near the trigger, while the other cups the base.

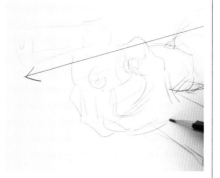

Gun

1 A handgun is a small object—to create a visually exciting image, draw it from an angle and with exaggerated perspective. Using a ruler, draw an arrow in the direction the gun will shoot to guide you, then start to outline the basic shapes of the gun and two hands.

Rifle

1 With a long range weapon, such as a bow and arrow or a rifle, it is important to make the direction of firing clear. To do this, draw two lines: One represents the direction of the weapon and the other the figure's sightline. You will draw the eyes to the top left of the sightline.

2 Fill out the rough outlines. Figure out the positions of the hands and fingers, and check these by posing in front of a mirror. Here, the right hand is holding the gun and pulling the trigger, and the left hand is supporting it from below to give a firm grip. Add joint lines and fingernails.

2 Pencil in rough outlines, using the two lines as your guide. The rifle should be drawn at shoulder height and held by both hands; here, the left hand supports the front, and the right hand holds the grip with the index finger on the trigger.

3 Ink on the pencil drawing. Use solid, determined lines for the firm fist, otherwise the hands will look too relaxed to fire the gun. The outline of the gun must be smooth, hard, and precise—consider using both straight and curved rulers to achieve this.

4 Add shading using markers and a ruler to define the shape and feel of the gun—the metal will reflect sharp, clear highlights. You can also add speed lines—these convey the movement of the bullet and the gun and create a dynamic atmosphere.

3 Ink over the outline with a thin pen. Define the muscles of the upper arms to show they are holding something heavy. Then add shading with a marker to give the rifle form. Keep the lines of the body of the rifle as straight as possible; use a ruler if this is necessary.

4 Add details such as grooves and locks with a fine pen. The figure's eye closest to the weapon is open and the other is closed to get a better aim.

Dagger

1 Decide on the angle of your dagger and draw a line with a ruler as a guide. Here, the knife will be drawn from the side to show the shape of the blade—and tilting forward, ready to attack.

2 Roughly outline the basic shapes. Knives do not have straight blades—they are surprisingly organic in shape, so use curved, flowing lines. Consider positioning the hand in a pose other than a fist. Here, the index finger is looser than the other fingers to add interest and movement.

3 Ink over the pencil sketch. Clearly delineate the finger joints to show that they are gripping, not just touching the handle. Position the thumb on the edge of the guard.

Spear

1 Draw a line with a ruler to use as a guide representing the angle and direction of the spear. Use perspective to make the spear shape look dramatic. Here, the tip is pointing up and toward the viewer.

2 Sketch in the rough outline of the figure. You can always check the posture by standing in front of a mirror holding a bar. Give your figure a solid base—the legs are open and standing firmly on the ground. Note that the right and left hands grip the spear in a slightly different way.

3 Ink on the pencil drawing with a thin pen and use a ruler where needed. Keep an eye on the perspective—the spear gets thinner as it gets farther away, and the figure's right hand is drawn smaller than the left hand.

4 Erase the pencil lines. Use a ruler and a thin pen to add speed lines and precise detail to the knife. Define the outline of the knife further to show that it is a dangerous object, and not just a piece of paper or plastic. Use a marker to add selected areas of heavy shading.

5 Add white speed lines with correction fluid and a paintbrush over the shaded areas of the knife.

4 Erase the pencil lines. Add shading with a marker; then draw neat lines with a thin pen on the blade to create the texture of metal.

5 Complete the image with a flash effect to add drama. Keep the area around the tip of the spear white. Draw thin lines radiating out from this point with a ruler and a thin pen; then fill the larger areas with a marker.

Props:
Vehicles

When creating a world with characters, you should also take transportation into consideration. However tempting it is to have your characters walk everywhere, it isn't plausible when they have to travel over very long distances.

. .

Vehicles are intrinsic to the setting of your manga as they reflect the culture, the levels of technology and development, and the occupation and status of the characters that use them. If you have set your manga in a real historical time period, you must research thoroughly to ensure your designs are accurate. Even if the setting is fantasy or sci-fi, knowing what the real-life equivalents or precursors actually look like and how they work will give you insight for your own creations. Is your vehicle geared toward speed, maneuverability, or transporting goods? If the setting is sci-fi, is it capable of flight? Whatever you go for, just make sure you fulfill certain criteria to make your story plausible: a cockpit for the pilot, doors to get in, wings to fly with, some form of propulsion engine, and wing levers or a tail for steering.

Motorcycle

1 To draw a motorcycle, you also need to draw a convincing rider. The figure should be aerodynamic with the head low and the body leaning forward; it should look well balanced on two wheels. Add a cape to depict wind.

. .

Ship

1 Study photographs of boats—you will discover they have a curved, organic shape. Bear this in mind and try to convey this as you sketch out the basic shapes.

2 Ink over the pencil drawing with a thin pen. Draw two fingers in front of the brake lever and the rest behind it. If you are creating a scene of the bike braking to a stop, draw all the fingers in front. Add a splash of material on the ground left behind by the tires.

3 Add shading with markers. Leave white highlights on all smooth surfaces, especially the metals and glass.

4 Add speed lines with a medium-sized pen and a ruler to indicate movement. These lines start from where the motorcycle came from. Do not forget to add lines behind the glass of the windshield. In a manga strip, you can also add a sound effect for the engine.

2 Ink the pencil lines and add details and textures. The curved lines of the mast and the splash at the edge of the boat are important as they indicate that the wind is pushing the boat forward.

3 Erase the pencil lines and add shading with markers. Use a thicker marker pen to depict the waves—having a dense color on the waves makes the boat look lighter.

4 Finish with a gray marker to add detail to the mast and shading to the flag. Adding a couple of seagulls to the background gives perspective and a realistic atmosphere.

Airplane

1 Airplanes are easy to recognize even from a distance due to their distinctive shape. First, draw the basic shape of the body. Consider perspective; here the plane is drawn from below and at an angle.

2 Refer to some visual sources to understand the details of planes. The most visually important are vertical and horizontal stabilizers and jet engines. Add these to your drawing.

Car

1 Study some visual sources of cars to get an idea of what model and make you want to draw and which angle you want to draw it from. A front view or profile can be boring, so try working from an angle and adding some perspective. Make a rough sketch of a box shape and add some circles for wheels.

2 Start placing details such as front lights, bumpers, license plates, and a rearview mirror. Remember that perspective means that the front wheels should be drawn larger than the rear ones.

3 Ink on the pencil drawing with firm lines, using a ruler for precision where appropriate. Add details such as the windows. Only draw wheels if you are depicting a landing scene.

4 Add shading with markers. Here, the light source is from above, so the shading is applied to the bottom.

5 Add a wash of light gray to indicate the sky and clouds. Finally, add strong beams of sunlight with correction fluid and a paintbrush. Do not place the plane in the middle of a comic, but in the upper section of a panel to create a sense of distance.

3 Ink over the pencil drawing. Add a strong outline around the car. Use a thin pen to draw the details, such as the fender, the steering wheel, the tread of the tires, and the door handles.

4 Erase the pencil lines. Add dark shading to the inside and ground underneath the car. Do not forget to add shading between the body and the wheels.

5 Add gray shading to the wheels with markers. Then add speed lines to the ground to depict a fast-changing shadow shape. If you are drawing a background, you can add speed lines to depict an even faster-moving car.

Animals:
Manga style

Cat Dog

Animals can play a huge part in your manga series. Perhaps your character has a pampered pet, a devoted companion, or a powerful steed. The type of animal you choose to show with your character can give clues about the type of person he or she is. Besides being an animal lover, an exotic pet may mean the owner is either rich or lives in an exotic location where owning such a pet is the norm. Maybe your tough hero has a softer side if he likes cute rabbits. There are many pitfalls to avoid with drawing animals, however.

Anatomy
The number one rule in tackling any subject matter is to do your research thoroughly. Drawing from vague ideas about how an animal looks will inevitably lead to some basic mistakes. The skeletal and muscular structure of one species will look very different from another. A horse and a deer may look fairly similar overall, but the set of the neck is different, the position of the knee changes, one has cloven hooves while the other doesn't, and so on.

Before drawing any animal, even if you have drawn them before, remind yourself of their appearance and get their shapes and joints right by looking at photographs or reference books. It is even better if you can see them in real life. Look at your own pet or go to the zoo and spend some time sketching them.

By practicing drawing many different animals, you can begin to build models in your mind and retain the important information about their defining characteristics. You can then go on to create amazing fantasy creatures by combining some of these features in a functional way.

Variations
When learning to draw a particular species, don't just look at a few photographs of just one animal. Try to find as many variations of that animal as possible, so that you can not only identify strong characteristics, but also get an idea of how far you can go with changing their design and adding individuality.

Style
Just as with humans, there is no need to be super realistic all the time—you can draw animals in different styles. If they have unusual qualities, such as being able to understand humans or talk, you can add human traits to them, like changing the shape of the top of the eye to mirror what our eyebrows would do, making the head bigger, and so on. But bear in mind that it doesn't make sense to have the style of animals out of sync with the style in which you draw your human characters in the scene.

Posing with animals
Anything that involves interaction requires you to keep a tight rein on the sense of scale you wish to create. Keep the human the correct size in relation to the animal. Aside from that, think about how you would pet, carry, or ride an animal. We scratch a dog behind the ears and ruffle its face, but we stroke a cat. We let a bird perch on our fingers, wrist, or shoulder. If riding an animal, account for the parts of the human's body that can't be seen. Make sure the human is drawn high enough to sit on top of the animal, not buried partway into the animal's body!

◀ Dogs have a truly amazing morphology— there are incredible differences between breeds. This is a Skye terrier with its iconic long, dark coat.

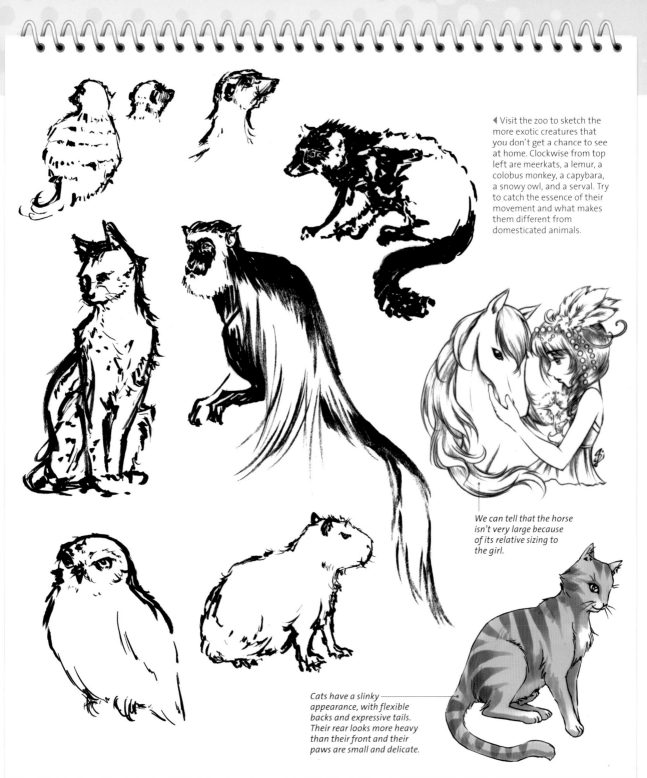

◀ Visit the zoo to sketch the more exotic creatures that you don't get a chance to see at home. Clockwise from top left are meerkats, a lemur, a colobus monkey, a capybara, a snowy owl, and a serval. Try to catch the essence of their movement and what makes them different from domesticated animals.

We can tell that the horse isn't very large because of its relative sizing to the girl.

Cats have a slinky appearance, with flexible backs and expressive tails. Their rear looks more heavy than their front and their paws are small and delicate.

Cat

1 Cats have expressive body language—study their movement before deciding on what pose to draw. Be sure to draw the basic shapes of ovals and triangles with rounded ends.

2 Even though cats do not have the face muscles to smile, it doesn't mean your manga cat can't. Here, both ends of the mouth turn upward, the eyes are shiny and lively, and the ears face forward. A bow around the neck has also been added.

Pony

1 Draw the basic shapes. The most important are large circles for the chest and thighs, a circle and square for the head with triangular ears, four triangular hooves, and a voluminous, silky tail.

2 Add more detail. You can use the mane and tail to add character—here, the horse has long eyelashes, a wind-kissed mane, and a lively tail. Give your horse an expression—here, she has a shy smile and dreamy eyes.

3 Ink the pencil drawing. Use softly curved lines and tufts of fur standing on end—here, on top of the head and at the end of the tail.

4 Apply the first layer of color with markers. You can add a manga touch by giving your cat rosy cheeks.

5 Complete the image with shading: on the fur, apply the color in the direction of the fur; inside ears, apply sharper strokes to make the fur appear bushy; on the bow, follow the shape of the ribbon.

3 Use a thin pen to fill in the details and a slightly thicker pen to trace the outline. Add flips to the mane and tail and feathery wisps of hair above the hooves.

4 It is not necessary to choose naturalistic colors; you can have fun picking unnaturalistic ones, as pictured here. Once you decide, add flat coloring with markers—do not worry if it looks two-dimensional for now.

5 Add shading to the body with a beige marker and white highlights to the mane with correction fluid to give the image three-dimensionality. Use lots of rounded shadows around the bottom of the belly and legs.

Animals:
Character inspiration

Animals provide a lot of inspiration for character design both in comics and in literature. You often use an animal, such as a cat, to influence a character's personality and movement. But, when you have the full freedom to draw what you want, you can create characters whose physical features are actually those of animals.

Anthropomorphism
The degree to which you can do this is up to you. It may be that you want a mostly human-looking character, but with a few subtle touches here and there, like a "Nekomusume" or catgirl. Alternatively, you may want a human head and torso, but an animal bottom, such as a centaur or mermaid. You could have an animal head with a human body, like a minotaur. You could even just draw the animal almost in full, but bipedal so that it can stand and walk around like a human. Do lots of research into animal designs so that you don't draw something incorrect or stereotypical. Animal anatomy can be complex and there is so much variety out there.

◀ This feisty vixen is human in appearance but her black-tipped ears, gold slitted eyes, bushy red tail, claws, and sharp teeth show her foxy heritage.

1 Sketch out the basic shapes of your character, taking some characteristics from the animal chosen and applying them to the human form. Here, we are drawing a fox girl who has caught her foot in a trap. You can see her fox-like bushy tail, pointy ears, and slim limbs, but human proportions.

4 Decide whether you are going to use naturalistic colors or not and block the colors in; do not worry about textures at this point.

2 Fill out the pencil drawing with more details. This is another area where you can combine the animal with the human; for example, although the fox girl wears human clothes, she has furry details on her boots.

3 Ink over the linework, paying special attention to the different textures you have included. Here, long, fine lines have been used for the fabric of her clothes, and shorter, sharper strokes for her furry tail and hair.

5 Add shading and highlights to complete the image. Here, the eye color and shading is based on that of a fox.

Body modifications

There are many things you can change about a human body so that it takes on animal characteristics or—taken a step further—seems extraordinary, magical, or alien. Let your imagination guide you—manga and anime are all about creating exciting stories, often in fantastical settings and with characters with special talents and unique looks. Here are a few ideas to get you started.

Hair

One of the most popular choices made in manga and anime to differentiate a character is to give them brightly colored hair in non-natural colors. Pale blue, bright green, pearly pink—these colors would never occur naturally—so that already makes a character seem out of the ordinary. Another thing you can do is give them an amazing hairstyle. Hair that seems to levitate, extremely long floor-length hair, intricate braids, or buns with twisted strands of jewels; again, go for a style that implies a lot of work or one that doesn't occur naturally.

Skin

Much like hair, having skin in an unnatural color is an immediate indicator that a character is quite different. Ghosts and zombies are drawn with gray or green-tinged flesh, for example. Hindu deities are often drawn with blue skin. It doesn't have to be completely crazy, though; you can make a character look exotic if you combine very light hair with dark skin. You can also add unusual markings to the skin, such as stripes or glowing tattoos.

Eyes

Unusual iris colors are very popular and simple to implement. Like hair and skin, you can come up with interesting combinations to give a character a unique look. That isn't all you can change, however. Try changing

▲ For a Japanese Oni, use triangular eyes, pointed ears, and a sharp nose. Outline the curved shape of the horns before filling in with rings. Draw large spikes of hair for the lion's mane.

▶ Add accessories that reinforce physical attributes, such as the bell around the neck of this catboy.

◀ Bunny ears look best with hair styles that cover up where human ears would normally be positioned.

the color of the sclera (the whites of the eyes): this makes eyes look very unsettling. You can also change the iris patterns, size of the iris, or pupil shape. Look at animals to get some inspiration.

Ears

A favorite feature that has been altered in fairytales for hundreds of years—ears can be large, pointed, or long to show that the character isn't human. Western pixies have small, pointed ears, for example. In Japan, characters can be made very endearing if they have animal ears. "Nekomimi," or cat ears, are incredibly popular.

Tails, horns, wings

There are many extra things you can add to a character's body to make them unusual. Tails are very popular and are often paired with animal ears. A Japanese Nekomusume will usually have a cat tail to go with her cat ears. You can add horns to the head, a design that is usually linked with demons. You can also add wings to a character's back, head, or ankles—position them wherever you like. There are many types of wings to choose from, both from the natural world and man-made designs.

▼ Start with undulating lines for the hair, then draw parts of butterflies going in and out of the strands, before drawing a few completely separated.

▼ For an etheral look, choose a silvery-gray skin palette. Add gems and markings to the face.

▼ To draw feathery wings, use lots of tapered strokes and layer the feathers on top of each other.

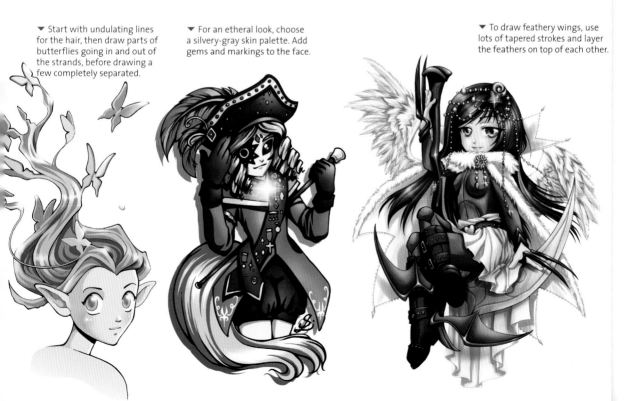

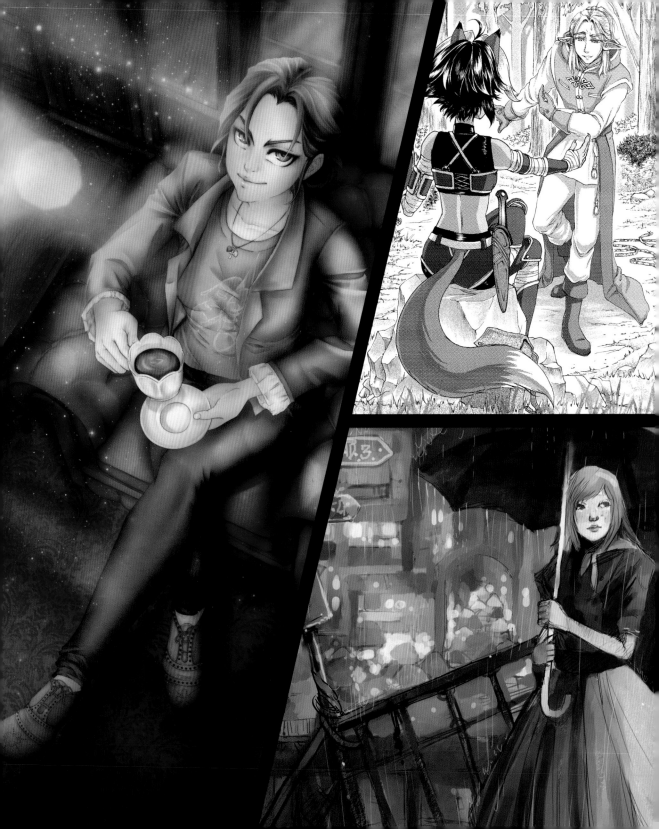

3

Settings

From a quick explanation of perspective to tips and techniques for creating the natural world, this section helps you draw your manga characters in different contexts.

Perspective:
Theory

Before you begin to draw the settings and backgrounds for your characters, it is vitally important for you to understand how the environment around you is constructed and how it appears to your eye. A still-life artist can simply draw what they see in front of them, but a manga artist has to create environments from the imagination and reproduce them at different angles consistently.

Basic theory

We perceive the world around us as three-dimensional, with objects that have height, width, and depth. The way we determine their scale, how far away they are, and where they are in relation to each other is based on two things. First is the level of the horizon line, where (so long as nothing gets in the way) the landscape would stretch off and disappear into the distance. The second is the location of one or more vanishing points along that horizon line or elsewhere. By having the edges of objects leading toward common vanishing points, we can build up a three-dimensional picture.

One-point perspective

This is the simplest form of perspective. Along the horizon line is a single vanishing point. By drawing guidelines emanating from the vanishing point, you can use them to depict the depth of an object. The top and base edges of an object's side must lead back to the vanishing point. The height and width are depicted with simple horizontal or vertical lines.

◀ This demonstrates the theory behind one-point perspective. The blue dot in the center represents the vanishing point. From it, the green guidelines are drawn to determine the sides of the boxes. The other edges are simply drawn with horizontal or vertical lines. In this example, the box on the left is closer to us.

◀ Even with a single vanishing point, you can build up a fairly complex image. These lines and boxes could easily form the basis for drawing a city with tall buildings of different sizes lining a long, straight road.

Two-point perspective

Instead of one vanishing point there are two. This form of perspective is actually more common in real-life situations as the world is filled with objects that are not facing us directly at all times; in effect, we are side-on or near corners. An object's height remains simple to draw with straight, vertical lines, but now both the width and depth of the object are determined by their respective vanishing points.

◀ This demonstrates how the width and depth of an object are determined by two different vanishing points when the view is off-center. This building has windows that are also drawn with the help of guidelines emanating from the vanishing points. The lines representing height are still vertical.

▶ You can use two-point perspective to depict interiors, too. Now you are inside a building. One wall spans the width of the building, while the other wall spans the depth.

▲ Imagine that you are on the street, gazing up at a very tall building. As the top of the building is so far away, it appears much smaller than at its base. The high vanishing point accounts for this, guiding the lines all the way up the height of the building to become closer together at the top.

▲ Now imagine that you are in a helicopter, flying high above a tall building. As you look down on the building, its base and the streets are so far below you that they seem tiny. The low vanishing point shows the scale of the building and consistently reduces its size as it goes lower.

Three-point perspective

This is used when the view is from below or above. The horizon line becomes much higher or lower to match with the angle of the view. There are two vanishing points along the horizon line, but the third vanishing point is high above or far below. Now each vanishing point determines a different dimension for the object. The two on the horizon are used for width and depth, whereas the one above or below guides the lines for height. The closer the vanishing points are to each other, the more extreme the angle of the view and the sense of scale will be.

Perspective:
Practice

Certainly it is one thing to know the theory, but it is another to identify and apply it effectively in practice. There are many situations where you will need to use vanishing points to draw backgrounds correctly and convincingly. Learn what applies to the viewing angle and the position of the viewer.

One-point perspective

Although this is the simplest, most basic form of perspective with just one vanishing point, it can be the most visually dramatic when used in manga. It adds epic scale, movement, and zoom all geared toward the reader's point of view, so it is particularly effective in action scenes, introductions with impact, or images that have a sense of foreboding.

 The key to remembering when this applies to your image is to consider whether you are looking directly head-on at an object or if you are halfway between two objects where both of them have parallel sides facing you.

▲ The reader is seeing this scene from the character's point of view, as they open a warehouse door to find an alien hiding behind oxygen tanks. The single vanishing point is in the middle of the image and is used to draw the details of the tanks facing the viewer.

Two-point perspective

This is actually the most common form of perspective that we are likely to encounter in everyday situations, walking around cities, or inside buildings, as it is rare to have a view that is facing head-on toward objects, or right in the middle of a long, straight road or hallway. If you are ever unsure about the type of perspective needed in a shot, try two-point perspective first.

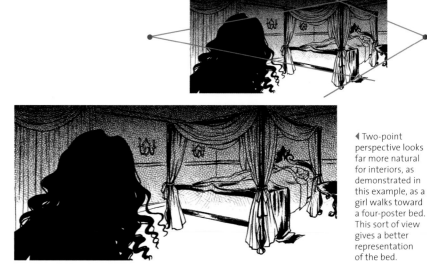

◀ Two-point perspective looks far more natural for interiors, as demonstrated in this example, as a girl walks toward a four-poster bed. This sort of view gives a better representation of the bed.

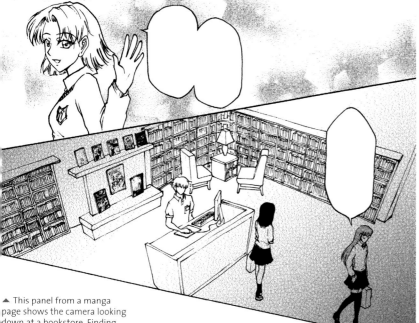

▲ This panel from a manga page shows the camera looking down at a bookstore. Finding the vanishing points is a little more tricky for this one! The camera isn't too high, so to lessen the effect of the third vanishing point, it has to be very far below.

Three-point perspective

This form of perspective only really comes into play when the camera is situated high and looking down onto the scene, or low and looking up. When a camera is high and looking down, it looks impressive because it paints the scene with all the characters in it. When the camera is low and looking up, it creates a dramatic view, making the objects seem like they are towering above you.

But, be careful! If the camera is directly facing the objects in question, it may actually be two-point perspective where there aren't two vanishing points on the horizon line; only one is on the horizon while the other is directly above or below.

Intuition and improvising

You don't always need to use vanishing points strictly when drawing backgrounds. If you have a reference picture you are working from, or if you are sketching from real life, it is better to trust what you see to create a more natural image. It is worth identifying where the points are, to improve your intuition.

For a less contrived image, you will need to use vanishing points that are farther away, often far off the page you are drawing on. This can make strict usage of vanishing points very inconvenient, so being able to estimate where the perspective guides should go is an important skill. Once you roughly draw at least two in place, you can use them to generate relative measurements; try chopping widths in half to create a third line, and so on.

◀ If the vanishing point is off the page you are drawing on, try estimating two lines coming from it (red). Then draw a line halfway betwen the two (blue). By doing this, you can generate the necessary angles.

Environments:
Architectural settings

Drawing the interiors and exteriors of buildings and other
built environments can often be quite difficult on several
technical levels. To draw convincing architectural
backgrounds, you need to consider several factors.

Perspective

You must be careful when any fixtures or
architectural and town planning features
create lots of clean, straight lines. This
means that you have to be vigilant about
using perspective and vanishing points to
ensure that all of the lines you draw are
correctly angled and distanced from each
other (for how to draw perspective, see
pages 114–117).

Context

Unlike trees, rocks, or rivers, which do
not give away a specific time period,
buildings are very indicative of when
they were built. Where possible, study
real-life references of buildings for the
time period you have chosen to set your
manga. Certain building techniques were
not discovered until fairly recently,
so avoid anachronisms.

Every culture has its own designs and
traditions, so it is important to research
the style of architecture used in your
setting. Even if your manga isn't set
in a real-life location, you should try
researching cities and cultures that are
most similar so that your designs seem
plausible. If you have created a fantasy
desert city, look at real-life architecture
from the Middle East and Africa, for
example.

The purpose of the building can
strongly influence the design of both the
exterior and interior. Do your research to
find out what features are essential for
certain types of buildings and incorporate
them into your designs so that they seem
functional.

▲ Inside the building, the viewer
faces the opposite wall directly,
so this image uses one-point
perspective to draw the upper
stories of the building and bases
of the statues.

Inspiration

★ **Venice, Italy:** fusion of
Renaissance and Byzantine-style
architecture
★ **Miami, Florida:** the largest
collection of Art Deco architecture
in the world
★ **Barcelona, Spain:** features
masterpieces by Antonio Gaudi
and Frank Gehry
★ **Shanghai, China:** blend of
traditional Chinese architecture
with modern skyscrapers
★ **Oxford, England:** college
buildings in the Gothic-revival style

▶ This building is very
clearly delineated,
and all of the glass
windows have to be
lined up perfectly,
so strong two-point
perspective is used
in this shot.

Omit detail to convey environment

For manga artists drawing strips, simplification is key to representing backgrounds. You need to be able to communicate environments with a simplified drawing. Draw only what is necessary to convey the environment and any details that reveal how it is relevant to the story.

FUTURISTIC CIVIC BUILDING IN JAPAN DISTINGUISHING FEATURES: *traditional roof and doors; sci-fi-inspired windows and communications towers.*

VACATION TOWN DISTINGUISHING FEATURES: *distinctive balconies, windows, and doors; whitewashed/painted exteriors; cobbled street.*

MILITARY COMPOUND DISTINGUISHING FEATURES: *low design; reinforced metal walls built for defense; sliding doors with input panel; hazard markings; external pipework.*

FUTURISTIC CITY DISTINGUISHING FEATURES: *skyscrapers; circular glass domes; needle-sharp communication antennae.*

Environments:
Natural world

The key to drawing the natural world is accumulating techniques for drawing different surfaces and giving a sense of unevenness. Drawing too cleanly or consistently can look artificial.

Trees, forest, grass

Do not be tempted to draw a tree based on the traditional idea of a straight trunk topped with one green, bushy cloud. Try to picture winding roots that go in and out of the ground, knobby tree trunks with wood grain, and branches that reach out from it in all directions and at uneven intervals. Bearing in mind that leaves appear on all sides of a branch, it is important to draw bunches in front, in the middle, and toward the back as necessary. You don't need to draw every single leaf—detail a few near the front, then use outlines for ones that are farther away.

Certain trees are very dependent on the climate and overall location, so it is important to make sure that you don't draw the wrong type of tree as part of your background. The pine forests of Scandinavia won't have any palm trees, for example. If you just need to draw one tree in the background of your manga, then pick a species from the country it is set in, or the nearest alternative.

If you want to draw a whole scene from a forest, then you really need to look at photos of forests from the appropriate country. Photos will show you the breadth of the species that grow in that forest, as well as the spacing between them.

Trees aren't the only things that make up a forest. Grass, dirt paths, sandy areas, undergrowth, and shrubbery all help to build a rich environment. It is far more realistic to show a variety of plants and trees at different heights and at different stages of growth.

While you don't need to use vanishing points, you do need to be mindful of perspective in general. It looks good to have flora in the foreground, mid-ground, and background, but increase and decrease their sizes accordingly.

You should also take into account the seasons. The look of a forest or meadow can change dramatically from the height of summer's blooms to the red leaves of autumn, and the stormy, lush greens of the spring to the blanket of white snow in winter.

◀ Details of the leaf shapes and wood grain are more obvious in objects nearer the front, whereas trees in the distance are simply outlined or silhouetted.

▼ You can enhance the appearance of rocks with lines and shading. The sides of the cliff face have sharp bulges and recesses, as if the rocks have been carved out. Notice how the rocks in the water cause ripples.

Rocks and mountains

Rocks and stones come in many shapes, depending on their mineral content and history. Pebbles are rounded and smooth, and usually found near moving water like rivers. Smooth boulders are also a common feature by the beach. Moving water shapes and smoothes rocks over long periods of time. Caves are often a result of water seeping through holes in the rock, so many formations are rounded.

Sharp, jagged rocks indicate that they have been unearthed fairly recently. This is also why naked cliff faces look so treacherous and sharp; if parts have fallen off recently, there will be raw exposure of fresh earth and rock.

No matter how smooth a naturally occurring rock is, they are never completely round or otherwise perfectly shaped (so no perfect circles, or straight lines that require rulers). Draw rocks freehand and add some contours.

When mountains are viewed from a distance, there are usually numerous peaks and valleys that make up a range, although some mountains can be taller and stand out from the others. In temperate climates they can be snow-topped during the colder seasons, but otherwise not. The main thing to remember is that they will not look crystal clear; anything at a distance should be drawn with thin, wispy lines, or be lightened or slightly blurred. If drawn too sharply or with thick lines, they will not look far away.

▲ This snowy landscape is built up from several components. Snow on the ground is drawn with smooth lines, but shaded with cool grays and blues. When drawing trees, keep them bare and concentrate on the trunks, branches, and ringed texture of the bark. The sky is dark, but lit up with soft, airbrushed lines to hint at the Northern Lights.

➜

Water

Water is tricky, first and foremost because it is transparent, but it can also appear opaque in many situations. Some types of water are simply cloudy (like fast-flowing rivers), while others will appear opaque if the lighting is strong (the sea). Use a combination of lines, shading, and highlights to show when water is transparent; for example, show rocks extending into the water below by continuing the rock's outline.

Movement is the next most pressing issue. Use lots of parallel lines and highlights to give the impression of running water. Even rivers have a few waves with peaks and troughs. Try to shade with a mix of darker and lighter tones to achieve a realistic effect.

▲ Still water has a fairly smooth surface, but add ripples in lighter and darker shades where the water connects with external objects (here, the edge of the pool and the girl sitting in it). The color of the water tints everything underneath, but is mostly translucent.

▶ No shading is used in this image, only pen and ink, so the lines are very fine and built up in parallel waves to add to the choppy appearance. Notice the reeds and bulrushes at the riverside, and don't neglect the edges of the water. Use plant species that would naturally grow near water.

ky

e sky can a beautiful thing to draw,
ainly because of the combinations of
lors and light that occur. Take time to
udy the sky in different weather
nditions and at different times of day.

Aside from the color combinations,
e most challenging aspect of drawing
e sky is the clouds. Again, you should
ok at the different cloud formations.
s also useful to see how other artists
terpret clouds and what features they
cus on. Don't restrict yourself to just
oking at manga artists, however. The
ore opaque and dense the cloud is, the
arper it can be drawn. Once you have
e overall shape of the cloud correct, you
ed to account for where the light is.
ouds are often backlit by the sun or
oon if they are in the picture, so be
reful and shade clouds to match the
sition of the sun or moon.

▲ The sky never looks
the same throughout
the whole picture so
incorporate a gradient
and make sure you shade
the clouds from above or
below to match the light
source. The colors at dawn
or dusk have shades of
pink and purple as well.

▶ Even when working in
black and white, you can
accurately portray the sky
by using a gradient fading
from dark to light where
the sun or moon is. The
sun is very bright, so you
can also add a flare or
sparkle on it with sharp
points and a halo.

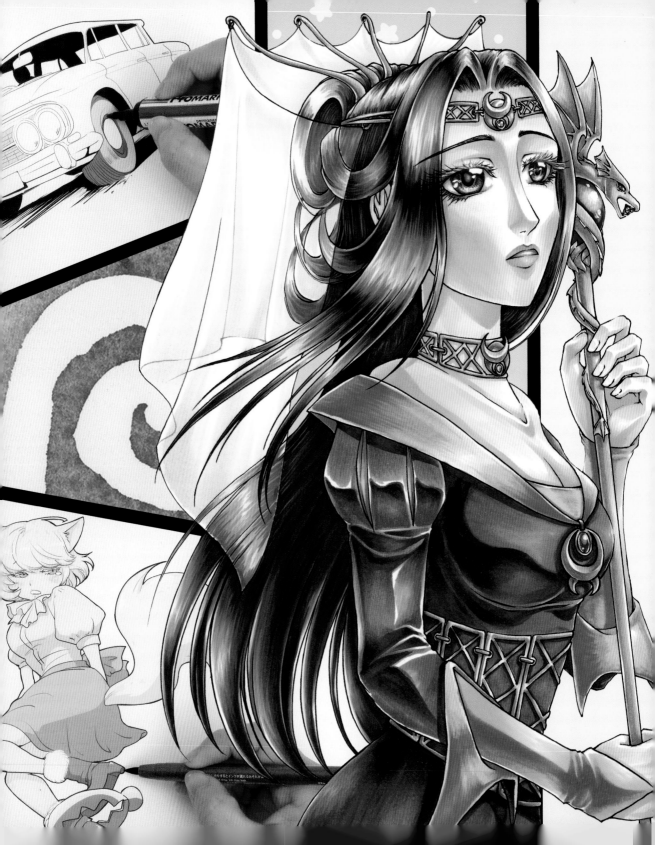

4

Rendering techniques

Once you've mastered your drawing skills, it is time to bring your characters to life with different mediums and shading. Learn how to use watercolors, markers, and other affordable materials in order to create a pleasing finish. Use your computer to create beautiful images.

Basic principles:
Rough drawing

It can be daunting when you look at a blank piece of paper in front of you and the image you have in your mind is so complicated and far away; you have no idea where to start. Don't be intimidated! Compose the overall image and rough everything out with basic shapes and lines, and add details gradually.

Composition

Consider how you want to lay out your image. How do you want to show off your character? If you want the viewer to be taken in by your character's eyes and face, perhaps to show off their emotion, you need to compose a drawing that is more closeup. Or do you want to highlight their physicality? Then, not only do you need a viewpoint that is farther away, but you also have to think about whether their pose would fit in a portrait or landscape canvas, or whether you need to try a more dynamic camera angle. If you want to showcase the overall atmosphere or environment, then try to show more of the character's situation and scenery, perhaps by zooming all the way out and choosing an off-center focus point.

Rough sketches

If drawing anything more complicated than a closeup portrait, you need to have a clear idea of your character's pose and the way they are positioned on the page. Try sketching out some rough stick figures—enough to work out the overall action line, any twists in the body, and where the limbs are positioned. It really helps to have a sketchbook to build up a library of poses for you to refer to. The same applies to complicated scenic vistas: sketch out your scene roughly in miniature. Think of where the vanishing points will be; contrast areas of blank space with areas of intricate detail; build an interesting silhouette with different heights, foreground, and background. Once you have settled on something you like, think about how it will fill the space and where you should crop the image.

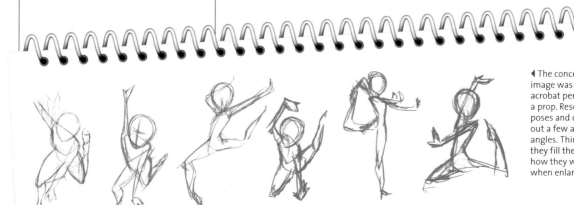

◀ The concept for this image was a Chinese acrobat performing with a prop. Research lots of poses and quickly sketch out a few at different angles. Think about how they fill the space and how they would look when enlarged.

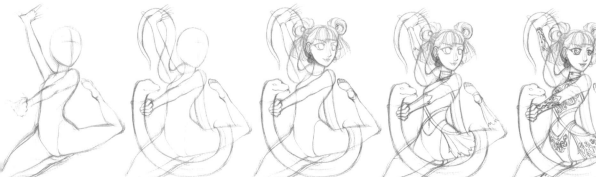

1 The image is presented on a diagonal to add dynamism. Start with the egg shape template for the head, then use strong lines to define the curve of her back, and the extension of her arms and legs. Add muscle and volume to her limbs, and bone structure to her knuckles, elbows, knees, and ankles.

2 The prop is a python! It is thick and muscular, so outline it accordingly. When adding it to the drawing, think about where the acrobat will hold it, how it drapes over her, and where it curves. Give it lots of weight and draw the parts that are unseen as they will help guide you.

3 Drawing the face of the character can help you affirm her pose and posture. Give her a confident smile, as not only is she an elegant and flexible performer, but she has to be strong and brave to be able to handle such a snake!

4 Define each part of the costume at this point, paying particular attention to shapes, straps, and edges. Think about where they join and how they drape over her body. Use guidelines to help you keep the complicated hems consistent, and divide the skirt into sections before adding the shaped hem.

5 Once the basic costume is drawn, you can add lots of elaborate patterns to the cloth. Just like the hems, use guidelines to keep the patterns correctly positioned and scaled for perspective. When dividing up sections, try to think about how the lines follow the contours of her body.

Basic shapes

When you move onto your actual canvas, start by defining the basic shapes of the character and/or background. Use action lines and perspective lines to help get the flow and scale correct. Then add volume by using spheres, cylinders, and boxes—the key is to visualize the basic shapes you need in three-dimensions. Draw simple outlines even for things that are blocked by something in front of them; you'll need them when they reappear, or you may find that they change the overall pose and positioning if they cannot physically work. Any props, vehicles, or interaction with the environment has to be tackled to make sure all of the elements connect correctly.

Build up details

Gradually add layers of detail to your drawing. There is no set order of things to work on as each drawing is unique. If the focus is mostly on the character, then it is useful to draw the details of the face, hair, body, and props before adding clothing, background, and effects. Sometimes you have to draw every nuance of a facial expression before moving onto the body, possibly even changing the body position, because a character's emotions will subtly influence their pose.

In an atmospheric image, which showcases the scenery, it is much better to draw the overall lines of the background and setting first so that you can use them as a point of reference to scale your character. Next, draw a quick outline of the character so you know where they are positioned, then go back to concentrating on the details of the environment. Don't worry about extra lines here and there; rough pencils will not be seen in the final incarnation of this image if you are inking or tracing your image later. Draw as much detail as you need to be able to ink correctly and remove any guesswork, particularly if you are passing the pencils onto someone else to ink.

Tools

★ **Ballpoint pens:** These cheap pens have a sketchy effect. This is fine if you intend to finish your drawing in this medium, or color it digitally, but the ink can smudge if any pressure or liquid is applied later, so avoid using this type of pen with traditional forms of coloring, or if you want a sharp, clean, black and white finish.

★ **Fineliners:** These pens have a fine felt tip and a fibrous reservoir of ink in the shaft. The ink flow is strong and consistent. They produce a clean, solid line. They come in many widths, ranging from the very fine 0.05 mm through to 1 mm. The fixed width of each pen can present a problem if you want to show more dynamic line width variation, so you'll often need more than one pen. They are easy to use and many are marker-proof as well.

★ **Dip pens:** The traditional tool of the comic artist, dip pens consist of a holder that can fit multiple nibs, which are dipped into a bottle of ink. The nib is made of metal and can have various thicknesses and shapes. Dip pens take time to master as the ink flow is fast and unforgiving, and the nibs can catch on the paper and cause spatters.

★ **Brushes:** Manga art uses minimal lines in long strokes—very fine Japanese- or Chinese-style calligraphy brushes are best. The brush should be very thin but with a medium tip length. Drawing high and away from the paper achieves thin lines; with pressure, these lines become thicker. If you don't dip the brush in ink for a while, you can create textured swathes.

★ **Brush pens:** These pens have a brush tip and an ink reservoir so that you don't have to keep dipping.

Basic principles:
Inking

Of all stages in the production of manga—and in all forms of comic artwork—inking will most obviously display the experience and talent of the artist. In many ways, it is their signature. In rough form, anyone can see the energy that went into creating the image, but inks are the polished, final form that readers will actually see. Just as good inking can transform a bad drawing, bad inking can ruin a good drawing. Whether inking traditionally with pens on paper, or digitally with graphics tablets, practice as much as you can!

Face

Every manga artist starts with the face, the focus of any character drawing. If a manga series is being drawn by a team of artists, the lead artist always draws the face, even if they leave the rest of the drawing to others. This is because your style will come through in the facial expressions of a character most of all; the subtlest change in the width between the eyes or the length of the nose can make a character look different.

Take particular care when inking the face. Use the finest, thinnest nibs you own so that you have the most amount of control over your lines. If inking digitally, use a small brush size. It's better to draw a very thin line only slightly misaligned to the rough guides underneath and then correct it by thickening it gradually.

Foreground details

When inking with real pens on paper, you don't get second chances (or you have to be prepared to correct everything with lots of white paint, or on a computer later). So logically, the next stage should be inking items that are in the foreground. This is because these things can block other parts of the drawing, which are farther behind, so you avoid mistakes later on, such as carrying your lines too far into the wrong parts of your drawing. It also helps you keep track of the thickness of your lines—use thicker lines for objects that are closer and thinner lines for objects that are farther away.

Midground

The next step is to ink the middle part of the picture. Use thinner lines than those in the foreground and make sure you don't ink anything that should be covered by objects in front.

Background

The objects and parts of the image that are farther away in the background are best saved for near the end of the inking process using the thinnest pen widths. Thin lines add to the impression of them being farther away as they aren't as sharp or bold as the objects closer to the viewer.

Fine details

Any final touches or small details should be added last, after the main components of the image are already drawn, so that you can correctly gauge where such details will go. During the

Techniques

TAPERED ENDS

When a fineliner pen is pulled across the paper with equal pressure and not lifted away, the lines have no variation in width and the points of turning have blunt ink pools. However, in manga, fine, feathery, thin points are required.

A hallmark of many beginners to inking is the presence of ink pools and blunt, thick ends to their linework.

You can avoid this by flicking your pen up and away from the paper as you finish drawing every line.

Easing off of the pressure on the pen will decrease the width of the line to create a sharp, tapered end.

LINE WEIGHTING

If all of the lines are the same width, a drawing will look flat and dull. Making lines thinner or thicker in the right places will make a drawing come alive and give it a sense of three dimensionality.

Thin lines
It is best to start off any drawing with the thinnest pen nibs appropriate for your drawing, particularly for characters' faces or other fine details. This example shows two oval shapes overlapping, drawn with a thin fineliner without any added weighting.

Thick lines
Draw areas closest to the light source with thin lines (here, top left). Add more weight to the lines farthest from the light source. Then think about what is on top of other things. The top oval shape casts a shadow onto the larger one beneath, so the line separating them becomes thick.

inking process, it is not uncommon for some lines to shift a little as you exercise your judgement; once a limb or piece of cloth is finalized, it can subtly affect the things around it so you may have to make adjustments accordingly. Fine pattern work or small details can look out of place now, so correct them as you need to. Remember to use thin lines to begin with, as you can always thicken them later.

Rotating your canvas

Inking requires smooth, controlled movements, particularly when drawing curves. Your wrist cannot make such movements effectively at just any angle. This is even more problematic if working with a dip pen, as it can catch on the paper if pushed away, rather than pulled toward the user. So rotate your canvas all the time to draw at the most comfortable and optimum angles for your wrist.

1 Start by inking the face as that sets the style, tone, and standard for the rest of the piece. Use a very fine-nibbed pen to begin with, and make an effort to finish your lines by lifting your pen up from the paper to create sharp, tapered ends. You can always make lines look thicker by going over them again, but unfortunately you can't make them any thinner once you've drawn them!

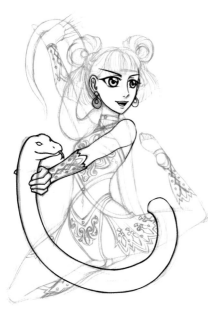

2 Because the snake and the hand holding it are closer to the viewer than everything else, it should be inked first so it is used as a guide for assessing the lines elsewhere in the image. When an object is closer, ink it with a thicker line. Don't be afraid to swivel the canvas around to give your wrist a more comfortable drawing angle for the curve of the snake.

3 When inking the midground, work from closer objects to those farther out to prevent mistakes with overlapping and to gauge the line widths correctly.

4 Don't just use thicker lines for things in front and thinner lines for things at the back. Add subtle shadows to the bottom of objects directly on top or in front of something else to create a three-dimensional effect. You can also thicken corners and seams, and thin any convex points of a curve. Notice how the hair ribbon stands out from the hair behind it. The strands of hair look more organic and the lines are thicker where the clumps join.

TIP: INKING DIGITALLY
If inking digitally, make sure that your software links brush size to pressure sensitivity.

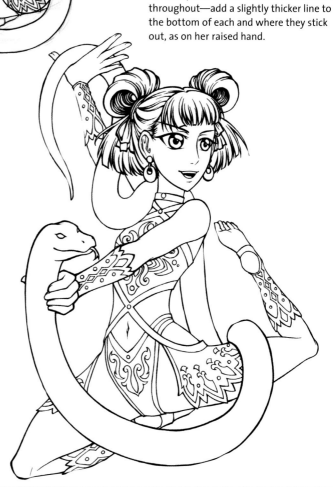

6 Ink the patterns on her costume with thin lines. They are not separate from the cloth, so drawing them with lines that are too thick will raise them up too much—the exception are the little beads scattered throughout—add a slightly thicker line to the bottom of each and where they stick out, as on her raised hand.

5 As the acrobat's raised hand and foot and the tail of the snake are farthest away, you should ink them last using thin lines, without fear of making any errors like overlapping objects in front.

7 When the rough pencil lines are removed, you can see how clean, yet dynamic and lively, the final image looks.

Basic principles:
Choosing colors and palettes

Producing a polished color image can be more difficult than it first appears, especially if your characters like wearing colorful clothing. It's good to learn which colors traditionally go well together in art and nature, but, in truth, there are no hard and fast rules about palettes; you can make almost anything look good by subtly altering some of the colors.

Basic theory

For hundreds of years, artists have used a system of choosing colors from a color wheel. It is a great way to arrange colors in a format that shows subtle progression from one color to another, and can be used to help generate some basic color palettes.

Primary colors

Red, blue, and yellow are the three primary colors in traditional painting that cannot be mixed or formed by a combination of other colors. They are responsible for creating all other colors.

Secondary colors

These are made from mixing two primary colors together. Blue and red make purple; red and yellow make orange; yellow and blue make green.

Tertiary colors

You make these by mixing a primary color with a secondary color and the results are named after the colors used. So blue-green is made from blue mixed with green, for example.

Color language

Even if you were to look at just one of the primary colors such as blue, there isn't just one blue. There are many types of blue, depending on how pure it is, whether it is dark, light, or washed out. Understanding some of the terminology for working with colors can help you to create the perfect color palettes.

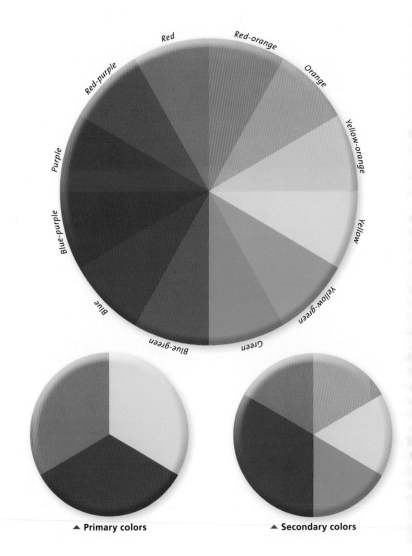

▲ Primary colors

▲ Secondary colors

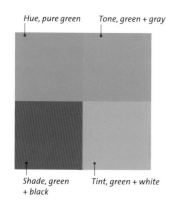

Hue, pure green *Tone, green + gray*

Shade, green + black *Tint, green + white*

Hue

This is the official name for what the main color of any given subject is supposed to be. Grass is green, and grass has a green hue.

Chroma and saturation

These two terms are similar in practice. Chroma deals with the purity of a color, and how bright and colorful it appears compared with white. Saturation refers to how strong a hue is relative to its own brightness. A bright, fire-engine red has high chroma and saturation levels, but a pale peach doesn't.

Values

A hue with a high value is very light, whereas one with a low value is very dark. White has the highest value and black has the lowest value.

Tones, shades, tints

Tones are colors with grays added. Shades are when you add black to hues. Tints are when you add whites. These additions make colors more muted, softer, or faded.

Suggested palette: traditional media

A glance at most artists' working palettes reveals that certain colors are almost always included. This is because time and experience have shown them to be versatile, and capable of creating thousands of colors associated with many different subjects and styles. The following list describes a good beginner's palette for all traditional media.

Titanium white A bright white. It mixes well and does not yellow. The white used in opaque watercolor techniques is known as Chinese white.

Ivory black This is an opaque black with a brownish undertone. It mixes well with yellows to create a range of dull greens. A black you may consider when using acrylic is mars black, an opaque black that is easy to use in mixes.

Cadmium red Cadmium reds are available in light, medium, and dark versions. It is a strong, opaque, warm red. It works well in neutral mixes.

Alizarin crimson This is the traditional "cool" counterpart to cadmium red. It is a popular glazing color.

Permanent rose. Like alizarin, this color is transparent, cool, and extremely strong. It mixes well with whites and blues to make a fine range of pinks and violets.

Cadmium lemon yellow This is a cool yellow. It mixes well with blues and black to create a good range of greens.

Cadmium yellow Like cadmium red, this color is available in light, medium, and dark variants, with the deeper shades being almost deep orange. Cadmium orange is made by mixing cadmium yellow with cadmium red.

 French ultramarine This is the standard "warm" blue. The shade can vary, depending on the manufacturer. It works well in glazes.

Cerulean blue The standard "cool" blue and traditional counterpoint to ultramarine. Although it lacks intensity, it is easy to control. Good alternatives are any of the phthalo blues, which are almost perfect primary blues. These have a very high tinting strength, so beware.

Viridian This is the standard green from which a huge variety of other greens can be made. Phthalo green is a good alternative to viridian—it is even more intense and mixes well. It needs to be used with care so that it does not overpower other colors. The range of greens it is possible to mix using phthalo green as a starting point runs into the hundreds.

Sap green This green is useful for landscape work. It mixes well with reds to create a range of interesting dull greens and browns. The actual intensity of the hue varies considerably, depending on the manufacturer.

Raw umber A "cool" brown with surprisingly good tinting strength. It can be made to resemble burnt umber with the addition of alizarin and a little ultramarine. The brown mixes well with greens. Various shades can be found.

Dioxazine purple This is a deep, rich, transparent violet with good tinting strength, and is an excellent start for mixing a whole range of purples and violets.

Generating palettes from a color wheel

Using a detailed color wheel, you can generate many color schemes by picking sections from it, or choosing colors positioned at different ends. Here are a few combinations to get you started.

Monochromatic
Choose one main hue to work with and use tones, shades, and tints of the same hue. This is a simple color scheme, but it is unlikely to be jarring.

Analogous
Looking at your color wheel, take three adjacent colors to form your palette. These three colors are likely to be harmonious, but possibly lacking contrast if they have similar chroma and saturation levels; you can add interest by using tones, shades, or tints.

Complementary
If two colors are positioned opposite each other on the color wheel, then they are complementary. They can produce eye-catching schemes, but be careful because, if they have similar chroma and value, they can clash when placed right next to each other. Use tones, shades, and tints to expand your palette.

Triadic
Take three colors that are equally spaced from each other in the color wheel. This can produce some diverse and well-balanced color schemes, particularly if you tone, shade, or tint one or two of the colors.

Warm color palettes
The half of the color wheel that progresses from red through to yellow consists of warm colors.

Cool color palettes
The half of the color wheel that progresses from green through to purple consists of cool colors.

How to use palettes

With all of the traditional combinations and techniques for creating palettes, you can break the rules and still create a stunning image, or follow traditional setups to the letter and have an image that looks terrible. The key is knowing how much of each color to use and balancing out bright colors with neutrals like white, gray, black, and sepia. For large expanses, it is best to use hues with low chroma or saturation, like dark shades or pale tints, reserving very bright colors for smaller sections and accents.

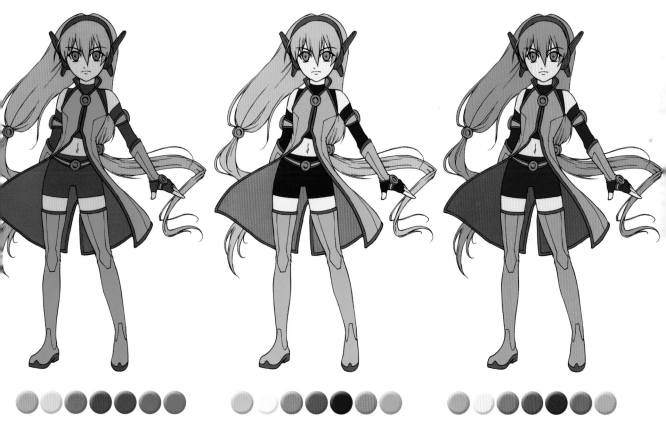

▲ The color palette has been generated from the color wheel in a triadic scheme of green, various oranges, and purple, with added blue. However, the character looks too jarring with the number of bright colors on her, as the chroma and saturation levels are all very high.

▲ Mute the palette by adding elements of black, gray, and white to the colors to reduce the chroma and saturation levels. This makes the overall effect much more harmonious and easier on the readers' eyes. It is important to add a mixture of shades, tones, and tints to maintain sufficient contrast.

▲ If you want to reduce the number of colors in a picture, pick only one or two very strong hues and keep the other colors in the palette very washed out or neutral, like warm or cool grays, in order to maintain balance. This enables you to have very bright, saturated accents and highlights without going overboard.

Basic principles:
Shading

To add a sense of three-dimensional depth and realism to your images, you must learn how to add light and shading to different shapes and objects. Humans are particularly tricky to shade because the contours of the face and body are complicated. You should also take into account the differences between shading skin, clothing, and accessories.

Basic theory

To see characters and their environments clearly, there must be light, and wherever there is light, there must be shadow. The first step in shading objects correctly is to identify where the light source is coming from. Light makes some parts of the object brighter and casts shadows in other areas. Exactly how the light and shadow appear depends on the shape of the object. Learn and anticipate how the shading will change on an object as the location of the light source changes.

Light

Identify the location of the light source before you begin shading. Think about whether it comes from the side, above, or below. The parts of the object that are closest to the light source will be brighter than the parts that are farther away.

Shadow

Objects cast distinct shadows if the light source is strong. The shape of the object determines the shadow cast on the floor or wall nearby. Shadows can also be cast on the object itself; think about whether light can reach certain parts of the object or if it can't because it is blocked by something else.

Highlights

If an object is reflective and glossy and if the lighting is strong enough, there will be distinct highlights. On characters, this mostly applies to hair, eyes, and shiny fabrics. Even skin that is normally matte can appear glossy when wet or oiled. Highlights appear in small, concentrated amounts positioned where the light is strongest and wherever its surface directly faces the light and reflects it back.

Hard and soft shadows

As already mentioned, shadows become more distinct when the light source is strong. The shape of the object can determine how sharp its shadows are—a cube with sharp edges has clearly defined shadows compared to the soft gradient on a sphere. But, the sharpness of the shadow is also affected by the distance from the object casting it. If the object is close to its shadow, the shadow appears sharper; if it is far away, the shadow is diffused, becoming blurry and lighter.

Top **Back left** **Front right** **On surface** **Lifted**

▲ This coffee mug is shaded to match various light sources, indicated by arrows.

▲ The coffee mug, side-lit from the front right, is made of a highly reflective gloss material, and therefore has distinct highlights.

▲ The shadow that the coffee mug casts on the table will become softer and indistinct as it is raised high above the table, farther away from its shadow.

Applying to the face

Applying lighting theory correctly to characters takes time and practice, but, if you remind yourself to go through the basic theory each time, you will get used to the shapes and their shadows. Think about how facial features, particularly the nose and hair, will block the light from reaching other parts of the face.

▶ The four images to the right are lit from various directions and shaded simply, without altering the shadows in any way.

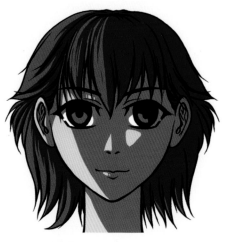

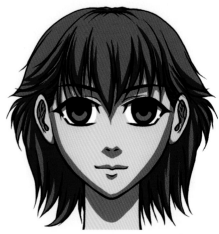

Back left
Three-quarters of the face is in shadow with highlights on the nose and lip and a triangle of light shining through the dip in the nose.

Top down
The majority of the face is lit, with shadows underneath the nose, lips, and chin.

▼ This face is lit from the front right and is now shaded with different shadow intensities and sharpness.

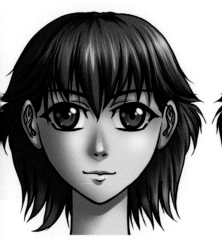

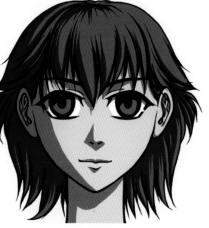

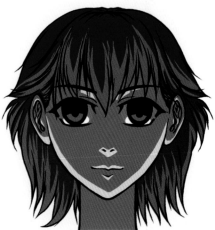

Front right
The nose and chin cast darker and sharper shadows than the gentler curves of the cheeks. The hair and eyes are glossy with distinct highlights.

Front right
Three-quarters of the face is lit, with shadows to the left of the nose and on the left-hand side of the face.

Bottom up
The majority of the face is in shadow with just the botton of the chin, nose, lips, and forehead catching the light.

Lighting environment

Once you have practiced shading three-dimensional objects and the complexities of the human face and body, you need to tailor your shadows and highlights to match subtle lighting conditions. Not all shadows are the same. Some factors that come into play include multiple light sources and their differing intensities, the color of the object that is being shaded, and the color of the environment surrounding the object.

Multiple light sources

In realistic environments, there is never only one source of light. There tends to be one strong source and one or more additional sources elsewhere. In the daytime and if the sun is strong, it is the main source, but sunlight also reflects off other objects, causing diffused light all around. If the sky is overcast, then the sunlight is already diffused. If it is night or you are indoors, there will be ceiling lamps, table and floor lamps, televisions, fireplaces, etc. This means that you need to balance the intensity of the shadows, fading them out or even placing slim but intense highlights over them.

Colored highlights and shadows

Shadows aren't simply a case of darkening the object's color with the addition of black. You should avoid this at all costs as it will make your images dull and lifeless. Likewise, highlights and strongly lit areas aren't just brighter or whiter. Make sure that your shading has a good amount of color saturation. Not only that, but there is a subtle hue shift that takes place, too. Shadows tend to become cooler with blue hues, whereas highlights tend to have warmer hues.

Color of the environment

Color is bounced off the environment around us, so you should account for this when you are shading your characters. For example, if your character is in a lush, green forest, you should mix warm yellows and greens into the color palette and shading. Clothing can also influence the shading subtly; a red dress can impart a slightly red hue to the skin next to it.

Troubleshooting complex surfaces

Even when you have taken into account everything that has been mentioned so far, certain materials are more complicated to deal with than others, and require special treatment.

Skin

Skin is a surface that baffles all inexperienced artists in both traditional and digital mediums. It is mostly a dull or a matte surface, but the natural oils present reflect a little bit of light; this is further enhanced if it is wet or oiled. As

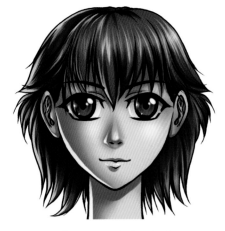

▲ This face is lit mostly from the front right, but is also backlit from the left.

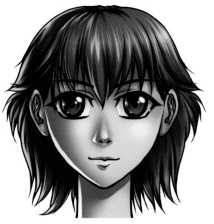

▲ Regardless of whether the main light source is white, warm-toned, or cool-toned, this face will have a warmer feel in the front right areas where the light is coming from, and a cooler feel to the shadows at the back and to the left.

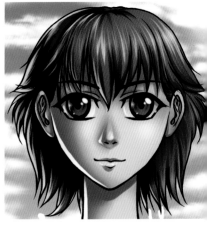

▲ If your character is backlit against a clear blue sky, there will be elements of that blue in the highlights and shadows.

▶ Build up layers of shaded fur, from dark to light.

▶ Outline a glass object with strong white and let the background show through.

skin is also slightly translucent, strong light can penetrate it then bounce within the skin before being reflected off as color: this is known as sub-surface scatter. This manifests most clearly where shadows occur—where the shadows start to appear on the skin, there is a highly color-saturated, illuminated area. Finally, skin also changes color depending on where it is on the body, with some parts being darker or lighter due to sun exposure. There tends to be more gray on stubbly areas; the nose and cheeks can flush red.

Fur

Fur can be tricky to shade, but it takes several steps to achieve this complicated look. Start by working from dark to light, lots of feathery strokes in a lighter shade on top of a darker shade, in one line. Then, a little higher than before, draw more light, feathery strokes, leaving plenty of dark, shadowed areas underneath to bring out the strokes and the texture. Continue, but get subtly lighter and lighter to match with the light source, until you cover the whole area.

Metal

Truly shiny chrome will have massive amounts of contrast, gradients mixed with sharp, streaked highlights, and shadow. Brushed metal has slightly more blurry shading. Metal easily picks up environmental colors. Common

environments (such as daytime and interior lighting) will have hues of blue and orange mixed in.

Glass

Glass depends very much on the background behind it and is a combination of sharp contrast and soft shading. Roughly block out the shape of the object, then fill very lightly with a light shade, letting the background show through. Then outline sparsely with strong white near the top where the light source is and add highlights just within the shape farther down. Finish outlining all of the other edges and corners with a dark shade.

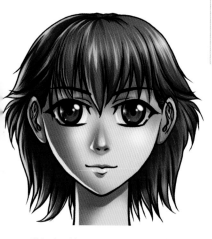

▲ Skin should appear more saturated and blushed where the shadowed areas begin.

◀ To shade metals, start with neutral grays. Use colorful gradients with strong highlights and backlights to get that super-reflective feel.

Tools

★ **Colored pencils:** Quality brands of pencil may be more pricey, but the expense is worth it. You can replace colors individually, the colors are consistent from year to year, the leads are strong and durable, and the brightness and saturation last. If you are on a budget, buy an inexpensive, non-branded set with as many colors as you can get, then top off the skin tones, browns, and grays with a more expensive brand. If you want to mix colored pencils with water or markers, experiment with watercolor pencils.

★ **Erasers:** They don't always work on the less expensive brands of pencils, but they can help if you make a mistake. They help keep smudging on the edges of the paper down to a minimum and they can erase light marks. You may need a couple of erasers: a large one for big areas of paper and a smaller one for working around delicate areas.

★ **Tissue paper:** When you want to soften your marks and create a blended fill rather than one that is too clearly lined, use tissue paper to diffuse the color, pressing hard onto the colored area and working in circular motions. You can also buy special blending tools made of rolled-up, compacted tissue paper or fibers (blending stumps or tortillons), but this isn't necessary if you are careful with your coloring in the first place.

★ **Paper:** Ideally, you should work with fairly smooth cartridge paper, where the surface is not so smooth that it's slippery (you need a little texture to hold the pigment). The weight and thickness of the paper needs to be more robust than standard printer paper, because sometimes you'll need to press fairly hard on the paper to achieve a fully saturated, sharp line.

Traditional media:
Colored pencils

Colored pencils are some of the most accessible and affordable art mediums you can work with. They are easy to handle and highly responsive to pressure, making them ideal for shading. Play on their strengths and don't try to force an unnatural finish.

Planning
Because colored pencils are not as easy to erase as other types of pencil, you should plan your drawing carefully. Use another sheet of paper if you need to and don't forget to think about how you are going to frame and crop the image.

Outlines
The number one mistake beginners make when using colored pencils is to outline everything in a normal pencil or with black ink. Nothing will squeeze the life out of an image more! Always outline in color and preferably in a texture that is consistent with the shading you will add later. Start by drawing your guidelines with a very light color that can easily be covered with darker tones later, and press very lightly as you go so you don't saturate the paper. Then outline with the colors you intend to use for the shadows of each area.

1 If necessary, draw some rough guidelines very lightly. Decide on the colors you will use for the shadows and add outlines in these colors on top of the guides; they will stand out and hopefully almost completely obscure your guidelines. Make sure to keep them neat and tidy. Keep sharpening your pencils.

Techniques

Colored
pencils demo

SHADING TECHNIQUES

The way you hold and apply the pencil will affect the marks you make and the effect you create.

Circular shading
Use gentle, circular motions and strokes that match the contours of the body and face to build up darker shades.

Sharp strokes
For control, precision, and to apply pressure, hold the pencil as if you were going to write with it. Use the sharpest point of the pencil for definition.

Angled strokes
To create light, loose, or even marks, hold the pencil from underneath as this encourages free movement of the wrist. Develop a broad, flat edge to the lead for a uniform finish.

BLENDING

An effective blend is made by loosely shading over an existing color of a similar hue or tone; the two mingle and appear as a blend although there are two distinct coloring layers.

1 Use the flat edge of the pencil to apply an even, light layer of the first color. Remember, you can always add more color, but it is difficult to take it away.

2 Apply a second color in the same way, so that neither is dominant and there is no discernible seam. Rich, vibrant colors are made up of a number of layers of blended colors.

2 When you are dealing with more than one character in an image, keep the lighting consistent to give your characters unique skin tones so that the reader can easily differentiate them.

Skin

Shading the skin early on helps you balance the tone and contrast with the rest of the picture. Gently shade in only the areas that would be in shadow and leave the rest uncolored. It is much easier to add color later on than to try to remove pigment from the paper. As the pencil tip gets more chiseled while you work, use the flat end for general shading, then twist the pencil around and use the sharp end for darker details.

3 As these characters' hairstyles have long, silky strands, make long strokes with your pencils to define the roots, ends, and shadows. For fur, such as the fox ears top right, use shorter little strokes in rows. Always try to match your pencil strokes with the texture and the direction of the hair.

Hair

Use the darker shades you intend to color the hair with and sharpen your pencils often! Use thin, feathery strokes with tapered ends to your lines to define the roots and ends of the hair. Lots of multiple strokes help to give the impression of hair and its texture. But don't color it all in; leave plenty of white for highlights and for adding lighter, more saturated colors in layers later on.

First layer shadows

Continue adding just the shadows to the drawing until the whole image is shaded in. So far, each section has been shaded with just one color. Consider this your first layer of color. At this stage, you want to make sure that the overall levels of shading, lighting, and contrast work together. This is the time to darken shadows and add light fills if you need to mix colors later (if you don't have the exact shade of pencil you want).

4 To finish the initial first layer of color, add your shading using only the pencils meant for shadows. For darker colors, a richer effect, or areas that are not supposed to have too much contrast (such as the blue cloak), fill them in lightly.

Second layer color fills

Incredibly important for skin tones, jewel tones, fabric such as silk, and mood lighting, colored pencils take on a magical appearance when you start layering different colors on top of each other. You can take your mostly complete image and add an extra dimension by softly adding a layer of color that is subtly or even greatly different from the shadow colors already laid down. Just be gentle and remember to use the appropriate type of pencil stroke and blunt or sharp tip as before.

Third layer darker definition

When you add various layers of color on top of base shadows, some of the contrast is lost. To add the contrast back in, sharpen your pencil tips and add very rich, dark colors to the edges of shadows, pressing hard in order to achieve maximum saturation and definition.

5 The drawing now takes on a richer appearance by adding warm peaches and yellows to the skin; green-gold accents; bright reds to the burgundy hair and to the blues of the lining of the hooded cloak to create a two-tone silk effect; and orange to the fox ears.

6 Make your outlines darker and sharper in places to add contrast, like the edges of eyelashes and loose strands of hair. Add fine details to the iris and hair texture in rich or contrasting colors to create silvery eyes, golden eyes, and strawberry blond hair.

Traditional media:
Watercolors

Watercolors are an affordable medium that can produce vibrant pieces of art. The drawbacks: they can create a messy working environment, they can be hard to control, and it takes time for the paint to dry. You also need to be aware that what works for landscape painting doesn't necessarily work with manga illustration.

Tools

★ **Watercolors:** The key to creating paintings on a budget with a clear, non-grainy feel is to prioritize quality over quantity; buy professional-quality pans or tubes with key primary colors that you can mix and blend, then buy more colors over time. Pans are neater, cheaper, and more portable than tubes of paint, but tubes can often be easier to blend with water.

★ **Paintbrushes:** Avoid the inexpensive, supermarket-bought children's set of brushes that are cut inelegantly with hairs that fall out after one sitting. Manga illustration is often fine and delicate, so buy quality synthetic brushes or sable blends of the smaller sizes and then spend a little less on the large brushes for washes.

★ **Paper:** The most common and affordable cold-pressed or rough-textured watercolor paper sold to art students and most beginners is highly textured and unsuitable for the closeup detail required in manga. The best paper for manga watercolors is the higher-quality hot-pressed satin grain, which has a finish as smooth as cartridge paper. As long as the paper density and weight are 140 lb (300 gsm) or higher, the paper shouldn't curl from the water.

★ **Masking fluid:** Masking fluid is used to cover areas of paper you want to keep white (for example, for highlights).

★ **Tissue:** Keep lots of strong tissue paper on hand so that you can soak up any messes and lift any color from wet washes. You can also add color to wet paper with saturated tissues to create interesting effects.

Roughs and planning

If you don't already have a clear picture in mind of your drawing before you start working on watercolor paper, do some sketches on a separate piece of paper. You want your final pencil outlines to be as neat as possible, with minimal guides that you can erase before you start painting. Once you paint over pencil marks, you won't be able to erase them. Think carefully about how to structure your drawing so that it doesn't cause problems for you when painting. If you have very fine areas to define, make sure you have small enough brushes or plenty of masking fluid; otherwise you may need to make your drawing less detailed.

Lightly and carefully draw your pencils on the watercolor paper. Erase your guidelines as much as you can so that you are left with the cleanest outlines possible.

Masking

This technique isn't always necessary in manga artwork, but it is a great tool if you want pale, intricate shapes against a dark background. To preserve the white of the paper for pale, detailed work, painting some masking fluid over those areas will protect the paper and keep it dry, regardless of how much you paint messily on top.

1 The demon goddess has pale hair and will be set against a background of lightning flashes in a dark sky. To create a dramatic, dark sky later on, carefully paint the masking fluid over the fine strands of hair and the lightning flashes.

Techniques

USING MASKING FLUID

Watercolors produce beautiful and colorful blends of washes, but these must be done with broad brushes and splashes of water, which can ruin the paper if you want to draw and paint lighter colors in adjacent areas. You can protect the white paper by painting masking fluid over the areas you want to preserve.

1 Once you have finished your pencils, apply masking fluid carefully to the paper, either using a paintbrush or any integrated spout on the bottle. Cover everything that you need to preserve and wait until the fluid is dry. To save fluid, concentrate on the areas that really stick out into the section you want to apply wash over, and remember not to paint your wash too far into the mask.

2 Apply a wash over the masked area. With a large paintbrush and plenty of water, wet the paper where you want to create the wash. Then, while it's wet, add pigment in bands to the areas that need a stronger color and tilt the paper to dictate where the most pigment will go. You can control the depth of color by using more pigment or more water.

3 Once you have finished, wait until the wash is dry, then carefully peel off the mask.

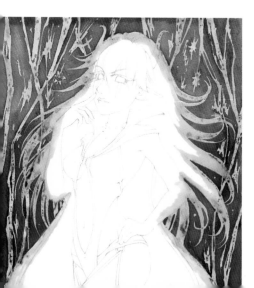

2 Start with a mid-blue wash over most of the background. While the paper is still wet, add a much darker blue near the bottom of the paper to create a gradient effect. Dot deep reds over the flashes of lightning to give them a purplish glow.

3 Wait for the paint to dry completely before removing the masking fluid. Carefully peel it off the paper to reveal the white underneath.

Techniques

WET IN WET

This technique is great for soft, blended shading. This makes a perfect start to shading the skin.

1 Apply water or a wash to the overall area you are painting.

2 Add more pigment to the areas you want to color or make darker.

DRY BRUSH

This produces a vibrant, strong color and works well on the darkest shadows.

Use a nearly dry brush that has lots of pigment, but only a little water to paint onto dry paper.

GLAZING

Once a wash or other pale painted sections of the picture are dry, you can add thin additional washes of paint on top in order to create subtle hues and tone. This is particularly effective for skin, which can have both warm and cool tones, and reflect some of the colors nearby.

1 Appy a thin wash of paint and leave to dry completely.

2 Add another, nearly transparent layer of paint. Continue to build up the color in this way until you reach the desired effect.

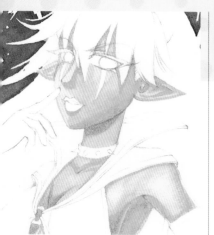

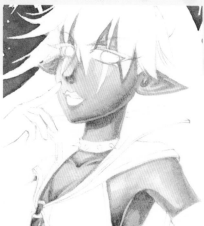

4 Add controlled wet-in-wet washes to the sections of skin in a brown and orange mix. While wet, add more pigment to the more shadowed areas, or dilute the highlighted areas by cleaning your brush and simply adding water to spread out the pigment gradually.

5 Add a light glaze of reddish-purple to the shadow areas.

6 Using a dry brush, add hints of blue to some of the shadows and blend in with extra water to make the skin more harmonious with the background.

Skin

Skin is always a good next step to take when coloring any character picture to help you gauge the levels and contrast of the rest of the image. Use a small brush and paint the skin tones in a controlled manner, as a light wash.

Hair

Use a combination of a medium-size paintbrush for general shading and a very fine brush for adding textured strands. As hair is a shiny substance, be sure to leave the paper white for the brightest highlights and focus on painting in the shadows.

> **TIP: ADD WATER NOT WHITE**
> Never add white paint to your colors if you can avoid it as it makes the paint opaque and muddy. Just use more water to dilute it and wash it out into the white of the paper.

7 As this demon goddess has cool-toned, silvery hair, use a dry brush technique with very little pigment to paint in the shadowed areas, leaving plenty of white paper at the edge of the picture.

8 Wait for the first layer to dry. Next, use a dry brush with more pigment to add depth and texture to the shadows.

Other materials

You need to think carefully about the reflective qualities of various materials used in your character's clothing in order to shade it correctly. Shiny surfaces need more levels of shading and contrast, with strong highlights and backlights. Matte surfaces don't have such strong shading. Use dry brushing and wet-in-wet techniques as appropriate to get the right mix of hard and soft shadows.

Finishing off

Your picture is almost done. But it is very easy to get bogged down in minutiae when working with finely detailed watercolors. Take a step back and look at the overall picture. Don't lose sight of which large areas should be most in shadow. Consider whether the tones of the whole picture work. Do you need to add additional glazes of color? Is there sufficient contrast throughout? Do you need to darken your outlines? Sometimes leaving your picture for a day and looking at it with fresh eyes the next morning can help you spot that extra little something that will tie it all together.

9 Her black leather suit and gloves are shiny, so blend strong gradients and leave white paper highlights.

10 The red lining of her cape is of a more plush material, so start with a red wash and, while the paper is still wet, paint in dark blue and purple shadows to blend into the red.

TIP: LIFTING OFF

If you want to lift off any excess paint or water, soak it up with tissue paper. For smaller areas, roll up a small corner of the tissue. If the paint is already dry, just add water and blot.

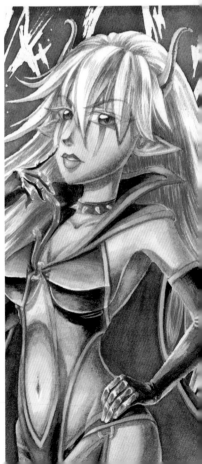

11 The red trim on her clothes, the metallic rings, spikes and horns, and her red eyes are very shiny, so use a fine, dry brush for the darkest areas and dilute with water to get dramatic blends.

Color palette

Watercolors
demo: part 1

Watercolors
demo: part 2

Watercolors
demo: part 3

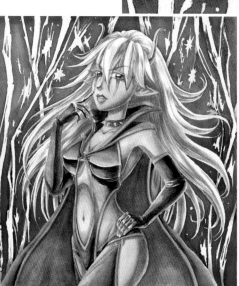

12 Add splashes of purple to the lightning flashes in the background.

13 As some lines can be drowned out by the bright colors in the painting process, you can add a few more pencil strokes to your outlines to reintroduce any lost definition.

Traditional media:
Markers

Markers demo

Markers are consistent and versatile, and are therefore the most popular tools of the manga artist when creating color illustrations. With some practice and control, they are ideal for coloring and shading intricate outlines, but, just like any other medium, it is essential to understand how they work to get the best results.

Tools

★ **Markers:** Experienced illustrators go for alcohol-based markers in a wide range of colors (including the essential grays, pale pastels, muted darks, and skin tones) with either a brush tip or multiple tips in different widths. If you are on a budget, choose a quality brand and try to get at least one light and one mid-shade in the essential colors mentioned above, and a bottle of surgical alcohol for blending with a brush. You can always make areas darker by layering colors, or hatching/cross-hatching with your black inks, or by adding some dry-brushed watercolors later.

★ **Pens and ink:** Use permanent or marker-proof pens for your linework to avoid smearing when you color over them. If the pen and ink are waterproof, the lines shouldn't smudge unless you really saturate the paper. Alternatively, use dip pens or brushes with bottled waterproof ink. Many artists draw their outlines with a normal pen and ink, then photocopy or laser print their design before coloring (heat-fixed printer ink is marker-proof).

★ **Paper:** Unless you have a very light touch, markers bleed through normal cardstock and paper, so place extra pieces of paper underneath, work on a drawing surface you don't mind getting color on, or buy special coated paper. Markers can be almost textureless, meaning that very small, fine details stand out from the smooth colors and paper; paper that is too roughly textured will detract from such detail. Thinner paper is beneficial if you use a lot of blending, as it is easier to saturate; thicker paper suits markers that may have too fast an ink flow, as they can soak up more excess ink.

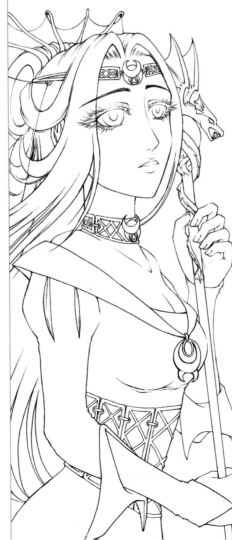

Roughs and planning

Start your drawing by making a pencil rough with normal, erasable lead. Keep a light touch on your pencils so that when you need to erase it, you don't damage the surface of the paper. When you are happy with your pencils, start inking carefully over them with marker-proof pens. If you're new to coloring with markers and you're worried about colors bleeding over the lines, ink with a thicker style of line art. Don't feel restricted to black outlines if your intended color palette suits other colors. Plan out your color palette on a separate piece of paper before you commit to your final piece of work.

1 Sketch out your drawing lightly with normal, erasable pencils so that when you ink on top, you can easily erase the pencil marks without damaging the paper. Then start to ink your drawing. As the color palette contains a lot of dark colors, most of the ink needs to be black to be able to stand up to that. The thin veil, the tips of her eyelashes, and details of her pupils are outlined in gray ink where the shading and coloring will be much lighter. Remember to vary your line weights appropriately.

Techniques

BLENDING—LIGHT TO DARK

As markers dry fairly quickly, have your graduated shades to hand. You either need to work very fast or really saturate the paper to lift the just-dried ink. You can start with lighter shades to build up color, then work darker and darker until you're happy with the depth of shadow.

1 Start by laying down your light shade on the paper.

2 Overlap with a slightly darker shade and repeat as necessary until you achieve the desired level of darkness.

BLENDING—DARK TO LIGHT

You can go over the dark shade several times with the light shade to blend them together, preferably while they're still wet.

1 Start with painting in the darkest shade in the shadow areas.

2 Working quickly while the paper is still wet, saturate the paper with the lighter shade, working it well into the dark shade for maximum blending.

SHARP STROKES

If you want to draw distinct, sharp shadows or want your strokes to stand out from any color background, you need to wait until the paper is completely dry before brushing quick marks on top to avoid oversaturating the paper. That way, there are distinct layers of color and no blending. You can do this with the same pen multiple times to subtly deepen your work, or use a significantly darker shade.

1 Start with laying down your light shade on the paper and wait until it is completely dry.

2 Layer on top with either the same shade again or a darker shade so there is no blending at all.

Skin

The skin remains an important starting point for coloring to properly set the levels and contrast of the image. To make skin look luminous and smooth, you need to have several close shades available to blend on top of each other several times, as well as using the white of the paper—particularly if your character is pale. Start by using the lightest skin shade to generously color in any areas likely to be in shadow, leaving white any areas that should be highlighted. If you wait for the ink to dry, you can color another layer on top that will look subtly darker. Gradually add darker colors to the most shaded areas and use the previous lighter shade to blend them in while the ink is wet.

Hair

As it complements the skin, hair is the next logical step. As it has a very shiny surface, hair needs multiple shades of color with considerable contrast between each. You actually want some textured streaks and distinct lines, so waiting for layers to dry in between each shade is important. Work from light to darker colors so that you keep your options open and levels of shading flexible as you go. Remember that you can always make the paper darker but it is harder to remove or lighten any marks you have made unless you really saturate the paper with alcohol to try to lift the color. Let lighter layers dry and try to make thin strokes in darker colors to achieve strands of hair.

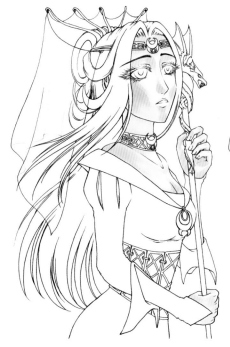

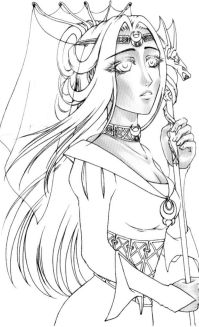

2 The lightest shade is used first for coloring in the skin. Use the white of the paper for the highlights.

3 A slightly darker peach is added and blended in or left as a distinct, dry layer of shade for achieving soft and hard shadows accordingly.

4 A darker orange is used to enhance the shadows and add contrast, generously blended in with the lighter shades for a smooth finish.

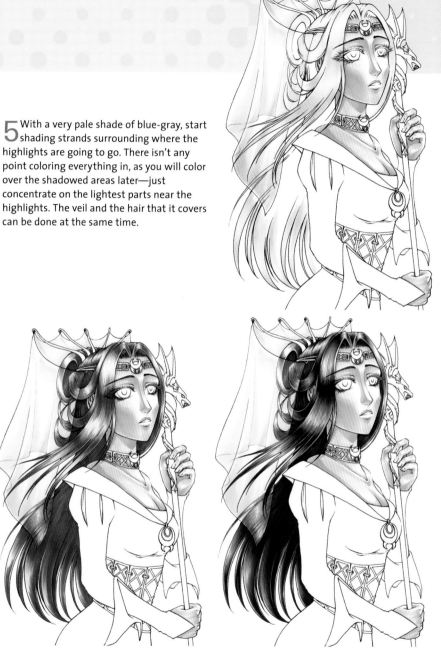

5 With a very pale shade of blue-gray, start shading strands surrounding where the highlights are going to go. There isn't any point coloring everything in, as you will color over the shadowed areas later—just concentrate on the lightest parts near the highlights. The veil and the hair that it covers can be done at the same time.

6 With a slightly darker shade of blue, add more strands over the lighter shade. To enhance the effect of the veil, add another layer of color just outside the veil to make the hair not covered by the veil look darker.

7 Now you should start bulking in the dark areas of shadow and add a few select areas of thin strands with a dark blue. Be very restrained on the areas of hair covered by the veil.

8 The very darkest shade should only be used for texture and areas completely covered in shadow. Don't add any of this shade to the veiled hair.

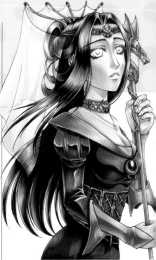

9 From left to right, you can see how to build up the shading on a rich, purple, silken dress. Use a mid-shade of purple to start with and define key shadows and folds, feathering out where needed into the white of the paper.

10 Then with a light violet, soften and blend those marks in, leaving white slivers for the shiniest highlights.

11 Finally, add dark indigo to key shadow areas and lines of contrast.

12 Color in the rest of the areas of the drawing. Remember to blend and shade as required, depending on whether the surface is shiny or matte, and whether the shadows are soft or hard. Strong highlights and backlights should be left as white paper.

Eyes

Eyes are another unique feature when coloring as you need a good amount of blending and contrast. Dark shades are required for the pupils and at the top of the iris, but the iris blends to a lighter shade lower down. You should also add interest like dark streaks for the iris patterns and leave plenty of highlights as white paper, adding extra glints and shine with white ink.

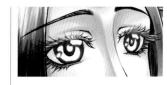

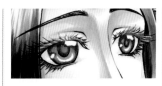

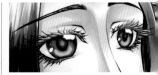

13 For her soulful brown eyes, start by outlining the highlights, iris edge, and pupil with dark brown.

14 Color in the pupil and ring the edges of the dark brown with a mid-shade.

15 Then with a yellow shade, saturate the paper enough to blend into the mid-brown.

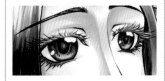

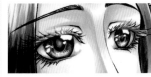

16 Wait until it dries before adding very thin, short streaks in dark brown for the iris pattern.

17 Add extra highlights with thick, white ink.

Coloring materials

Markers work in a similar way to watercolors, except they dry much faster. So, if you are shading in areas that have soft shadows, you need to blend the colors as you go along while the ink is wet, or you need to really saturate the paper to make the colors run into each other. You may find that working from a dark or mid-shade and going lighter will give you a more blended effect. For harder, distinct shadows, work from light to dark and allow time for the layers of color to dry fully. Don't forget to use the white of the paper to your advantage; always remember that is the lightest you can go.

18 The finished image—with red jewels added and the lips in a shade of pink.

TIP: ADDING EXTRAS

Don't be afraid to add extra media to your image. Use opaque, white ink for highlights, sparkles, and loose strands of hair. Colored pencils add texture and definition. Add a splash of color to the background with watercolor. Brush rubbing alcohol onto the paper; then, while it's very wet, blend some markers into it for a watercolor wash effect.

Color palette

Tools

★ **Screentone:** These are clear, matte transfers or stickers with all forms of shading rendered as patterns of black ink printed on their surface. There are various brands available to purchase online and from art stores. If you have access to a laser printer and the right type of sticker paper, you can create your own.

★ **Scalpel:** You need a sharp knife that is easily maneuverable and with blades that you can replace as you wear them down.

★ **Cutting mat:** If you're going to be slicing anything with a sharp blade you'll need a cutting mat to protect your work surface or table. Get one that is large enough to fit your comic pages comfortably.

★ **Metal ruler:** When you have to slice straight lines, you need a metal ruler, or even better, a clear, plastic ruler (so that you can see the artwork through it) that has a metal edge.

★ **Tone hera:** A tone hera is a Japanese tool used to stick the screentone firmly to the image. Place a piece of paper over the picture, then rub the tone hera on top in even sweeps. Alternatively, you can use your fingers or a ruler.

★ **Tone eraser:** To rub away tone from the sticker surface to create special effects, you need a particularly abrasive eraser. If you can't get one designed specifically for this purpose, you may be able to find a rough-surfaced ink eraser that does the trick.

★ **Paper:** Use a thick weight of paper. As you slice through the screentone you will probably dig into the paper from time to time, so your paper needs to be robust enough to handle that.

Traditional media:
Screentone

In Japan, black and white screentoned pages of dynamic manga panels are iconic. While other countries dabbled with screentone for their newspaper strips, manga artists took it to a whole new level, creating beautiful and striking images that didn't need to be in color to make an impact. Screentone removes the uncertainty about how any particular printer will interpret soft grays or color by providing the image in a pure black and white format.

Prepare lines

Rough your image out with pencils, ink over it, and erase all pencil marks if using normal lead. Thoroughly remove all eraser shavings and make sure the surface is as clean as possible; once screentone is laid on, it will pick up any dust and dirt on its sticky side. Non-photo lead is fine to leave without erasing, as that won't show in black and white printing.

1 Prepare your line art so that the inks are clear and clean, ready for sticking screentone on top.

Laying the screentone

You need to cut out a larger amount of screentone than you actually need and stick it very lightly onto your lines. Screentone backing paper is often slightly translucent, so to make it easier to gauge the shape and size of this initial cutting, lay everything on top of your drawing and make a few marks with a pencil (preferably in non-photo lead, but this is not essential as the edges will be removed eventually).

2 Use your inks to trace out an area that is larger than you need on your sheet of screentone. Then place the sheet of screentone on a cutting mat to cut it out, keeping it as one continuous cut where possible, so that you reduce the risk of tearing it at the edges when you lift it off its backing sheet.

Screentone
demo: part 1

Screentone
demo: part 2

Cut away excess

Do this carefully on a cutting mat. With your knife, slice away all the tone that you want to remove, leaving only the exact areas you want to shade. If the shape is determined by the linework (say you're adding a pattern to an entire skirt), then it is relatively easy to follow the lines. If you are laying down shade that isn't marked by outlines (like skin shadows), you may find it useful to use a color pencil or non-photo lead to mark out complicated twists and turns before cutting the screentone.

3 Lift off the large swathe of screentone and stick it very lightly onto your inks, covering all the areas you want to shade with plenty left over for error.

4 Gradually cut away the pieces you don't want. Rotate the image as you go along so that you can cut in a continuous line without lifting the blade from the paper. For the more complicated little pieces, you may find it useful to ease the back of your scalpel underneath the screentone to lift it off without cutting into the paper. Use the backing sheet you took the screentone from to stick the cut-offs to keep them away from your work space and to save any large pieces for future use.

Stick firmly to the inks

Once you're happy with the screentone and you don't want to cut away any more, put a sheet of paper on top, then burnish the surface with a tone hera or equivalent to stick it to the inks and paper, without trapping any air bubbles.

5 When you are ready to stick the screentone firmly down to your linework, always put a sheet of paper on top before pressing down firmly.

Techniques

LAYERING SCREENTONE

You can place multiple layers of screentone on top of each other, but you need to avoid moiré, where the layered dots form repeating patterns when misaligned. Either try to line them up perfectly and keep the dot density the same, or use a very different screentone pattern.

Moiré
Dots misaligned

No moiré
Dots correctly aligned

ETCHING WITH A SCALPEL

Sometimes, the areas of tone you want to remove are far too fine to be cut away, in cases where you want to denote very thin highlights, for instance. Instead, etch the screentone with a scalpel.

Stick the screentone down firmly onto the paper, then use your scalpel to carefully scratch or etch away the printed dots.

ETCHING WITH A TONE ERASER

For a soft, burnished highlight, you can etch away the screentone with an abrasive eraser.

Stick your screentone down firmly; then start working on a small area first to test its strength before increasing the pressure and size of your movements.

Special effects

Once you have laid the initial layer of screentone, there are several special effects you can add.

6 You can add a darker dot tone but, to avoid moiré, make sure they are the same dot density (distance apart) and stuck on at the same angle. Stick your initial large cut down and hold one corner with a finger, then rotate the tone very slightly until the layered effect is satisfactory.

Eyes and hair are the most common areas of character art that benefit from white highlights, but you can use them for backgrounds, too.

10 Etching looks particularly effective for thin strands of highlights on hair. Adding white: As with other mediums, you can add highlights with a drop of opaque, white ink or paint as you see fit.

7 Then, cut away the excess screentone as before, but be careful when cutting through and lifting the screentone that you don't lift the first layer underneath. Avoid this by making sure the first layer is firmly stuck down before adding additional layers.

8 You can also avoid any repeating patterns by layering a very different screentone.

9 Softer highlights can be obtained with a tone eraser if it is too harsh to cut away screentone.

Digital media:
Tools and software

Working digitally can be extremely rewarding for beginners and experienced artists alike. You can easily correct your mistakes and make alterations that would otherwise be difficult to implement with traditional media, such as changing color schemes and resizing your artwork. Smooth, polished images can be achieved fairly quickly. But, to work efficiently, you need tools that allow natural hand movements and software designed to enable you to achieve the finish you are after.

Hardware

There are so many products available for the modern-day digital artist that it can be hard to figure out what is essential and what is optional, let alone choose the best equipment in each case. While it is difficult to recommend any one model because of the rapid rate at which technology changes and develops, here are some key factors to help you make informed decisions.

Computers

Most new personal computers and laptops are perfectly capable of running the most popular image editing and painting software, so you shouldn't worry about exact technical specifications. But, if you want to be able to deal with very large and complex images without experiencing any slowdown in performance, be sure that your computer has a fast processor and large working memory. You also need a good amount of disk space to store all of your files. Bearing in mind that large image files reach around 50 megabytes in size or more, you'll need several gigabytes' worth of space.

Then you need to look at the physical output of the computer. If you need to work on the move, you need a laptop rather than a desktop computer. Are the screen size, resolution, brightness, and range of colors suitable for working with complex graphics? If you like to paint lots of dark pictures, it's no good having a screen that can't handle those shades. Does the angle of the screen greatly affect the colors? If you need to pass large files from your computer to clients or printers, make sure it has a CD/DVD rewritable drive, USB, or other removable storage slots for memory cards and cables. Internet connectivity is also a necessity, whether it is built-in or has slots for such peripherals.

Graphics tablet

Trying to draw or paint images with a conventional mouse or touchpad is not only slow and awkward, but dangerous as it can damage your wrist. A graphics tablet is a pad which is plugged into your computer, over which you can draw with a special stylus instead of a mouse. Holding a stylus feels much more natural for drawing and painting. Good graphics tablets will sense the pressure and tilt of the stylus and translate them into lines if you have specified your software to do so, with similar results to what you would get from real pens, pencils, and brushes on paper. They are not a magic wand for transforming your artwork though; it takes practice to learn to watch the screen as you draw, not your hands! Your priorities in picking the right tablet are connectivity and software integration, size, and pressure levels.

A graphics tablet needs to be able to plug into your computer easily or sync wirelessly. It should have good driver support to ensure that it will work on your computer and with your chosen software. Aesthetically, you need to figure out what size is most comfortable for you to work on, depending on what you find comfortable for your drawing style. Too small makes it difficult to draw long, sweeping lines; too large can be very expensive and you might not use the space effectively, possibly wearing out some sections faster than others. Finally, you can choose whether to splurge on models that have high-pressure sensitivity if you do a lot of inking and painting digitally. These let you produce subtle variations in line width and, with the right painting software, very realistic brushstrokes.

You can also buy graphics tablets that are integrated computer screens. Professional-quality digital drawing tablets can be very expensive, but they are the ultimate luxury as you draw with your stylus directly onto the computer screen. The screen is designed to be drawn on and is geared for the stylus

(**1**) Laptop computer
(**2**) Desktop computer
(**3**) Removeable hard
drive (**4**) Graphics tablet
(**5**) Scanner (**6**) Printer
(**7**) Digital camera

point to be perfectly calibrated to the screen with pressure, tilt, and no slowdown.

Tablet computer

Tablet computers have a touchscreen, so you would think they would be ideal for drawing on, but be wary of buying an inexpensive, conventional tablet computer primarily for creating digital art. Most are meant for everyday personal use with fingers on the touchscreen, and their technical specifications are often streamlined and unable to handle complex image editing software. The stylus strokes also have limited pressure and tilt sensitivity. If you have a large budget, then you may be able to obtain one with the required specifications that approach the standard of the mid-range graphics tablets (if they have good support for art software and working with a pen stylus). There are also the benefits of a portable, all-in-one system.

Research your purchase thoroughly as this is a technology that is rapidly improving all the time.

Scanner

The price of hardware has dropped considerably as better technology has emerged and manufacturing has improved. As such, most recent models on the market are suitable for scanning your artwork and sketches, particularly if you have software that can edit those scans for brightness, contrast, and more. When choosing a model, look for one that can scan fairly fast at high resolutions in different color modes with a platen glass that can handle your preferred paper size. The worse case scenario is having to scan your artwork in separate sections and having to piece them together, with each scan taking several minutes to process at high resolution; modern scanners are better than this!

Camera

If you draw or paint on a large scale, then scanners are not appropriate for digitizing your artwork, as it is likely it won't fit in the machine. Also, you can't really take a scanner with you to events if you want to keep a record of sketches that you may be giving away to clients. A digital camera is a great tool for capturing your drawings. Look for a model with high resolution and a good macros mode which enables you to take sharp photographs of objects closeup. It won't be as sharp as using a scanner, but with some editing, cameras are great for producing images that you can ink over or refine later. Just be careful when you are taking the photograph that you don't distort your image by taking it from a shallow angle.

▲ Many software programs allow you to download a free trial so that you can experiment with them before comitting to buy. Above: GIMP; right: Open Canvas; opposite page: Manga Studio.

Software

Once you have obtained the right tools and hardware, you need software that suits your needs. There are many computer packages and programs available for artists with all budgets. While a good artist can make good art regardless of the tools they have, good artwork is produced much more efficiently if the right software is used to achieve certain effects. Think carefully about the type of art you create and what finish you want to produce. Here are some popular software choices to consider for the manga artist, all of which have the key feature of being able to work in layers.

Adobe Photoshop

An industry stalwart for decades, Adobe Photoshop is professional image editing software that allows you to create images from scratch with powerful tools to enhance and modify your images. It is an all-purpose program, suitable for sketching, outlines, and coloring, and

output for print in different image formats. You can add and edit text, design publications, create short animated image sequences, and filter your image through many effects. But, with such capability comes a hefty price tag and a fairly complicated user interface. To draw and paint realistically, for example, you need to learn exactly what settings to change on your brushes to get the effect you want and the default settings aren't the best for getting what you want. However, Photoshop is very well known and used, so there is strong customer support in all languages and countries, and it is well supported by graphic-related hardware with numerous plug-ins available. There are plenty of other users who will be willing to share advice and resources you

can download and use, like brushes and textures. If you don't have the budget for the full-sized professional version, you can use its pared-down edition, Photoshop Elements, which still has many of the functions of the full-version, just not as many filters, options, or tools. You can still draw, paint, work in layers, and transform your images.

Adobe Illustrator

Adobe Illustrator is a vector graphics editor that allows you to create scalable images from shapes, lines, and patterns. It is best used for creating sharp images like logos, technical drawings, stylized character artwork, and general graphic design. You can define outlines, fills, and gradients with vectors—essentially, mathematical formulae that designate

the shape of each line. This makes them infinitely scalable; you can blow up a vector drawing to several stories high without any loss in quality. There are limitations to working in this style and software, however, as it is hard to define soft, painterly styles in vectors. As it is professional software, it is quite expensive.

GNU Image Manipulation Program (GIMP)

This is an open-source, free image editing program that has very similar options and capabilities as Adobe Photoshop, but the workspace and processes are quite different, with an even more complicated user interface. It has high-quality tools that can output in many image formats. It is very technical, so you need to share advice and feedback with its regular users to get the best out of it. It may be difficult to get used to, but it is free!

PaintTool SAI

This Japanese software is a popular choice for young manga artists as old

versions of it are available for free and current editions are very affordable. It is geared toward only drawing and painting, with very limited editing options, but its simplicity is part of its appeal. It is a very lightweight program, easy and fast to run even on computers with weak processing power. The default settings on the brushes and tools feel very natural and can be customized further as you get used to working with the software. Working in SAI is simple and intuitive so you can get up and running very quickly. It can also open and export Photoshop files.

Open Canvas

Like PaintTool SAI, Open Canvas is another graphics editor from Japan used to create manga illustrations, particularly bright, light, and delicate colors over fine pen or pencil-style outlines. Current versions of it are very affordable and have fairly good editing capabilities, with filters, layers, perspective rulers, and screentone patterns. The default brushes are good for beginners and more

experienced users alike. You can even share event files that allow you to save the progress of your work in steps and look at other artists' event files.

Manga Studio

This is a dedicated, powerful program for creating digital manga artwork in black and white format and full color. You can sketch, ink, and color your artwork. Where it really comes into its own is when you're creating the iconic black and white screentoned manga pages. There are page templates, various speech bubble and panel tools, even three-dimensional models to help you with drawing backgrounds and settings. Your workspace can be automatically set to produce artwork that is print-ready, letting you ink naturally with smooth, crisp lines. Screentones are integrated into the software. The most current version is quite affordable.

Digital media:
Core skills

Working digitally may seem daunting, but there are some common core skills and processes required, no matter what hardware or software you use. Many artists prefer to create parts of their artwork on paper before finishing it on the computer. Getting your artwork digitized and onto a computer isn't just for digital artists; clients and printers require digital files rather than working with originals, particularly if they are overseas. Marketing your work online is a vital part of being an artist. Finally, even if you do not intend to make major edits to your artwork, you should still learn how to make your traditional work look its best in digital form and on screen.

Preparing artwork for scanning

Before you start drawing, you should keep in mind what you intend to use it for. If you want to ink some outlines that you can then scan and color digitally, make sure that you erase all rough pencil marks thoroughly, or use non-photo/non-reproduction color pencil lead. If using the latter, try to use only one color so that filtering out the color becomes easier. You want your inks to look as distinct as possible from the white of the paper or the colored pencil marks so that it becomes easy to darken the outlines and convert the rest to a clean white.

Scanning

Store your scanner on a raised surface away from the floor so that no dust gets trapped inside. Check that the glass platen is clear of dust and smears before scanning. Place the artwork flat against the platen without any folds or edges sticking out—you want the light of the scanner to get a clean, bright image without introducing any shadows. Scan in full color and at a high resolution—around 600 dots per inch (dpi). Usually this is higher than your final output, but it is always better to scan at a resolution higher than required as your image will look more refined when you size it down.

Touching up scanned artwork

The initial scan is rarely ready to print from the outset. No matter how good the scanner is, colors tend to get washed out slightly and if you scanned at a high resolution to get as much detail into the image as possible, it is likely that the slight shadows in the texture of the paper are visible. You need image editing software (such as Photoshop), which can resize and crop the image, but can also adjust the brightness, contrast, hues, saturation, lightness, and overall levels.

◀ Initial scan before being touched up.

1 In Photoshop, you can resize your image in three ways:
- Resize your image as a whole by going to Image > Image Size and shrinking it. Avoid enlarging your image as it reduces its quality.
- Resize the canvas by going to Image > Canvas Size and cropping the edges.
- You can also crop the image by selecting a rectangular portion of it, then going to Image > Crop.

2 There are many adjustments you can make to your image in Photoshop. Go to Image > Adjustments > Hue/Saturation. Adjust the sliders if you want to shift the hue of the image, increase the saturation and intensity of the colors, or lighten the image.

4 Go to Image > Adjustments > Levels. Adjust the sliders along the bottom of the bar chart to darken or lighten parts of the image that are below or above certain values.

3 Go to Image > Adjustments > Brightness/Contrast. Adjust the sliders to control the brightness and contrast of the image.

▶ Final image, after touching up. Compare this with the initial scan on the opposite page.

Cleaning up outlines

If you are working with black, inked outlines over non-reproduction colored pencil marks, you need to manipulate the color channels of the image to filter out the pencils. Open up the Channels window and click on each of the color channels to see which are the cleanest and remove those which have strong pencil marks.

 If you have removed the colored pencil lines, or if you had used normal pencils and erased them from your inks, you can clean up your lines by making them darker and lightening the paper by adjusting the levels. But, if you want to convert your inks to pure black and white format for manga comic pages in black and white, use the Threshold function.

All channels visible

1 The raw scan of the inks over the colored pencils.

2 Look at the channels to determine which ones don't have the colored pencil marks. Delete the channels with the pencil marks, leaving only the channel that has clean ink outlines.

Red channel only *Green channel only*

Blue channel only

3 As one channel is left, it will be in a bright color, so desaturate it.

4 The inks in the image should now be in gray, which can be adjusted for contrast. Use the Threshold adjustment to set a gray value at which anything below (darker) becomes black and anything above (lighter) becomes white.

▶ The clean, ink outlines.

Understanding layers

Working digitally means that you will be working in layers. The best way to imagine the concept is that you have several panes of transparent glass layered on top of each other and you can choose to paint on each. The order in which you arrange your layers will mean that layers situated at the top will obscure anything on the layers underneath.

The blue is the background layer at the bottom, then the green square, the pink circle, and the white triangle is on top.

By pulling the green square to the top, it obscures the shapes underneath.

Working with graphics tablets

If you work digitally, you should be using a graphics tablet to ensure a natural wrist and hand position while drawing. Additionally, the built-in pressure and tilt sensitivity help you produce natural, flowing lines and brushstrokes. To get the natural widening of an ink line when you press harder with a pen, or a darker tone when you press harder with a pencil on paper, you need to link the pressure sensitivity of the pen to the brush size, opacity, or both.

Photoshop comes with a variety of brush presets and shapes for different effects.

Linking pen pressure to brush size means that as you press harder, the width of the stroke increases.

If you link pen pressure to opacity as well, then, as you press harder, the stroke gets darker.

Digital media:
Cel shading

Cel shading is the most iconic coloring style used in manga and, predominantly, anime. It is very clean, bright, and sharp. The art is usually kept quite simple due to the amount of work involved, but can be ramped up to higher levels of detail if used as a one-off image, such as for a cover or promotional work.

Origins

The word "Cel" is derived from its traditional use; transparent sheets of celluloid have the line-art drawn on the front, with the colors painted on the back, then laid over static backgrounds for animation. Cel-style shading works very well digitally as it involves working with distinct layers; nearly all image editing software has this basic capability.

Clean lines

Scan your sketch into your image editing software (see pages 164–165). Ensure that your outlines are clean and on a dedicated layer. If your software allows you to name and lock this layer (so that you don't accidentally color on it), do so!

◀ Lines layer

Applying flat colors

Insert a layer below your lines. Start flat coloring in the base colors. These are the mid-tones and predominant colors of your image. You can simply paint the flat colors in with the Brush Tool. However, this can be slow and painstaking. You can speed up the process by using the selection method or the Paint Bucket Tool. You will probably find using a combination of different methods to be the best approach. Choosing which method to use will depend on the shape and outline of the area you are working on.

Selection

When using selection techniques for flatting, the key is to make sure that areas of separate colors are completely enclosed by the outline. Choose your selection tool (either the Lasso Tool or the Magic Wand Tool, see page 181) and select your area. Zoom in to see exactly how much of the area you have selected. To make sure the color fills up to and underneath the line, select inside the area, then increase the area by 3 pixels. Click inside the shape to select it, select further areas of the same color if appropriate, and then fill by clicking Edit > Fill.

▲ Select inside the eye, then increase the area by 3 pixels.

▲ Here the eye color area is bigger than the inside line so that you can see it clearly. In the final piece of art it will sit below the linework.

TIP: FILL TO THE EDGE
Make sure the colors fill the areas—don't leave any messy uncolored fragments or edges next to the lines.

Paint Bucket Tool

For enclosed areas where the outlines create
solid lines, you can click into each area with
the Paint Bucket Tool. Its main settings can
be adjusted for sensitivity (tolerance) and
whether you want to select everything else of
a similar range in the image, rather than just
the one closed-off area. Generally, for flatting
you will use the contiguous setting (check
contiguous in the top information band), as
you will be choosing specific areas to fill in
different colors. Fill the areas with the chosen
flat colors, then de-select and use the Brush
Tool to paint any small areas that you might
have missed.

Check Contiguous

Paint Bucket will fill with
the foreground color

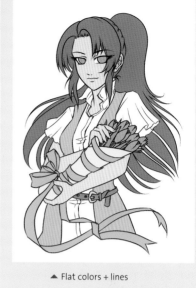

▲ Flat colors + lines

▼ Flat color layer

◀ Here the Paint Bucket Tool
has been used successfully
to color the two enclosed
shapes of the hand and arm.
But the hair line on her face
has broken lines so the fill
color has bled into the hair.

◀ There will be some areas,
such as the hair line, where
you will have to paint the
complex shapes and edges
with the Brush Tool.

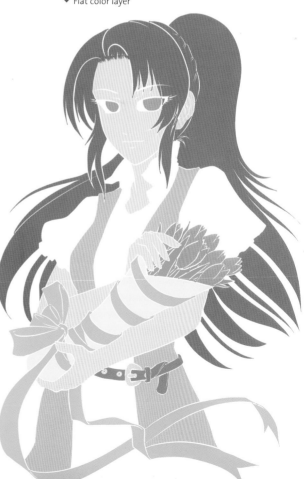

Normal — Opacity: 100%

Lock: — Fill: 100%

LINES

FLATS-BASE

Shadows

Insert another layer below your lines, but above your flat base colors. Name it shadows. Start painting in all areas of shadow in a darker shade, again making sure you don't leave any messy bits.

There are some handy things you can do to make coloring in some areas of the shadows easier than just painting them with the Brush Tool.

Painting or filling selections

You can make selections from each of the colors on the previous flat base layers using the Magic Wand Tool. Here we have selected the pale purple, then switched to the blank shadow layer and colored with a darker purple as required. You can either use the Brush Tool (the selected outlines mean that your brush marks won't go over into the wrong areas; it acts like a mask or stencil) or you can fill the area with the darker purple color using Edit > Fill > Foreground Color. Then fine-tune the now solid areas by using the layer mask technique shown opposite.

This use of selections for each flat base layer color is particularly good when shading many different surfaces on top of each other.

Create a new Shadows layer.

▲ Start to choose darker shadow colors for each of the main flat base colors.

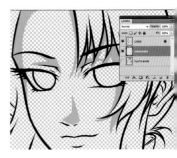

▶ Paint detailed areas of shadow with the Brush Tool or draw with the Vector Tool.

▲ Select the pale purple section from the flatting layer; then click onto the blank shadow layer and the selection will move with you.

▲ Paint with broad strokes in the darker purple shadow color—the selection edges will act as a "retaining" mask.

Duplicate and rename the flat base layer.

Color adjust duplicate layer

You can also set up a shadow layer by duplicating and renaming the flat base layer—then darken the value of the colors by switching the layer mode to multiply. Then in Image > Adjustment > Levels, move the output levels until you reach the desired shadow darkness. This darker layer will then have areas removed by using the layer mask technique to reveal parts of the pale flat layer below.

In the levels window, drag the output level black triangle to 97.

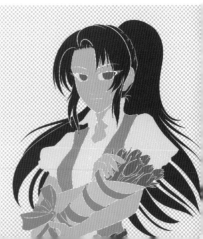

Layer mask for fine tuning

Adding a layer mask for the cel shading process is useful for tweaking the shapes and edges of the different color shadows or for painting out larger areas of the darker color adjusted layer technique mentioned opposite. Choose the layer, then click on the mask button and for fine tuning use a small size paintbrush to paint out areas. You will be working in black or white (depending on which you have highlighted in the foreground) on the mask—anything you paint in black becomes transparent, resulting in the base layer showing through. If you make a mistake, or feel you have revealed too much, toggle to the white swatch and you can paint back in the color from the layer.

This works well when shading something on the same plane or showing overall lighting.

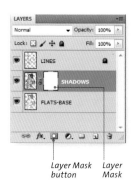

Layer Mask
button

Layer
Mask

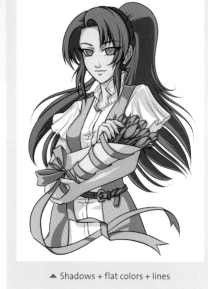

▲ Shadows + flat colors + lines

▼ Shadow color layer

► This image shows the first stage of the layer mask—the areas painted out from the hair color. The same process will be done for each of the colors.

Black-painted layer mask knocks out the dark shadow color so that on the shadow layer it will appear white or transparent, allowing the paler mid tone to show through.

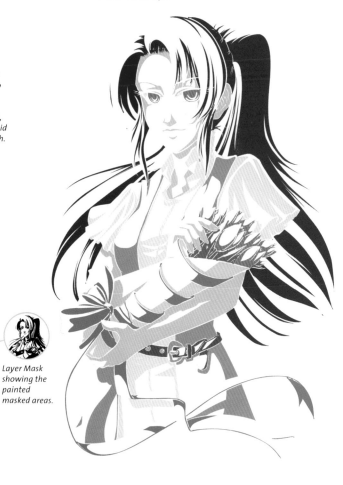

Layer Mask showing the painted masked areas.

Adding depth and highlights

First, think about whether it is absolutely necessary to add another level of shadow or highlight. Many of the best animations out there look very effective with just one level of shading. Having too many can make your image look artificial and awkward. Furthermore, different surfaces naturally have more levels of shadow and highlight than others; shiny hair should have more than matte cotton fabric, for example.

Depth layer

Add additional layers for more depth of shadows. Generally speaking, the areas most in shadow should be approximately three times darker than the base color you began with. Keep the saturation levels correct and in line with the lighting conditions—don't make them overly black, cool, or warm.

Make sure that you keep track of the order in which you arrange the layers, so that the right things are on top!

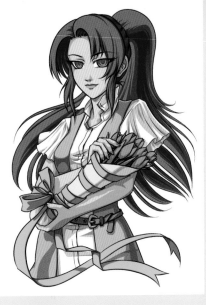

▲ Depth + shadows + flat colors + lines

▼ Depth layer

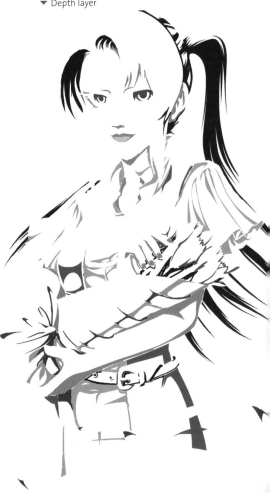

Place the deep shadows carefully, using the theory on pages 136–139.

Highlight layer

This is often when the image comes to life. Color in the areas which may give reflection or which may glow in the light. The shapes of the highlights depend on the texture of the surface—rounded blobs are fine for smooth surfaces such as chrome, or even the main highlight in the eyes. Zigzag textures are effective for hair, to give the impression of strands. You may find using the Pen Tool useful so you have full control over the long, thin curves when defining smooth shapes. You can also use more than one level of highlight if appropriate, as seen on the hair.

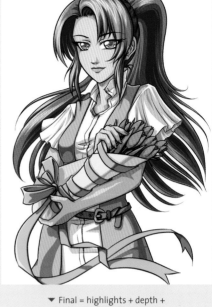

▼ Final = highlights + depth + shadows + flat colors + lines

 Be restrained when using white for hair highlights; keep it to only what is necessary.

▼ On darker hair, as seen here, white highlights look better when tempered with an intermediate shade.

▼ Highlight layer

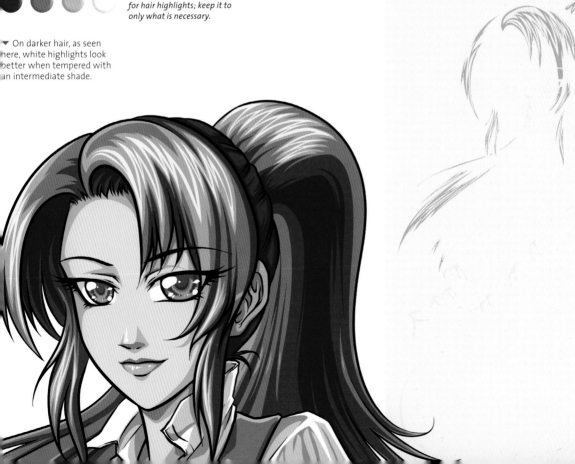

Digital media:
Painting

The main advantage of using computer software to paint is the ability to correct mistakes easily and separate parts of the image to work on individually using layers, which can save a lot of time. What you mustn't lose sight of is the overall feel of what you are painting, so try to show some blending and brushstrokes in the final image rather than making it look too perfect.

Shading techniques

You can paint with colors straight away, but a technique often used by manga artists, particularly if they work in the videogame or animation industry where modifications are requested at late stages and color schemes can change, is the grisaille method of shading. This is where you do most of your shading in grayscale (or sepia, or other shades—whichever suits your image), then you tint your shading by laying the colors on top near the end. The immediate benefit to working in this way is that it focuses your attention on just the shading, making it easier to get the overall levels, contrast, and lighting correct.

Work back to front

Whether you are using the grisaille method or painting straight onto the canvas with colors, you need to establish an effective order of work. Always paint from the back to the front—so anything which is underneath or behind objects should be done first. This is because when you are painting with opaque brushes, you can always paint cleanly on top of background images, whereas painting a foreground object first makes it more difficult to paint backgrounds neatly. As you get close to the edges of the foreground object, you are forced to work around it.

Order of work

1 Roughly sketch out your image, then lay down the background colors in broad brushstrokes.

2 Using a limited color palette, paint in rough tonal areas of light and shadow to build up volume and depth.

3 Add more and more contrast and detail to add definition and texture.

Rough sketch

You can sketch on paper and then scan it in, or you can sketch digitally on painting software such as PaintTool SAI. Make sure to include enough detail so that you can use the lines effectively as guides for painting. If you want very clean lines in the final image, then you can ink over these guides, or scan in your outlines; but this is optional, depending on the style you want. Many paintings don't have obvious outlines and are painted in a lineless style, or the lines are colored over to match the shading underneath.

1 Draw your rough sketch with enough detail to interpret the lines as you paint, and keep them on one layer.

Background wash

Make sure your lines are on the top layer and make them transparent and faint. Create a new layer underneath and paint on a rough wash with an opaque brush. Paint on any rough gradients or general points of lighting in the background and change the hue and saturation of the colors as you go along. Ensure that the brush is set to have a good level of blending so that each brushstroke mixes with the colors already laid down. A colored background with some variation and brush texture can make a lot of difference to the overall tones of the character art, especially when you're painting; it helps you gauge and mix the colors and lighting correctly.

Your rough sketch is the top layer; set to Multiply so that you can see the background underneath.

▲ Rough sketch + background wash + grisaille shading

Grisaille shading

Build up the grisaille shading in shades appropriate to your image. Paint directly onto the background layer so that the colors blend naturally. Start off with large brushstrokes in a mid-to-light shade of blue-purple to rough out the areas that are lit up, and use dark blues on the shadow areas.

Palette of colors used for grisaille shading

3 Lay a few rough brushstrokes down to catch the main highlights and shadows of the characters.

The colors used for this picture are mid-shade violets and dark indigos.

2 Set your rough sketch or line layer to Multiply and lower its opacity so that you can clearly see the paints you put on the layer underneath. Ensure your brush has some amount of Blending and Dilution, and a Persistence and Density Level that is less than 100 so that the colors blend into each other naturally, like acrylics or oils. The palette is made of indigos, blues, and purples, so paint darker tones around the edges of the picture and throw in swathes of pinks and blues farther up.

Add detail

Keep adding more detail and contrast with smaller brush sizes until you are happy with the outcome. Remember to work from front to back: A good order of work when painting characters would be skin, clothes, and then hair, although you need to swap back and forth to match when something is nearer the front or back.

4 Start by shading the face and neck, then add shading for the clothes. As the character's arms are held in front of her blouse, here, shade those last.

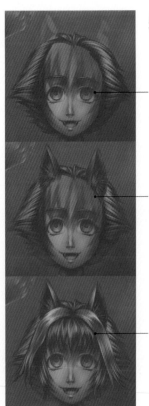

5 The hair and ears are done in three parts.

The hair on the back of the head is painted first as that is farthest back. Start with dark colors; then paint on lighter strands of hair.

Then the ears, as they are further forward. Always start with dark shades before defining volume with light.

Then the fringe and layered sections at the front. As this character has lighter colored sections of hair, use a slightly paler palette for them, to set them apart from the rest of the hair.

6 The full grisaille image with completed shading and higher contrast.

▲ Background wash + grisaille shading + color tint

Tinting your shading

Add a new layer and, using an opaque brush with high density, paint on colors that suit your characters in mid-tones, as you would for flatting cel-art. Most painting and image editing software will have a layer setting which is appropriate for tinting the shading underneath or above. If working in PaintTool SAI, position the layer above the shading and set it to Overlay. You can always recolor or add even more subtle shading by painting on the tint layer to change the final outcome.

7 Start by painting on opaque, flat colors and add extra airbrushed shadows and colors if required. Make sure you set your layer to Overlay and position it above the shading layer. Use large brushes to lay down main swathes of color, then reduce brush size for fine details.

8 Colors look dull and boring if they are too straightforward or lacking in contrast, so add extra dark tones in blues and pinks to shadows, folds, and sections of the characters to make them more three-dimensional. Use warm colors in the highlighted areas.

Palette of colors used for tint layer

▼ Color tint layer

Further shading to the face on the tinting layer.

A light blue gradient added to the background for a magical glow.

Highlights

Add a new Normal layer to your work and use it to paint on any highlights as you need, using whichever tool gives the desired effect, be it a pen for sharp lines, brush for painted stroke, or airbrush for soft, burnished areas. Generally, it's easier to do all of this on a new top layer, since you have a clearer picture of the final look of the image, so you can use the Pipette Tool to catch colors for colorful highlights. It also preserves all the work you have done underneath.

▲ Draw a reindeer with a sharp pen in white.

9 The magic spell is an enchanted reindeer dancing in the air. Draw this with a sharp pen tool on a new layer. Add extra lines and sparkles, and then replicate that layer and blur it slightly to give it a soft glow.

▲ Then copy the layer and blur it for a glow and add to the sharp layer.

▲ Use another layer on top to add sharp, white highlights to the eyes.

Importing

Don't be afraid to import your image into other software if it is better suited to any particular action. Often what is good for painting isn't good for editing. PaintTool SAI is very streamlined and intuitive to work in, but its editing capabilities and filters are limited, so many artists finish their work by bringing it into Photoshop in order to adjust the colors and add additional effects.

10 A snowflake pattern is added to the background by copying from a patterned file and pasting on top of the background. It is then made slightly transparent for the blue background to show through.

Digital media:
Screentone

The benefits of adding screentone digitally are that you never have to replenish actual sheets of tone (and you won't ever slice your fingers by accident)! You can also achieve much more detail and correcting mistakes is easy.

Prepare lines

You need some clean, inked outlines to work over, preferably in pure black and white with no gray pixels or anti-aliasing at a resolution of 600 dpi and higher (see page 166 for details and instructions). The whole point of using screentone is to send pages that are in pure black and white to the printer so that the printer doesn't need to put any gray pixels through its own black and white filter, which can lead to unexpected results. Getting rid of anti-aliasing at any stage is helpful.

Paste

Digital screentone can be obtained in different ways. You can buy sets of digital patterns in CD/DVD packs or download digital patterns by browsing the Internet. There are many free resources available online. You can also buy sheets of actual screentone, then scan them in, or you can even try creating patterns yourself. However you go about it, convert any grays to pure black and white, like you would with cleaning up lines. Paste your chosen screentone in a layer above your lines and make all whites transparent by adjusting the layer settings.

◄ Using digital screentone means you can quickly and easily apply many different patterns and add a variety of effects.

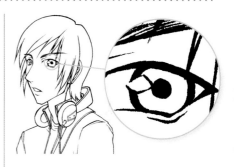

1 Start with clean, crisp lines. The closeup shows that there are no soft, gray pixels, or anti-aliasing at the edges of lines. The image looks harsh zoomed in like this, but at resolutions of 600 dpi and over, it will print perfectly and will look clear and sharp.

Set your lineart as your bottom background layer.

2 Use software that allows you to work in layers, such as Adobe Photoshop. Set your lines as your background or bottom layer.

3 Open up the screentone file, select the entire image, and copy.

4 Then paste the screentone as a new layer above your lines layer.

5 To make the whites transparent so that you can see the lines underneath, change the Layer Setting to Multiply.

Screentone removed using Lasso Tool

Screentone removed using Eraser Tool

Remove excess

Just like traditional screentone, you have pasted some on top of your lines, so now all you have to do is remove the pieces you don't want. There are multiple tools and ways to do this digitally, some of which are very useful for complicated shading.

6 Remove the excess/unwanted screentone using one of the techniques to the right.

Don't lose sight of the overall shading of the image. Shadows form toward the bottom right and things like the arm cast shadows onto the rest of the body.

Removal tools

LASSO TOOL

Using the Lasso Tool, select areas you want to remove; then cut them away. Uncheck the Anti-alias Box in the above Options toolbar so that the cuts don't have soft, feathered edges.

ERASER TOOL

You can simply erase the bits you don't want. Be careful not to introduce any soft grays; you want to erase very cleanly. Use a sharp, dense style and set the Eraser to Pencil mode.

MAGIC WAND

 This tool selects whole areas of the same color or shade. For screentoning, it's useful to select sections that you have closed off with lines. In the Options toolbar above, uncheck Anti-alias and check Contiguous to select individual white sections. Uncheck Sample All Layers if you're using the line layer for selecting the areas.

MASKING

Add a Layer Mask to the screentone layer and, using a Pencil or Brush that is sharp and dense with the mode set to Dissolve, paint black on the mask in the areas you want to remove.

The layer mask hides the parts you paint in black. The screentone is effectively removed from the image in the areas you choose to paint in.

Pattern brush

When working digitally, you're not restricted to pasting and cutting away screentone. You can paint screentone on with a brush.

Rectangular Marquee Tool

Pattern Stamp Tool

7 Open your screentone file, select the area of screentone desired using the Rectangular Marquee Tool, go to the top navigation drop-down menu Edit, select Define Pattern, then name and save it. In the main tool menu, select the Pattern Stamp Tool.

8 Choose the pattern that you have just set in the Options toolbar along the top and select Aligned so that the pattern remains aligned no matter how many brushstrokes you make. Uncheck Impressionist as that renders in a paint dab effect. Adjust the brush style to something sharp and dense with mode set to Dissolve.

9 Paint your pattern on a new layer set to Multiply.

Special effects

You can create special effects just as you would with traditional screentone, but it does require more planning and forethought to set up your tools correctly so that you don't accidentally introduce any soft grays and anti-aliasing.

10 The inked outlines with screentone laid on top as shading.

Special effects

LAYERING SCREENTONE

Layering screentone digitally means you have total control over the placement of each layer of tone, reducing the chance of moiré.

Paste another layer of screentone on top of all of the layers you have made so far and change the Layer Setting to Multiply. Zoom in and shift the layer to your preferred amount of dot overlap.

ADDING WHITE

Add white highlights on a new Normal layer.

Draw basic highlights with the various tools or convert screentone to white dots and patterns on a transparent background and paste them over your art.

ANGLED ETCHING

With traditional screentone, if you want to etch long, straight lines, you use a ruler to guide your knife. When doing this digitally, you create a custom brush at the angle you require.

Make a custom brush in the shape you choose.

1 Make a new file and draw a long, thin, tapered line at your chosen angle using the Pen Tool or Polygonal Lasso Tool. Then go to the top navigation drop-down menu Edit and select Define Brush Preset; name and save it.

ETCHING WITH TONE ERASER

For those soft, burnished highlights, you need to work with a Layer Mask.

Pick a brush with an airbrush style that is soft, but set the brush mode to Dissolve so that no grays are introduced, and black pixels change to pure white or vice versa in a random noise pattern. Softly paint black onto the Layer Mask to create highlights.

ETCHING WITH A KNIFE

To create a similar effect to etching thin lines away with a knife, you should use a Layer Mask.

Choose a Pencil with pen pressure linked to size and draw thin lines onto the Layer Mask, or use the Lasso Tool to select sharp, freehand scribbles before painting over the selection.

Select your custom brush from the drop-down menu.

2 Select the Brush tool and in the Options toolbar along the top, go to the Brush Preset drop-down and select the brush you have just saved. Set the mode to Dissolve. Etch away on the Layer Mask. Long, angled etches are good for lighting effects.

Digital media:
Alternative styles

While certain styles of artwork are more prevalent in manga, you shouldn't feel as if you have to finish off an image in any particular medium or shading style. Manga has much more to do with the slick and stylish character artwork as well as the manga storytelling techniques and layouts used in comic pages. Here are just a few alternative styles of digital coloring and shading you may want to consider to broaden your repertoire.

▲ Allude to the original, clean, black and white monochromatic feel of manga art by making images using only inked lines and fills.

▲ This chibi character is kept simple with black outlines and color fills. Gradients and blends are used, with a flower pattern on the kimono. The tattoo-like wings have a white outline to make them stand out from the background.

▲ The character is outlined thickly with muted colors and has flat fills of color within, but a marbled texture is laid over the flat fills to add interest.

Strong line art

Most manga illustrations are drawn with very fine, slender lines, but some images can look striking if drawn with much thicker lines. When drawing with thicker lines, it is particularly important to include a lot of line width variation to add a sense of depth and movement. Thicker lines can be further enhanced if you tint or color them as well.

Vector style graphics

You can create manga graphics in vector-based software such as Adobe Illustrator, or in a similar style. Strong and bold logo-like images are popular as one-off illustrations or mascots. Vector artwork should be kept relatively simple with strong outlines and flat or gradient fills of color. Complex shading tends to get lost among bold line art.

Textured fills

Another way to add interest to strong line art with flat fills of color is to add texture to the fills. Try layering textures over lines, fills, or both to add depth to your images. Try out different layer settings and opacities to achieve different effects; add some color to your textures to really make the results pop.

▲ This image has some very strong foreshortening as the students conduct their interview and thrust the microphone toward the viewer, so flat shading would look out of place. By adding some simple airbrush shading, a sense of depth is achieved while maintaining a streamlined look.

▲ Use a brush style that is highly textured to give your digital work a rougher, more visceral feel. This emulates traditional media, so it looks great with rougher outlines.

Colored screentone

Give your artwork a pop-art feel like Lichtenstein or color newspaper comic strips by inking and shading as you would for black and white manga pages, but in color. Use screentone shading techniques; then add color to the outlines and the patterns.

▼ You can add color to a screentoned image for a crisp, pop-art feel.

Airbrush

If you want to subtly shade your artwork while keeping the clean feel of flat fills and gradients, using a large airbrush to add shadows and highlights can be the way to go. The effect is very soft up close, but when you take a step back and look at the image as a whole, you can achieve a good impression of depth.

Textured shading

Moving away from the simpler look and into stronger and more complex shading, most digital manga illustrations use relatively smooth textures in their fills and shadows. Turn this around by using a strongly textured brush for all the shadows. This looks out of place with clean or precise linework, but is very effective when paired with rough, textured outlines like those made with a dry brush.

5

Character Library

Look over the shoulders of professional manga artists as they create a range of classic manga characters. Read about their methods, the inspiration behind their style, and the techniques they use to create engaging art. Although most of the techniques explained in this book are based on traditional media, many professional artists work digitally.

Contemporary:
Jake—skater

Jake is a laid-back teenager with a relaxed attitude toward life and exams. School weighs him down only as much as his trusty backpack and, even then, it's not so bad because he rides his skateboard everywhere.

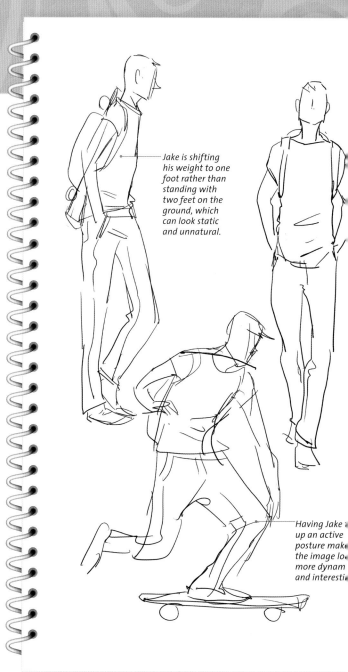

Jake is shifting his weight to one foot rather than standing with two feet on the ground, which can look static and unnatural.

Having Jake up an active posture make the image lo more dynam and interesti

Color palette

A masculine palette of greens, blues, and browns was chosen, accented with light and bright hues so as not to appear dull.

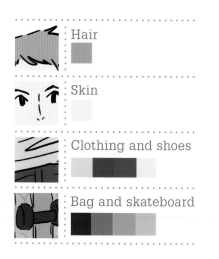

Hair

Skin

Clothing and shoes

Bag and skateboard

Sketches

Quick observational drawings helped spark ideas and capture natural poses. Note the most dynamic poses come when the figure's weight is not evenly distributed.

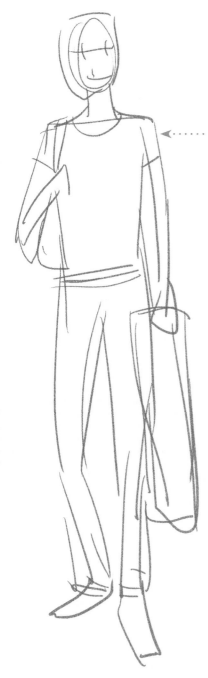

See pages 12–13 to position the features correctly.

Step 1

Chosen sketch

From her rough sketches, Ho chose a pose that showed off Jake's easy-going nature. His posture leans naturally to one side, but is counterbalanced by his skateboard on the other. He grasps the strap of his backpack with his free hand.

Jake's skeleton and joints are highlighted clearly.

Step 2

Rough skeletal outline

The artist used her rough sketch to draw a skeletal outline—this enabled her to check that the proportions were correct and that the pose was balanced. She worked on the head, shoulders, ribcage, hips, hands, feet, and joints—then joined these up. The figure wasn't drawn straight on, so the rules of foreshortening (see pages 60–61) were applied.

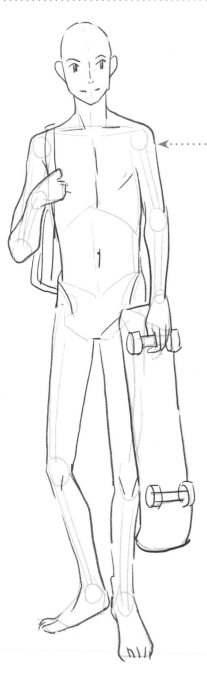

Step 3

Outline figure

The skeletal drawing was used as a guide to draw the shape of the figure. Ho used the structure of the bones and joints to fill in the musculature: where there was little muscle, the outline was drawn close to the bone structure (for example, wrists and ankles) and where there was a lot of muscle, the outline was drawn farther away (for example, thighs and calves).

Step 4

Clothing

The clothing and hair were added. Clothing is always bigger than the body part it covers, so the outline of the clothing was drawn outside the line of the body. Then Ho drew in folds and creases, especially at the joints.

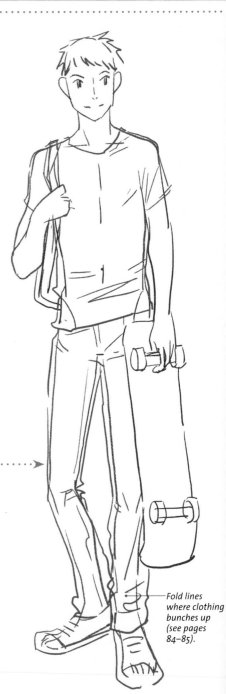

Fold lines where clothing bunches up (see pages 84–85).

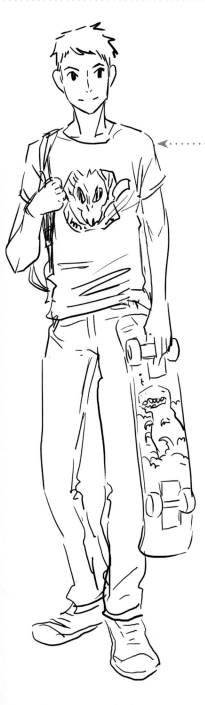

Step 5

Linework and details

Using her previous sketch as a guide, the artist drew neat digital linework. On a computer, she dimmed the layer the sketch was on, created a new layer, and used a stylus and tablet to draw the final linework on the new layer. Then she added design details, such as the T-shirt motif and skateboard artwork. Anything too contemporary will age quickly, so she aimed for a less eye-catching, but more timeless, design.

Step 6

Adding color

To choose the color palette, Ho thought about what colors a teenager would choose for himself. She decided the skateboard could be considerably brighter than his clothes. The artist felt that the sketchy, urban line art style would be shown off best with flat colors (see pages 168–173). She created a new color layer and dropped in her chosen palette on this layer, below the line work layer, making sure there weren't any gaps in the fills and adjusting the contrasts, tints, and shades until it felt harmonious.

Contemporary:
Lili—sorority girl

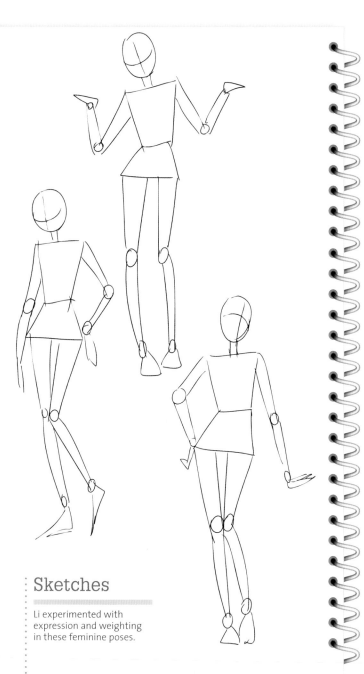

Lili is a second-year college student. She is a cheerful girl and likes spending time with her roommates, whether they're out shopping together or going to the library. Lili normally dresses down, but today she's going to a house party with her friends so she's put on a classy dress and heels.

Sketches

Li experimented with expression and weighting in these feminine poses.

Color palette

Contrast and coordination are key here: her gray dress contrasts with the pink tights and green belt, while the tights coordinate with her hair, and the dress with the shoes.

Hair

Skin

Clothing and shoes

Artist: Yishan Li

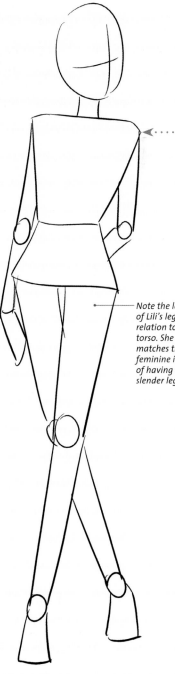

Step 1

Basic shapes

Li drew a rough sketch of a balanced and feminine pose. Lili is slender and has long legs, so the head to body ratio is about 1 to 7, and the legs are about twice the length of the upper body.

Note the length of Lili's legs in relation to her torso. She matches the feminine ideal of having long, slender legs.

Step 2

Rough image

A rough image was needed before moving on to the inking stage. The body was fleshed out and the hair, facial features, and clothing were sketched in. Different outfit combinations were tried until a style that suited the character was found—a cocktail dress with a peplum skirt is fashionable and flirty, which is perfect for a party.

Step 3

Inking

Soft, long lines were used to match the feminine subject matter. The artist drew the linework neatly to keep the figure clean and simple. Only a few additional lines were added to her dress and hair to give volume.

Extra lines added for three-dimensionality.

Two layers of shading used to define the light source and the areas of shadow.

Step 4

Shading

Li used two layers of shading. The large areas of light gray shading were used to define the direction of the light source (top right), while a second layer of darker shading on top of the first defines areas of shadow, such as the underside of the hair and the right side of the body.

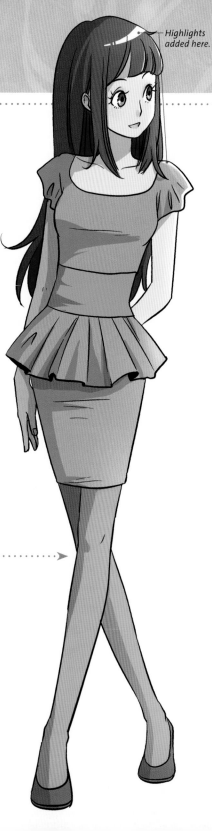

Highlights added here.

Step 5

Color and finish

With all the shading in place, the artist worked on the color palette. First, she decided on the skin and hair color, then that of the clothing. She used fashion magazines as reference material and experimented with a few combinations before settling on the final color palette.

The color of the tights is echoed in the shade of Lili's hair.

Step 6

Highlights

Highlights were added to areas that directly face the light source, such as the edge of the sleeve and side of the face, as well as surfaces that are particularly shiny, like the hair and eyes.

Historical:
Keisuke—samurai

Keisuke is a young, ambitious swordsman. From an early age, he has strived to be the best fighter in his village after inheriting his father's sword. Now he is finally striking out on his own, seeking fame, fortune, and strong opponents!

Color palette

Natural, healthy tones were chosen for the skin, and bold colors for the clothing and weapon. This creates a strikingly colorful figure.

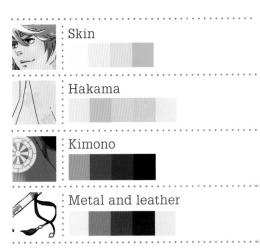

Skin

Hakama

Kimono

Metal and leather

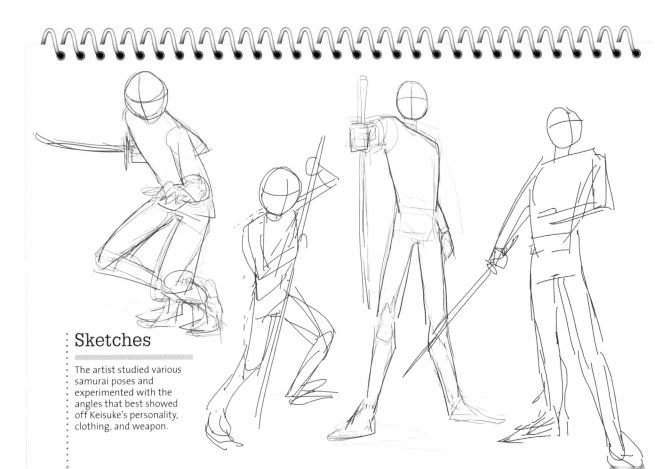

Sketches

The artist studied various samurai poses and experimented with the angles that best showed off Keisuke's personality, clothing, and weapon.

"Scribbly," gestural marks give volume and movement.

Step 1

Basic shapes

To decide on the pose, Ai Takita-Lucas tried to put herself in her character's shoes and imagine what his personality traits were. Keisuke is confident—so is drawn standing tall and proud, with his chest puffed out; alert—his head is turned toward something; and ready for action—his hand rests on his sword.

Step 2

Rough sketch

The artist added clothing to the basic shapes. Keisuke is drawn wearing a kimono wrapped tightly around the front and secured in place with a belt. The lower part is tucked into a pair of traditional Japanese culottes that are called "hakama."

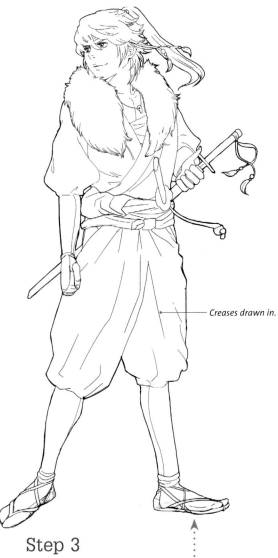

Creases drawn in.

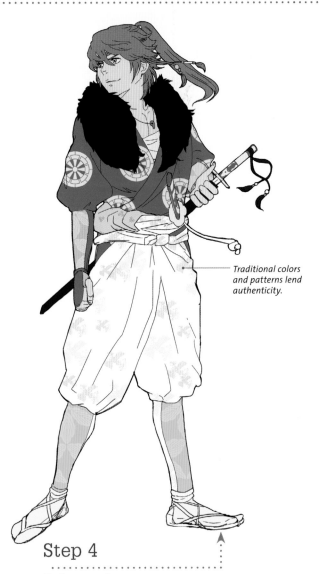

Traditional colors and patterns lend authenticity.

Step 3

Linework

Ai Takita-Lucas cleaned up the rough lines and started adding detail to the face, hair, and clothing. She added crease lines to the clothing to make the drawing come to life—soft lines were used to express the delicate texture of the kimono and to show movement in the hakama.

Step 4

Color work

The artist wanted the clothing to look authentic, so researched traditional colors and patterns. A wheel design in bright colors was chosen for the kimono and a dragon motif in pastel colors was chosen for the hakama; the bright yellow tights tie the upper and lower halves of the body together.

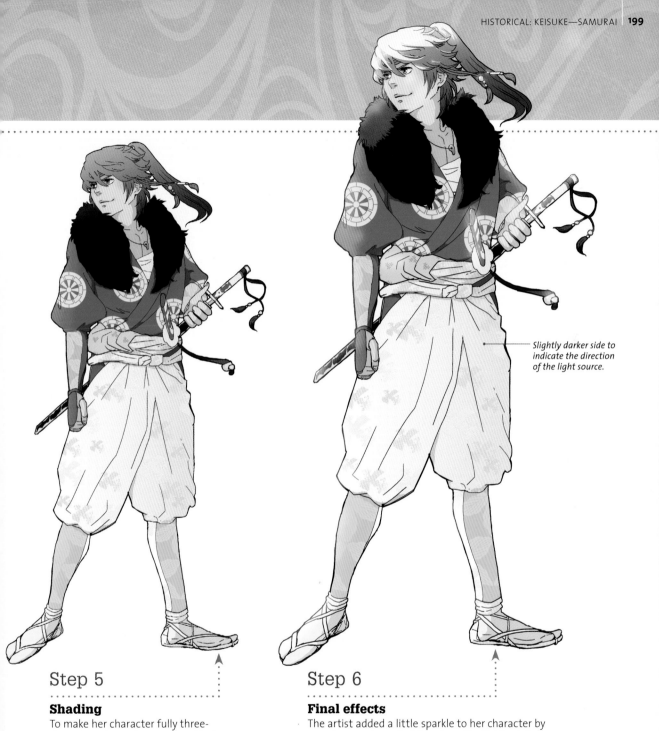

Slightly darker side to indicate the direction of the light source.

Step 5

Shading

To make her character fully three-dimensional, Ai Takita-Lucas added shading. The light source comes from the left-hand side of the body, so his right side is slightly darker than his left.

Step 6

Final effects

The artist added a little sparkle to her character by painting touches of white where the light catches on shiny or prominent features, such as the hair, eyes, jewels, and sword. To add more depth, the artist added a soft gradient on top of parts of the image, starting with light colors in the top left, softly fading to darker shadows in the bottom right.

Fantasy:
Shi—fox spirit

Shi is a fox spirit from the Heian Period. He has spent the last few centuries asleep in an isolated shrine, but has recently woken up. He is usually cheerful, curious, and playful, but his past is steeped in mystery.

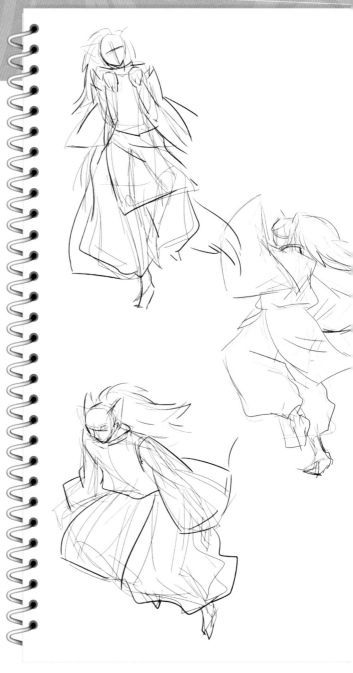

Color palette

Kutsuwada used organic tones for Shi's hair and skin to make him look fresh and alive. She researched traditional clothing and built her color scheme based on her findings to give her character authenticity.

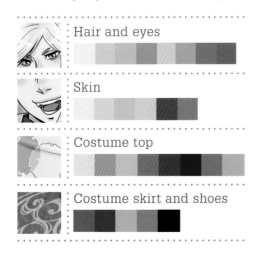

Hair and eyes

Skin

Costume top

Costume skirt and shoes

Sketches

The artist wanted to express this character's foxy nature without making him look too feminine. His costume has distinctive features such as loose, billowing sleeves and a flowing gown, so a pose that enhanced these elements was required.

Artist: Chie Kutsuwada

The hand is obscured by the sleeve that hangs from it.

Step 1

Basic shapes

Once she was happy with the composition, Kutsuwada outlined the basic shape of the unclothed body, making sure the figure was properly proportioned and balanced. She checked the limb lengths were correct and there were smooth action lines through the spine and between the legs.

Step 2

Detailed rough sketch

Using references, the artist started clothing her character. She made sure she drew the clothes over the body and included drapes and folds (see pages 82–85). She added details, such as the hair and facial features. Then she tried to make any rough lines as neat as possible before inking.

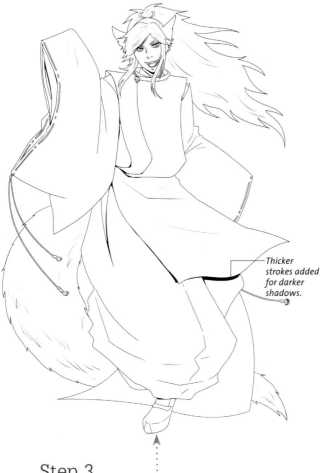

Thicker strokes added for darker shadows.

Step 3

Linework

When inking, Kutsuwada used different line weights: medium and accented ones for the outlines; thin, delicate ones for the detail; and thick, dark ones for the shadows. She used loose strokes for the hair and light clothing, but hard lines for stiffer material.

Step 4

Color work

To start coloring digitally, the artist created a new layer (see page 167) below the line art for the skin color. She added a slight blush on the cheeks and nose to make the character look vibrant. Then, she created different layers for each color section (pink clothing, blue clothing, and hair and tail) and added the colors for each. She used ready-made patterns for the clothing.

Step 5

Shading

Kutsuwada added general shading to all parts of the picture, taking care to use colorful, tinted shadows to tie the look together. For some of the shadows, the brush was set to Burn for a deeper effect.

Step 6

Highlights

The artist added soft and hard highlights to coordinate with the shading. She softened the color and the line art in the brightest areas. She used the Color Dodge setting on her brush with style set to Airbrush in order to create spots of brilliant shine.

Digital painting programs let you add sparkle using the Dodge Tool.

Fantasy:
Daichi—guardian

Entrusted with the duties of a guardian, Daichi helps to maintain the balance of the natural order. However, he is a mischievous spirit and something of a wise guy.

Color palette

Daichi's color palette consists mainly of natural colors, predominantly blues, greens, and a contrasting rose taupe. The colors are either a muted variant of their bright spectral color or a pastel tone.

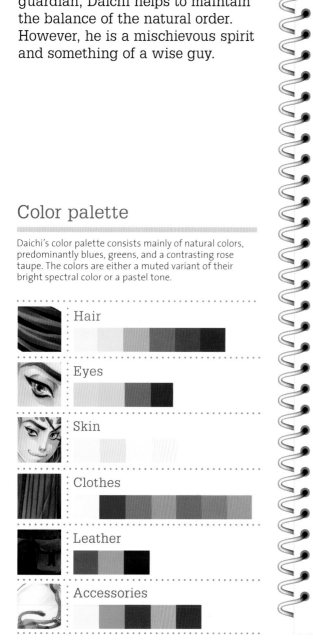

Hair

Eyes

Skin

Clothes

Leather

Accessories

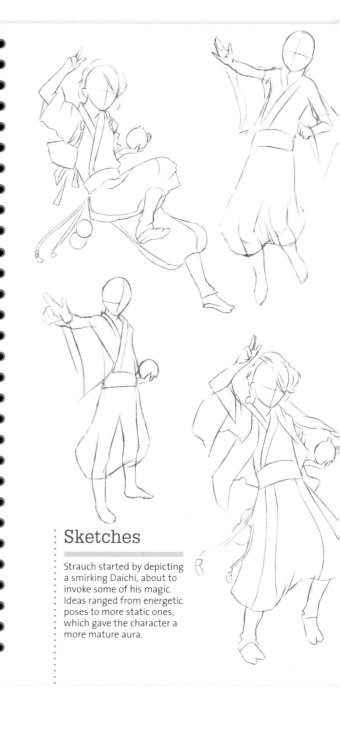

Sketches

Strauch started by depicting a smirking Daichi, about to invoke some of his magic. Ideas ranged from energetic poses to more static ones, which gave the character a more mature aura.

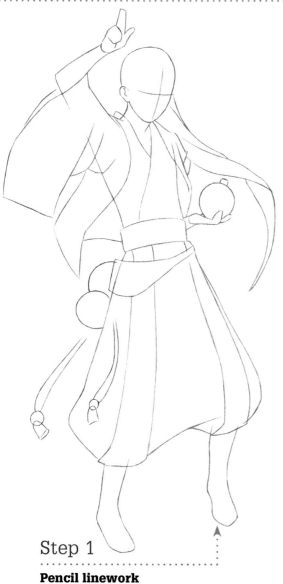

Outlines drawn in color instead of black to soften the final image.

Step 1

Pencil linework

Strauch used a pencil with a soft lead for the character sketch to avoid damaging the paper when applying pressure. She built up and defined the rough shapes, then started to add details.

Step 2

Colored linework

To gain a softer final look, the artist inked the outlines with colored fine-liners instead of black ones. She used marker-proof pens to avoid any smudging. Once the ink was dry, she erased all the pencil lines carefully.

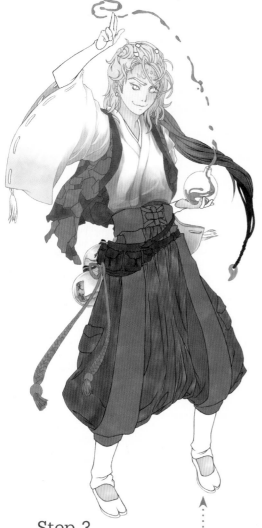

Colored shadow used.

Step 3

Light colors

Strauch used markers to color the linework. She started with the lightest color in the image, concentrating on a single area at a time, and building up depth with more color layers.

Step 4

Mid-tones

The artist worked from light to dark—within each area as well as within the overall picture. Once she had finished the light colors, she added the mid-tones. She used colored shadows for more impact.

Colored pencils used to define patterned clothing.

Step 5

Shadows

To create the volume of the fabric, Strauch defined the deep shadows in dark tones—she used feathering strokes of the brush nib and followed the shape of the folds of fabric.

Step 6

Details and highlights

The artist used colored pencils to add small details, such as the patterns on the textiles, and to brighten up the shadows with color. Finally, she added highlights with opaque white to the eyes and the bright green liquid.

Fantasy:
Maral—archer

Despite her youthful looks, Maral is 103 years old—a mere teenager within her race. A forest elf, she wears practical clothing for comfort and movement. She is naturally curious and loves to explore her surroundings.

Color palette

A warm overall color palette was chosen for Maral to mirror her character and complement her red hair and light complexion. Earthy tones were used for her clothing; the muted colors tie in nicely with the steampunk elements, giving them an aged look.

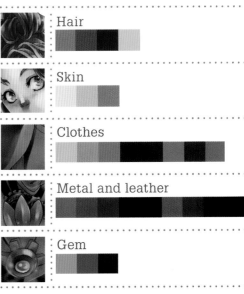

Hair

Skin

Clothes

Metal and leather

Gem

Sketches

Strauch experimented with poses that reflected something of her character's quirky nature. She started with rigid, static poses, but eventually chose a pose that implies the beginning of a movement.

Artist: Aileen Strauch

*Line thickness
varies throughout.*

Step 1

Basic shapes

Strauch started by focusing on the
character's body posture, keeping the
anatomy of the nude figure in mind.
Maral is leaning forward, turned slightly
toward the viewer, so her face and raised
arm seem quite large; the artist has
placed Maral's legs slightly forward of
her hips to keep her weight balanced.

Step 2

Inking linework

The artist inked the linework digitally by
scanning the sketch into her computer,
creating a new layer, and inking the
linework on the new layer. She used a
hard-edged brush set to between 1 and 2
pixels. Strauch varied the line thickness
throughout and added line weight for the
hair and clothes.

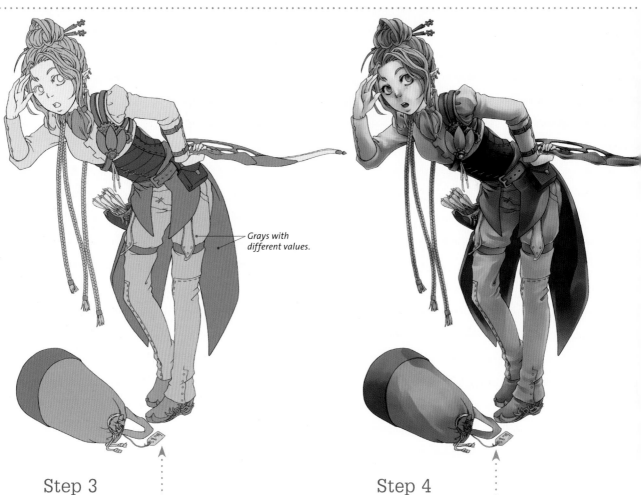

Grays with different values.

Step 3

Value

Instead of adding color straight away, Strauch worked with grays first. By thinking of the grays as values (see pages 132–135), she was able to focus on the shading rather than struggling with color choices.

Step 4

Adding volume

The artist added another layer on which to lay down the overall shadow. She set this layer to Multiply so that its values, when combined with the flat grays below, created darker, more contrasting shadows. She continued to add more layers of shadow and blended the edges with a soft brush.

Step 5

Adding color

Once she was satisfied with them, Strauch merged all the shading and shadow layers together, leaving the lines as a separate layer on top. She then added layers of color on top as a tint (see page 174–176). She added additional shadows with more Multiply layers.

Step 6

Touch-ups

The artist added sharp highlights to the metal and softer ones to the hair, eyes, and lips. To soften the hard, black linework, she preserved the transparency on the lines layer and colored them to match the browns of the clothes underneath. Finally, she adjusted the overall Hue, Saturation and Color Balances to touch up the final colors.

Science fiction:
Despoina—battle angel

Despoina is a formidable bionic space warrior. Cybernetically enhanced for strength, speed, and mobility, she wields a mighty sword as if it weighs nothing. Powerful and refined, she is majestic when she appears on the battlefield.

Color palette

The color palette is dark and cold. This helps give the feeling of metal without being too dull and desaturated. At the same time, a shift to warmer purples makes the image glow futuristically. The combination of purples and blues gives the impression of deep space, with pinpricks of light from distant stars. The yellow lines help pick out the detail.

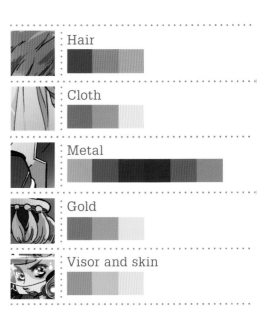

Hair

Cloth

Metal

Gold

Visor and skin

Sketches

Aggs felt any shape could be justifed by futuristic technology, so was unconstrained as he played around with design ideas.

Step 1

Rough layout

Aggs began by drawing basic shapes and interlocking objects. He traced the shapes and moved them around until he arrived at a pleasing arrangement. Design, not anatomy, was the emphasis.

Step 2

Line art

The artist worked from the rough layout to pick out the contours of objects and to form the figure, then began to add detail. He ensured the interlocking shapes from the previous step were not obscured, as they help the viewer interpret the image.

Heavier lines used for outstretched hand and nearest leg.

Step 3

Inking

Aggs inked the drawing. Far from just tracing, this is where he emphasized or diminished elements for clarity. He used a heavier line to show darker areas and to outline objects to show depth—for example, the figure's outstretched hand or closest leg.

Step 4

Silhouette

To color the image, Aggs first created a silhouette. He checked that the silhouette was readable and dynamic. A strong silhouette is very important when the image has a background or heavy detail.

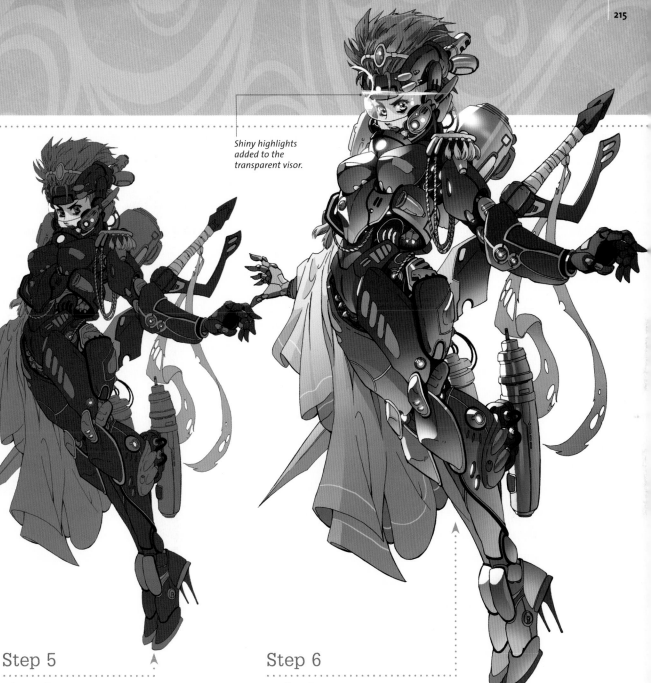

Shiny highlights added to the transparent visor.

Step 5

Flat color

The artist broke up the shapes of his drawing into areas of flat color. He used a color palette of similar colors with small highlights of opposing colors for balance and vibrancy.

Step 6

Full color

Once the design was established, Aggs added effects and rendering, keeping in mind the light source to give the illusion of three-dimensionals. As with line width, he used brighter, higher contrast between light and shadow to bring foreground objects forward, toward the top left of the image.

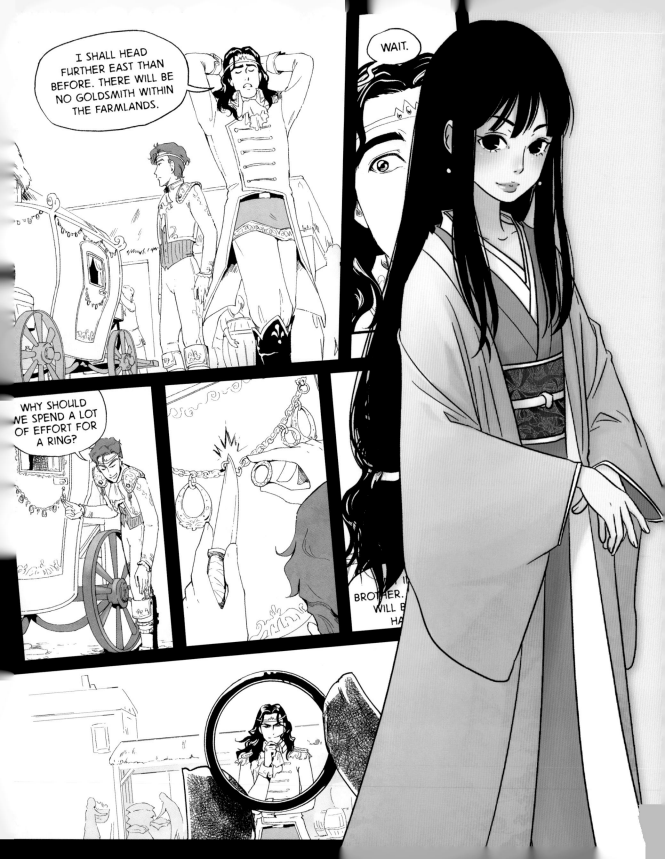

6

Making Manga

You can draw the characters and their settings, but how do you make a comic out of it all? This section is the culmination of all the skills you have built up throughout the book—it teaches you how to lay out your panels and pages to tell your stories in an exciting and intuitive way.

Preparation: Recommended tools, materials, and practices

If you are inventive enough, you can make manga pages using almost any standard drawing tool or material, but it helps to know which is most effective and appropriate, along with how to use it.

Drawing surfaces

You can buy specialist comic-drawing paper from art stores that is tailor-made for drawing full pages of comic, but it can be pricey. The key factors to consider when choosing paper are size, weight, and surface.

Size

Always draw and ink on a piece of paper larger than your chosen final printed size. Not only does this make it easy to create images that bleed off the edge of the page, but reducing the artwork gives finesse to your lines, making them look finer and more detailed. As a rough guide, drawing on paper twice the size of the final version reduces down nicely. If you want your work to appear finer or if you have a heavier hand, you may want to draw on even larger paper, but think about your scanner capacity—it is inconvenient to scan a large page in sections and then have to join them together.

Weight

Lightweight paper is inexpensive and easily available from office stationery stores. It is perfectly acceptable for drafting your work in pencils and light inking with fine liners. The problems occur when you want to make corrections or use pens with a faster ink flow—too much erasing will crease or degrade the paper and too much ink will soak through it. Heavier weights of thick paper or cardstock are much more robust; some can handle sharp pen nibs and knife scrapes. Once you get much heavier, though, the costs go up and storage becomes an issue if you draw hundreds of comic pages.

Surface

A smooth surface such as Bristol board is ideal if you want your ink lines to look neat and taper off finely. It can look sterile and streaky if you're using brushes and markers, though, so for a more organic look, try a rougher-textured heavy-weight paper. The surface can affect the absorbency of the paper as well—some finishes will cause more ink pools and bleeding than others, so test them out before buying in bulk or committing to a full page of inking.

Drafting pages

When laying out your rough pencils before inking, don't worry about making a mess—your pencils will be erased so readers will only see the inks in the final product. Use as many guidelines as you deem necessary to help you with your inking. Write notes on the side if it helps.

Thumbnails

Before even touching your actual comic pages, start with "thumbnails," or small layouts on a separate piece of paper. Mark out your panels and place your characters within them as stick figures. It's easier to change things at this early stage and make sure that the chapter or comic works as a whole. Then use these thumbnails as a reference when penciling your actual pages.

Penciling

You can use a graphite pencil, but to save time sharpening, try a mechanical pencil.

Colored pencils

Another time-saving technique is to use colored, non-photo leads in your pencil so that when you ink over the lines in black, you can remove the pencil lines easily by photocopying your artwork, or scanning it and filtering out the colors. You can even convert your black pencils to color by scanning and tinting your lines and printing them out to ink on.

◀ Specialty comic-drawing paper has rules around the edges, center marks, and trim marks (see enlargement).

Inking

Inking is part of the final product that your readers will see, so make an effort to ink expressively (see pages 128–131). These days, work is usually given to printers in a digital format and it is fairly easy to correct mistakes. Therefore, it is better to draw with fluidity and make corrections afterward, than to ink with hesitant, shaky lines. The main problem with inking for manga pages is to remember which pieces to fill in—you may choose to ink your characters but leave speech bubbles and panels for drawing digitally, for example. This is another reason why inking in black over colored pencil work is useful, as it is easy to see when something has not been inked before you start erasing.

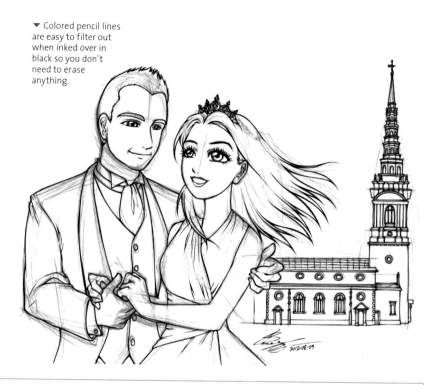

▼ Colored pencil lines are easy to filter out when inked over in black so you don't need to erase anything.

Working digitally

Many artists choose a combination of traditional and digital processes to create their comic pages to suit their strengths and personal style. Some work entirely on a computer from start to finish. If you want to do this, you'll need some essential computer software and hardware.

★ **Computer specifications:** You will need a computer with a high-quality graphics card, fast processing power, and lots of memory. This is so that you can generate and store larger images at print resolution. Your monitor should ideally be large, bright, and consistent in its output so that the colors of your image are accurate and you can clearly see any nuances in your shading.

★ **Drawing tools:** A graphics tablet or tablet computer with a stylus is essential if you want to draw digitally and comfortably with a natural hand position. Using a mouse or touch pad is only for basic image editing and would be very damaging to your hand and wrist muscles.

★ **Software:** Specifically for sketching and inking, you need software that picks up your pen strokes effectively, and for manga comic pages you need software that can output high-resolution black and white images. Don't feel restricted to using just one program—it is common practice to port images between software to take advantage of different features. To avoid spending too much money, test out trial versions and use software that comes bundled with any hardware you buy (such as graphic tablets or scanners). Review pages 160–167 to help you choose the right tools and setup.

Preparation:
Page setup and guidelines

Before working on your manga comic pages it is important to ensure that they are formatted correctly. Few things are more disappointing than drawing and inking a page, only to find that once it is printed, half of the artwork gets cut off. Research your printer's limits or, if you are submitting to a publisher, study their page specifications carefully.

Understanding the jargon

When working with a printing company for the first time, it can be very confusing to figure out what in size and format to provide your artwork. You must understand what they need and what names they give to certain margins. The key terms are illustrated opposite.

There are popular comic book sizes out there you can use from many of the major publishers and most printing firms—they will often have a submissions process, which tells you the figures or even provides templates for you to download and use. But if you want to create a book in an unusual size and shape, then use the following guidelines for controlling your output.

Quarter-inch rule

A common measurement used by modern printers is ¼ inch, or roughly 7mm. This is a standard amount allowed for wiggle room for most things, be it safety from the edge of the trim line to the bleed line when cutting the artwork down to final trim size. Say you want to print a 6 x 6 inch image at final trim size and the artwork bleeds fully to the edge: Add a ¼ inch border all around to provide it at 6½ x 6½ inch full bleed size and reduce by ¼ inch all on the inside to ensure everything important is within 5½ x 5½ inch safety.

Generous safety and bleed

If you want to print your comic across various formats and sizes, or if you are submitting a project where the final size isn't decided on yet, make sure that your safety margin and your bleed are large—for example, safety is 1½ inches from trim line and bleed is 1½ inches out from trim line. This means that book sizes of different ratios of height to width will still print well.

Spine

Another factor to consider if you are printing in a book with more than 50 pages is how the thicker spine makes it difficult to spread the pages out fully, so design your pages as left or right pages and consider a larger safety margin on the inside, closer to the spine.

Practical considerations

If working digitally, it is fairly easy to create your workspace: Just load up any downloaded template you have from comic publishers or create a new page at the full-bleed size. At final print resolution, mark out the trim and safety lines, and draw accordingly. But, if you work traditionally on paper, you should be drawing larger than final print size to improve the quality of your work when it is reduced. As such, you need to calculate and resize the safety, trim, and bleed, and apply them to this larger, raw drawing size.

To do this, create a blank digital page with guidelines marked out, then print it as large as you can on your drawing paper—you can use this to trace, measure, and copy for drawing guidelines on that size of paper. You can save additional time if you draft using a colored pencil—print your guidelines in that color and then filter the lines out, just like the pencil marks, once inked and scanned.

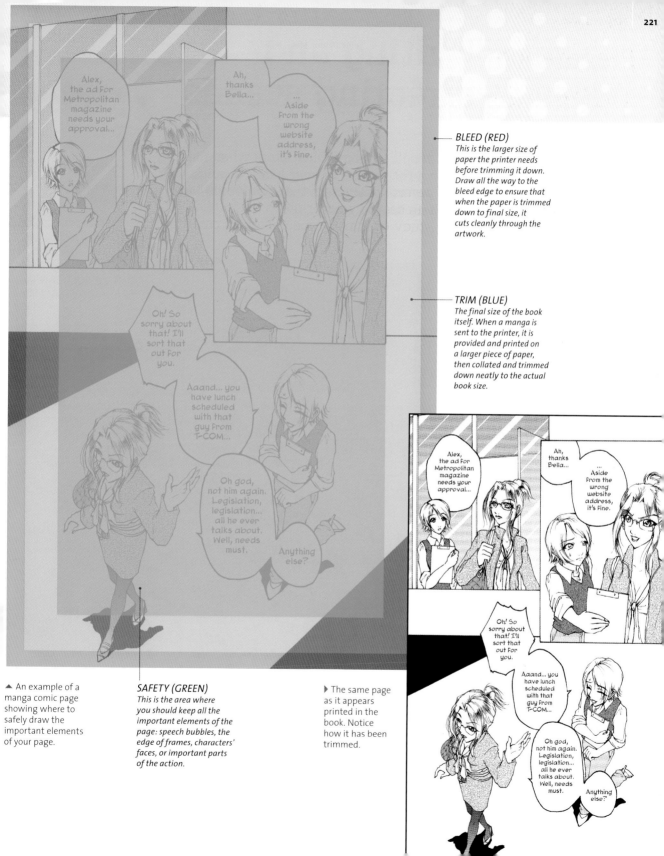

BLEED (RED)
This is the larger size of paper the printer needs before trimming it down. Draw all the way to the bleed edge to ensure that when the paper is trimmed down to final size, it cuts cleanly through the artwork.

TRIM (BLUE)
The final size of the book itself. When a manga is sent to the printer, it is provided and printed on a larger piece of paper, then collated and trimmed down neatly to the actual book size.

▲ An example of a manga comic page showing where to safely draw the important elements of your page.

SAFETY (GREEN)
This is the area where you should keep all the important elements of the page: speech bubbles, the edge of frames, characters' faces, or important parts of the action.

▶ The same page as it appears printed in the book. Notice how it has been trimmed.

Preparation: Writing and directing scenes

Writing stories can be quite difficult for some illustrators when making their first comic. You may have a rough idea in your head: a cautionary tale, a fantasy world, perhaps several characters that you would love to make a comic about, but where do you start?

Brainstorming

Get your ideas out from your head and onto a sketchbook or notepad. Don't use a word processor. Write down as much as you can, scribble in small sections, leave spaces between them so you can draw arrows connecting themes, annotate them further, or doodle a related picture. Once it's on paper for you to see, it's much easier to figure out what to throw out and what to keep. Fill in the gaps and add depth to your story by going through each of these ideas in turn—the key ingredients that make a story.

Characters

Describe your characters and their background. What role do they play in the story? What makes them interesting to the reader? Do they remind you of anyone in real life? Do they change? What type of relationships do they have with each other? Engaging characters are the first point of call for writers to create an appealing story.

Setting

The world in which your story takes place can be a story in itself, especially if it is out of the ordinary—historical, fantasy, sci-fi, steampunk, or simply an exotic country; anything goes. Even a contemporary setting should still show something of interest to the reader, be it the darker elements of the city or the quirky eccentricities of tradition. Some sort of event could be happening; a war, a dangerous outbreak of disease, a competition, or a natural disaster.

◀ Brainstorming is messy, but it is organic and lays all the key themes out in front of you so the story becomes clearer. Jot down names, maps, systems, spider diagrams, lists—everything counts.

Message

What impact do you want your story to have on your readers? What do you want them to feel after reading your manga? Do you want to teach them about something? Are you looking to shock?

Do you want the reader to feel happy? This is a subtler way to create a story, but very important to give a real sense of identity to your work.

Visual mediums

Prose that you read in a book is presented in a completely different way than in films and comics. You don't need words to tell a story; you can see it unfold in front of you. Write as if you are directing a film. Don't let narration and dialog fill in the obvious. Instead, let the images set the context and show the subtleties. The manga format in particular spreads out its story with dramatic closeups, drawn-out pauses, and large splash images—you use up a lot more pages than you might anticipate to depict an entire scene.

▶ This sequence speaks volumes without words because of the way the main character reacts to what is happening.

Limitations

It is important to have clear ideas about the limitations of your story. Beginners often embark on an ambitious epic because they have a passion to create, but if your story is too large and overreaching it will never get finished. Set yourself some basic limits so you end up with something usable.

★ **Story length:** A first project should always be short and stand alone as a way to learn and gain experience. Many manga artists begin their career by making a small, short comic to sell or swap at conventions, or by entering a competition or submitting a chapter to an anthology. Aim for a comic shorter than 30 pages to begin with, before tackling anything bigger.

★ **Number of characters:** A ten-page short should have two characters at most. Even with a series that lasts multiple volumes, there are usually fewer than five main characters. It is better to tell fewer characters' stories well than to stuff in too many characters into too small a space.

Practical steps

How do you end up with a finished story that you can turn into a comic? Here are two approaches you can try.

Free writing

The official definition of free writing is to write anything that comes into your head for a set period of time. You don't have to be strict about it, but if you have a story brewing and you've already brainstormed it out, then you may have just the right combination of passion and coherence to write it down from start to finish in one stream of consciousness. Write your story as prose or as a script; it doesn't matter. Take a whole day, or several days, if you need to. Then read it from the beginning and annotate it ruthlessly. Split it up into scenes, then work out how much you think you can fit into a single page; then notate any key panels or images you want to showcase. Check your limitations and edit your story as necessary—tighten it up or expand sections to match your page count and size.

If you have a lot of creative freedom over your manga, this approach can be very enjoyable. It's a great way to get your first story out of your system and may result in something very powerful, lyrical, and fluid. The danger is that if you are inexperienced, you can lose the plot—literally!

> **"** She reaches the bus stop, looks at the timetable... **"**

> **"** You! I need your help! **"**

▲ A messy block of text that comprises both description and dialog, but notice how it's split up with lines to show how much applies to each page.

Love Stuffing Chapter 1

It's morning and the sun is shining through a girl's bedroom window. School uniform draped over a chair and a desk. There is a knock on the door.

DAD
(muffled)
Jenny? Princess? It's 7.30…

Cut to Jenny's sleepy face. She looks at her biggest Teddy bear at the foot of her bed, Kodiak.

JENNY
Heehee, Kodiak, you sound just like my dad...

DAD
(creaks the door open slightly and peeks in)
Um, Jenny, shouldn't you be dressed by now? School starts in 30mins.

JENNY
Wh… WHAAATT??!!!

DAD
Good luck...

He closes the door. Jenny now frantically throws herself out of bed, drags on her pullover, buttons up her skirt, tripping up whilst doing so. During this, there is a monologue from her.

JENNY – MONOLOGUE
My name is Jennifer Foxton. But I prefer Jenny – it's cuter that way. I'm 14 years old, but I'm turning 15 next April! I collect soft toys.

Pulls on her socks, grabs her school satchel and slams the door. She comes back, opens it again to say good bye to her stuffed animals.

Pitch format

This is based on what potential publishers want to see from comics that are pitched to them. Start with a sentence that summarizes your story, then expand it to a paragraph. Next, use a paragraph to describe each book, each chapter, and each scene. Then write that scene in film-style script. A pitch takes just one or two such final sections of script, a vertical slice of the project, but applying this process throughout allows you to work on any section you want to, at any time, without losing sight of the overall story. Bit by bit, you will finish it. Most of the time, it is safer and more efficient to use this approach and start with broad brushstrokes that you can gradually fine-tune into a script. This is particularly important when creating a script for a client to approve at different stages.

◀ This is an example of film-style script format, which is most useful when you are writing for someone else to approve before it is drawn.

Layout:
Reading direction

Given the popularity of manga all over the world, when someone picks up a volume of manga, the first thing they figure out is whether it reads forward or backward. That determines how the eye naturally moves over the page. A good comic creator understands and anticipates the reader's instinct.

Forward or backward?

Manga originated in Japan and the Japanese language traditionally reads right-to-left, although this has changed in recent times to match with globalization, international transactions, and the dominance of the English language.

As manga became popular outside of Japan, it started to be published in the West, translated into English, and often flipped or rearranged to read left-to-right for the Western audience. This not only resulted in delays and extra costs in production, but also affected the artwork. As a result, manga is now left in whatever direction it was originally drawn in and is simply translated, with a guide included that explains how to read it right-to-left.

Manga created outside of Japan can be drawn in either direction, depending on the language it is drawn in, which audience it is aimed at, and the preference of the publisher or creator. Don't assume that you must draw it right-to-left for it to be any more authentic.

◄ It looks odd when a page is flipped from its original orientation, even without any writing. The character designs change subtly, such as the parting of the hair.

Dealing with diagonals

Once the reading direction of the comic has been established, the reader's eye will travel across as well as down the page. You will naturally be drawn to one of the corners at the top of the page, then work your way down in a roughly diagonal line to the bottom opposite corner. When visualizing how your story plays out, be sure to design the action so that it eventually snaps back into this natural, diagonal page flow.

◀ In English format left-to-right, the eye naturally starts at the top left, then meanders down to the bottom right. You can see how this page follows the diagonal page flow intrinsically.

▶ Starting at the top left (English format), it is easy to follow the girl's actions. The panels move consistently from left to right and top to bottom.

▶ In Japanese right-to-left format, the positions are flipped and you start at the top right, ending at the bottom left.

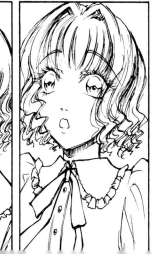

Layout:
Intuitive panel order

One of the first comparisons readers make between Japanese manga and traditional Western comic pages is the style of panels and frames. Instead of the more rigid rows of rectangular panels, manga employs panels of different shapes and sizes arranged all over the page without relying on grids, arrows, or numbers. It uses visual tricks to group sections of the page and guide the reader through the panels.

Panel gutters are the blank spaces in between the panels, where your panels are expressed as box frames. They are marked out here in blue.

Going across
So long as the reader is made aware of the reading direction of the manga (easily inferred from the book cover), the easiest way to order your panels is to place them in a row going across. In English, you start from the left.

Going down
All languages have a top-to-bottom element to how they are read, so this is another obvious way to order your panels. The first panel is the top one.

Group your panels
While it can work in moderation, it is not appropriate to draw your panels as full rows or columns over the whole height and width of the page all the time. The artwork within the panels should not be pinched too tight in either direction. Pages will also need to have more panels than can comfortably fit as full-length rows or columns. You must split the page into two or more groups, which you can then divide into more rows or columns.

Panel gutter size

You can place your panels right next to each other so there is only a small gap between them, or you can place them far apart so that you have very large gutters. If the panel gutters are narrow, they feel closer together and related—the reader will see and process the panels as one bunch. If they are far apart, they feel separated, like they don't belong together—the reader will see each side of the divide as individual entities. Use smaller gutters within a group and use larger gutters to separate groups.

Compare the size of the panel gutters used within the groups (marked in blue) to the size of the gutter separating the top group from the bottom group (marked in red).

Compare the size of the panel gutters used within both left- and right-grouped columns (marked in blue) to the size of the gutter going down the middle (marked in red).

Panel gutter alignment

Lining up boxes can have a powerful impact on the reader as it creates a border in their mind, as is the case when an outline is drawn around the boxes. If the outer edges of several boxes are aligned, it forms a group. The opposite is also true and just as powerful—if the inner panel gutters of one group are not aligned with the inner panel gutters of another group, they look like they don't match, so it becomes clear that they are in different groups.

When defining groups, make sure that their edges line up on the outside.

Notice how the vertical panel gutter in the top group (marked in blue) does not line up with the one in the bottom group (marked in red). This gives each group its own identity, making it obvious that they are separate.

Layout:
Speech bubbles

A good comic should be effortless to read, not a chore. Speech bubbles and other forms of narrative text play a huge part in this. They should be like a maître d'hôtel— match perfectly with their surroundings, draw your attention when required, and help you in an elegant, smooth fashion.

◀ It is much easier to digest dialogue that is broken up into sections than to read a large block of text.

Position

Just like the theory behind reading direction and page flow, it is important to place your speech bubbles correctly so that the reader knows immediately which one to read first. It is obvious when there is only one speech bubble per panel, but when there is more than one speech bubble per panel, ensure that they follow the imaginary diagonal line of the page flow.

You can use speech bubbles to guide the reader from panel to panel, perhaps by putting an arrow in between them. This is particularly good when the images used in the panels are providing background context. Using film as an analogy, it's like hearing the dialog continue as the camera cuts to a reaction shot.

Speech bubbles should not be treated as an afterthought; you must plan for them during the thumbnail stage. Make sure they don't cover anything important. Traditionally, they are hand drawn during the inking stage along with the rest of the artwork, but you can add template speech bubbles from stickers or digitally at a later stage if you prefer.

Shape

Speech bubbles come in many shapes and sizes, depending on the style of comic and what type of text is inside. Dialog is different from inner thoughts,

▲ In this example, the speech bubbles get progressively darker, to show you the order in which to read them. Notice the diagonal flow from top-left to bottom-right, not just within panels but as a trend through the overall page.

which are different from narration. Even dialog can come in many forms. The size and shape of the bubble helps to tell the story and allows the reader to understand who is speaking and how it is being spoken. There are also some design features unique to manga speech bubbles.

Size

Manga-style speech bubbles are quite generous compared with the size of the text inside them, so draw your bubbles larger than you think! This is due to tradition—the artwork (with speech bubbles drawn in already) is given to the publishers who then letter it, and the artist always errs on the side of caution and makes them large so that the publisher has enough room.

Combined bubbles

You can't have a humongous speech bubble containing a huge swathe of text. Break up the words into separate sentences or clauses, and put them into their own bubbles, but overlap and join them.

Width

Japanese traditionally reads vertically before going across, so original manga bubbles are drawn tall and narrow. Other languages read across before going down, so it is more typical in the West to see short and wide bubbles. It's up to you what you decide to go for—many artists

▲ An example of Chibi faces inside the bubbles to make it clear to the reader who is speaking.

go for something in between as a compromise for all languages.

Tails and attribution

Manga speech bubbles do not always have tails to attribute them to their speaker. If used, they are very small and merely point to the characters; they do not trail all the way to the mouth. This is partly due to the way stories are presented: There are more closeups and mid-shots of characters in manga, so it is fairly obvious who is speaking. Another popular technique to show a funny conversation is not to draw a panel of comic at all, but to draw large bubbles and include a Chibi drawing or just the face of the character inside.

Round versus angular

Most dialog uses rounded shapes for speech, whereas narration works well in square or rectangular frames, particularly when the character is revealing their thoughts to the reader.

Effects

Speech bubbles are not always outlined as a basic oval—that would be the equivalent of all characters speaking in monotone. The style of the bubble should clearly indicate who is speaking, what is said, and how it is being said. Some effects are used in comics worldwide; others are manga-specific due to the tools used.

LOREM IPSUM DOLOR SIT AMET, CONSECTETUR ADIPISICING ELIT, SED DO EIUSMOD TEMPOR INCIDIDUNT UT LABORE ET DOLORE MAGNA ALIQUA.

▲ Don't wrap the outline of your speech bubble too close to the text. Center the text and leave lots of breathing room around it.

LOREM IPSUM DOLOR SIT AMET, CONSECTETUR ADIPISICING ELIT, SED DO EIUSMOD TEMPOR INCIDIDUNT UT LABORE ET DOLORE MAGNA ALIQUA.

▲ To denote a different sort of speaker, shade in the bubble and invert the text into white. In this instance, this is a demonic voice.

LOREM IPSUM DOLOR SIT AMET! CONSECTETUR ADIPISICING ELIT! SED DO EIUSMOD TEMPOR INCIDIDUNT UT LABORE ET DOLORE MAGNA ALIQUA!

▲ A universal way to show shouting or alarm is to make the bubble spiky. Manga shout bubbles are usually more organic and irregular.

LOREM IPSUM DOLOR SIT AMET, CONSECTETUR ADIPISICING ELIT, SED DO EIUSMOD TEMPOR INCIDIDUNT UT LABORE ET DOLORE MAGNA ALIQUA.

▲ For a thought bubble, use sketchy edges. Manga versions can be angular or rounded, but are usually loose and not clearly defined.

LOREM IPSUM DOLOR SIT AMET, CONSECTETUR ADIPISICING ELIT, SED DO EIUSMOD TEMPOR INCIDIDUNT UT LABORE ET DOLORE MAGNA ALIQUA.

▲ Another manga-specific way to show thinking is to outline the bubble with a soft or shimmery patterned screentone instead of ink.

LOREM IPSUM DOLOR SIT AMET, CONSECTETUR ADIPISICING ELIT, SED DO EIUSMOD TEMPOR INCIDIDUNT UT LABORE ET DOLORE MAGNA ALIQUA.

▲ If narrating a historical tale or romantic fantasy, putting a floral border around the text gives it an Old World feel.

Layout:
Lettering and sound effects

All forms of lettering in a comic have to be considered carefully, as lettering plays many vital roles in conveying the story. It must range from appearing unobtrusive through to commanding your utmost attention. The way the words are styled influences their impact, particularly when used for sound effects.

Dialog

In most full-length graphic novels and comics, much of the story is understood through the dialog of the characters. Because it is featured so much, you must present dialog text in a style that suits the comic and the character speaking—it should not appear too strong or overwhelm the artwork, which should be the main focus. Establish a consistent style throughout your comic; then add effects and styles when required.

Digital versus hand drawn

For consistency, efficiency, and ease of use, you should use digital fonts. There are many beautiful and authentic-looking fonts available in all sorts of styles. There are also many ways to customize digital fonts, by changing the line spacing, paragraph height, and so on. You should only consider using hand lettering if you have spent years perfecting it. Hand lettering is most appropriate if there is very little dialog and most of the text is florid narration.

Case

Traditionally, the majority of comics and graphic novels used upper case lettering for consistency, ease of hand lettering, clearer printing, and readability at small sizes. However, as styles and technology have advanced, there is a growing number of comics that use lower case letters for a more personal, delicate feel. Selectively using upper case lettering in a book that mostly uses lower case lettering is only appropriate if the character is shouting, or if they are very different to other characters in the book.

Weight

Use italics or lighter weights if someone is whispering or thinking. Bold or bold-italic is good for when someone is putting emphasis on their words, or raising their voice.

Size

Volume and gravitas can be expressed with letter size: the smaller the letters, the softer the tone, and vice versa. A good rule of thumb is to have no more than three sizes for general dialog, with a noticeable difference between them. It looks messy if you use too many variations throughout.

Styles of lettering

Compare the various styles of lettering—think about which one would suit a sci-fi, fantasy, or contemporary setting.

Effects

Here, the same font has had different effects applied. Try to imagine what tone of voice the character might be using for each example.

Sound effects

Onomatopoeia is part of the immersive experience of comics. We can already see what the characters are doing. By reading the dialog in speech bubbles we effectively "hear" what the characters are saying. But what would a gun fight be without the sharp crack of bullets, or an explosion without an enormous boom?

Japan is especially fond of sound effects and in a broader sense, ideophones—words used to describe not just the sound, but the feel or look of something. For example, something that is sparkly is "kirakira," something fluffy is "fuwafuwa," and something warm is "pokapoka." There is even a word for a gentle smile, "nikoniko."

The lettering style you use for your sound effects must be appropriate to the noise it represents. That way, even if the

words chosen aren't perfect or if the ideophone itself is unfamiliar, the reader can figure out what it is supposed to sound or feel like based on the look of the lettering.

Sound effects should be integrated into the artwork closely, so it is better to draw them in by hand than to rely too heavily on digital fonts. If doing the latter, make sure you thoroughly customize the lettering so that it matches your artwork and the scene.

▲ This example shows two sound effects, both using different fonts and styles that match their sound. They are also styled differently.

▼ This hand-drawn example of sound effects shows the measuring tape being pulled out of the shop assistant's pocket with a rustle of fabric, then quickly pulled taut with a whipcrack.

Layout:
Panel shapes and pacing

Getting your readers to read the panels in the right order is a necessity, but using panels to convey atmosphere and to control the speed at which they read is a masterstroke. Panel shapes are hugely influential in manga and are one of the ways in which they are more creative than film—you can't change the shape of a television screen, but you can change the shape of a comic panel in every shot.

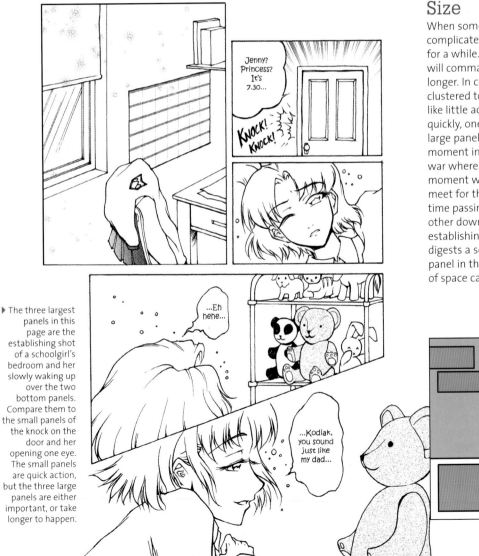

▶ The three largest panels in this page are the establishing shot of a schoolgirl's bedroom and her slowly waking up over the two bottom panels. Compare them to the small panels of the knock on the door and her opening one eye. The small panels are quick action, but the three large panels are either important, or take longer to happen.

Size

When something appears large and complicated, one can't help but stare at it for a while. This means that larger panels will command the reader's attention for longer. In contrast, small panels that are clustered together closely make it seem like little actions are happening fairly quickly, one after the other. You can use large panels to highlight an important moment in the story, such as the end of a war where both sides shake hands, or the moment when the two main characters meet for the first time. It can also convey time passing—two rivals staring each other down during a long pause, or an establishing shot where the reader digests a scenic vista. Drawing a small panel in the middle of a large expanse of space can work in the same way.

◀ The blue panel is the largest and will command the reader's attention more than the red panels.

Irregular shapes

Odd shapes such as extremely thin or narrow rectangles, triangles, and trapeziums with diagonal edges not only fulfill a practical purpose when it comes to keeping long or thin objects in shot, they also add to a sense of dynamism and movement. Think about how a diagonal tilt in photographs showcases someone using a long sword or your favorite guitarist in a rock band. Long and angled lines can also throw the reader off balance, adding to the feeling of tension and anticipation. This makes irregular-shaped panels great for action scenes, thrilling moments, or moments of conflict and indecision.

◀ The diagonal edges and sharp points give a sense of urgency as well as uncertainty.

▶ This layout combines size and shape. What story could this layout be telling? Perhaps something is revealed in the first and second panels, the reaction to which is shown in the last three panels.

Alice!! LOOK OUT!!

KRAK!

KYAAAH!!

▶ The panels start off more regular, then become more slanted and sharper as the action unfolds.

Layout:
Example layouts and uses

Manga page layout follows certain guidelines, but in practice, it is more subtle. Like all forms of art, some rules will be broken and some techniques will be combined on a case-by-case basis.

▲ Don't underestimate the power of leaving lots of blank space on the page. The confrontation between these two characters is punctuated by long silences.

▲ No gutters are used in this page but it is clear where the boundaries are through the narrative boxes and the change in camera zoom.

▲ Screentone is used to define the panels on this page, not only through placement but also with the density and darkness.

Blank space

Like large panels, large expanses of space can slow things down or draw attention to something important. Within a panel, drawing a character taking up only a small amount of space gives it gravitas and possibly a sense of isolation. Lots of space outside the panels implies the passage of time between what is happening in the panels.

No panel gutters or frames

Panel gutters keep the page neat and tidy. But, it can be interesting to mix things up by not leaving any gutter, so there is only a line separating two panels, or even no line at all. In order to ensure comprehension, only do this when you can clearly show the boundaries of the panel through other means. Make sure that adjacent images have sufficient contrast or they will look muddy and jumbled.

Floating characters

Manga employs many instances where artwork is outside formal panels and boxes. Similarly, this is why many manga artists choose not to draw backgrounds in their panels all the time—once the reader knows where the scene is taking place, the focus is much more on the character and the action. Having a character pop out of their frame has high impact and energy.

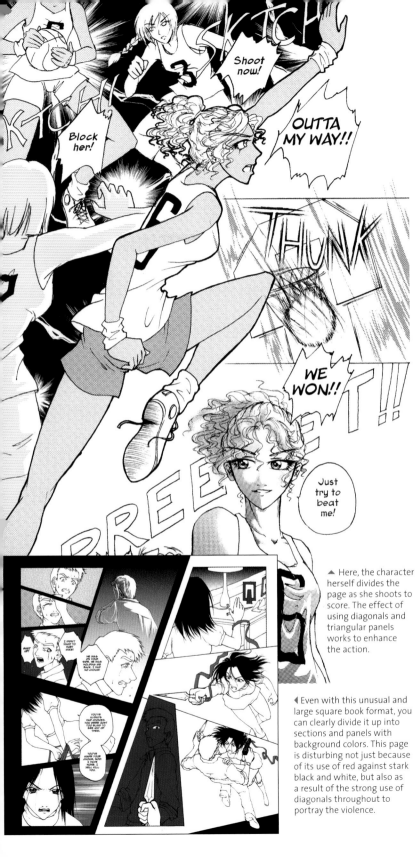

Overlapping panels

The use of overlapping panels intuitively leads you to think that events are tumbling over each other, so it can imply chaos, lots of things happening at once, an interruption, or actions that follow each other in very quick succession. Even if this wasn't the intention of the artist and it is used purely for visual effect, it has a quickening and unbalancing atmosphere.

Divide and conquer

All comic artists have to think about how to divide their page into smaller, readable sections—this becomes even more important if the page size is large. You can theme different parts of your page by providing backgrounds for your panels, changing the style of your box frames, or changing your drawing style.

▼ This page showcases an overlapping panel in the top left. It's appropriate because the character suddenly screeches to a halt in front of the store.

▲ Here, the character herself divides the page as she shoots to score. The effect of using diagonals and triangular panels works to enhance the action.

◀ Even with this unusual and large square book format, you can clearly divide it up into sections and panels with background colors. This page is disturbing not just because of its use of red against stark black and white, but also as a result of the strong use of diagonals throughout to portray the violence.

Layout:
Four-panel gag strips

The four-panel comic (or "Yon-Koma") is the Japanese equivalent of the traditional Western newspaper comic strip. It is not intended to tell a long story like a graphic novel or serialized comic book issues, but instead small snippets are used to tell one joke or gag in fewer than four panels.

▲ A Japanese gag strip reads vertically from top to bottom, consisting of four panels, always of equal size.

▲ A typical Western comic strip that you find in newspapers would have three panels going from left to right. Sometimes they have different widths.

Usage

Japanese newspapers and magazines will often have examples of four-panel strips in the leisure sections, featuring mascots or popular characters commenting on current issues with slapstick comedy or amusing puns. There are also full-length storylines and characters, and these are managed carefully so that each strip is self-contained and can be enjoyed by readers who haven't necessarily read all the strips up to that point.

Another popular usage of the four-panel strip format is at the end of a volume of manga, in the Extras (or "Omake") section—like bloopers or outtakes from a film. It's cute for the readers to see funny strips featuring their favorite leads acting out of character, breaking the fourth wall by speaking directly to the reader, or talking about the creators.

Format and layout

It is very important to note that gag strips in manga are always drawn vertically, not horizontally like Western comic strips. There are four rectangular panels arranged to be read from top to bottom. This is always applicable, regardless of whether you are writing in English or Japanese. But reading direction in accordance with the language you are writing in will apply to the order of speech bubbles—i.e., if you have more than one speech bubble in the same panel, you start in the top-left and end in the bottom-right if you are using English.

▲ Keep the gag easy to digest and simple because you have only four panels in which to tell it. Use repetition in the images to help show the change in action.

Style

As each panel is a wide rectangle, in order to fit in more of the characters and speech to tell the joke and to match with the comedy, characters are normally drawn quite simply and in Chibi or super-deformed style. Even if still drawn with fairly realistic proportions, the heads and upper bodies are the main focus and will be exaggerated with plenty of facial expressions and visual grammar.

I AM LIVING IN A MADHOUSE. I HAVE NO ONE TO TURN TO. I CAN'T-

HEY, SIMONE! GOOD TO SEE YOU AGAIN.

YUEN! MY FRIEND! MY OLD BUDDY! SHE'S HERE!

SHE'LL SAVE ME FROM THE MADNESS.

WOAH... SO... INTENSE...

YUEN! MY SAT NAV, AND THE POLICE, AND THE WEIRD CLOTHES, AND WHY IS SHE SO MEEEAAAN~!

◀ Chibi or super-deformed proportions fit perfectly in the panels and tell the story visually.

MY LAST SAVE WAS AAAAAGES AGO...

KEZIAH, WHAT DID YOU DO?

WASN'T THAT BAD-

N-UH. STRAW. CAMEL'S BACK. LAST ONE.

SIGH HI-I'M-KEZIAH-NICE-TO-MEET-YOU-SORRY.

▶ Although realistic proportions are used in some of the panels in this strip, there are plenty of exaggerated expressions to keep things comical.

Publishing:
Printing considerations

The way in which manga and all other types of comic are produced today is very different to when they were first popularized. Many production techniques have been digitized and advancements in technology mean that you can now achieve high-quality results even for bespoke, limited quantities. This has resulted in an explosion of small press creators, who are drawing and printing their own work to professional standards. There are some important things to consider to get your finished manga looking as polished as possible.

Printing options

In the past, directly photocopying your pages, then binding and collating the pages by hand was the most cost-effective way to produce small numbers of comics due to high setup costs. Printing technology is now able to print accurately from digital formats to get a good quality, even from one-offs and small quantities. You can use computer software to draw digitally, or you can use traditional media and scan artwork to a high quality to create a good digital master.

Digital printing

Modern printers and bookbinding machinery will allow you to print small quantities—even just a single copy. The quality of small print runs (or Print on Demand) can vary greatly between printing firms, but is generally becoming consistently higher. This type of printing commonly uses conventional laser or inkjet printers to produce any number of pages and designs as required, before binding into a book. The cost per page is relatively high, but there are no initial setup costs or processes and the turnaround is quick. This makes it ideal for samples, proofing, and small runs of fewer than 100 books.

Offset printing

This form of printing uses a large-scale printing press, where the images are engraved onto metal plates, which then have ink applied and offset onto rubber before being transferred onto the paper. So long as your originals are of a high quality, this produces clear, sharp, and highly consistent results. The setup costs are very high due to the custom plates required for each image to be printed and it may take several weeks for the plates to be finished but, once ready, you can produce thousands of pages without much additional cost. As a rough guide, if you are printing more than 500 books, it becomes more cost-effective to use offset printing.

Short-run digital prints look more like images printed by conventional laser printers on normal, bright white printer paper.

With offset printing, you choose the type of paper. Manga volumes are traditionally printed on slightly thicker, pulpy, off-white paper with more texture.

Printing in color

When printing your manga comics in color, there are several details you must consider to get good results, depending on the method of printing you are using. Even if your inner pages are mostly black and white, it is good to apply these points to your color covers.

★ **Resolution** Books are not like large posters or banners—they are smaller and subject to close scrutiny by readers. As such, you need to print at a minimum of 300 dpi for good printing quality. Higher than 600 dpi is usually unnecessary and uses up a lot of computer storage space for relatively little perceptible gain. Images with soft shading and edges translate fine in lower resolutions, but if there are sharp, crisp edges and very distinct line art, go for higher resolutions.

★ **Color mode** There are two main color modes used by visual artists: RGB and CMYK. RGB stands for red, green, and blue of the light spectrum and is a device-dependent additive model where cameras, scanners, and display screens add varying levels of colored light on a base of black to create the whole image. CMYK is a subtractive color model based on the ink levels of cyan, magenta, yellow, and key (black) to produce an image in print on a base of white. RGB uses less computer memory and appears very striking on screen, but doesn't always translate accurately in print. For small runs that use color laser printers or inkjets, there is usually no major problem with RGB. However, for large print runs with offset printing, it is imperative to use CMYK and test the outcome on various printers before committing.

Cyan (C)

Magenta (M)

Yellow (Y)

Black (K)

◄ This collection shows how an image is broken down into its separate CMYK color channels.

Printing in black and white

The majority of manga comic pages are drawn in black and white, with only a few images or pages in color for promotional use. This is due to the way in which manga is produced and consumed—collected volumes are relatively small in dimension, but tell long stories that are serialized over several years. Printing in black and white keeps costs down as fewer metal plates are used in offset printing. To ensure a sharp and clean result there are some important factors to consider.

Resolution

Manga uses a lot of screentone and delicate inking, originally meant to be reproduced well even with traditional photocopiers. Black and white files are relatively small in digital memory, so you can afford to send a higher-resolution file to the printers. For pure black and white bitmap images, 300 dpi is too low as it's visibly jagged at the edges; 600–1,200 dpi is best. For softly shaded grayscale images where the edges can appear less defined, 300–600 dpi will suffice.

300 dpi **600 dpi**

▲ This closeup of the difference between 300 dpi and 600 dpi demonstrates the difference in quality with pure black and white printing.

Grayscale

This is a monochromatic color mode that records all levels of gray between black and white. Some manga uses soft shading with markers or gray washes of watercolor, but it is not very popular because it is less reliable for printing. Black and white printing renders grays not as gray ink, but as a dispersal or dither of black ink on the white paper. Printers can be calibrated differently, so sometimes the pattern dither or the level of darkness is affected. Test out your pages on home or office printers before submitting to professional printers.

Bitmap

When printing manga pages that use crisp inking and screentone, you get the sharpest and cleanest results if you ensure your pages are in pure black and white. Soft blurring of edges, known as anti-aliasing, is introduced when images are digitized so that there are no harsh edges on the screen. Any grays in shading or soft anti-aliased edges to your lines should be dithered. Bitmap mode only records black or white values. It keeps file sizes down and, when printed, will always look the same across all printers so there is no ambiguity.

▼ This closeup shows the different dithers when converting gray images into pure black and white. The original image with soft, anti-aliased edges is in the top-left. The bottom-left uses a pattern dither, the top-right is a diffusion dither, and finally, the bottom-right is a simple threshold. Choose a dithering method that suits the finish and style of your manga.

Anti-aliased edges

Diffusion dither

Pattern dither

Simple threshold

Perfect-bound comics

This is the most popular form of binding for paperback books and is used for the majority of collected volumes of manga. The pages are printed, cut, and arranged in reading order, then glued at the spine and covered before final trimming at the outer edges. There are variations to the way the pages are gathered to increase sturdiness. The minimum number of pages for this format is roughly 60; otherwise, the spine is too thin. Maximum pages can be up to 1,000, but a book this thick is not advisable as you would lose too much in the spine and it would be difficult to read; 600–700 pages is more comfortable.

◀ A perfect-bound comic, glued at the spine.

Saddle-stitched

Books come in many different bindings and this format is most commonly used for slim publications with large pages, such as children's books, magazines, and single-issue comic books. The pages are printed on double-width paper, folded in half and stapled along the fold to form a book. It is relatively easy to bind this sort of book by hand; you just need to figure out how to collate the pages correctly so that when combined and folded, the book reads in the correct order. The ideal number of pages for this format would be roughly a chapter's worth, between 20 and 60 pages, although the limits will vary depending on the paper stock you use. The page numbers must always be divisible by four because each double-width, double-sided sheet contains four pages.

▶ A saddle-stitched comic is folded in half and stapled along the fold. You can see the staples when the comic is laid out across the middle.

Publishing:
Cover and logo design

A key factor that influences a reader's decision to choose a manga is what they see on the book cover. You may have the most wonderful pages inside but they will never be seen if a reader doesn't even want to pick up your book because the cover didn't catch their eye. The image used, the overall design scheme, any logos and titles—all must work together to be clear, bold, and indicative of the contents.

Bold images

To make your cover stand out, you need to use an image which is bold, easy to see, and easy to process. There is debate about whether it is appropriate to have a single character on the cover, or a multitude of characters, but it can only be assessed on a case-by-case basis.

▶ A panned-out, full-body shot image (far left) is good if the focus is an alternate world, or if it features a lot of action, like this sci-fi example.

◀ When a manga isn't about one main character, it may be more truthful to have a cover with several characters featured, but be wary of including too many, as it will lose its impact and look muddy from a distance.

Title and logo design

You should spend as much time, if not longer, designing your title and logo as you would your main characters. They must reflect the story and convey the right mood; they have to be visually unique and recognizable; they must stand out from the range of backgrounds you use; and, finally, they must be easy to digest and legible to read. Here are some examples and some suggestions to help you achieve all of these goals.

★ **Research and customize fonts:**
There are many fonts available to use for free (or to buy) that could be perfect for your manga. Take your time to search and preview lots of examples. When searching, input keywords that match with your story such as sci-fi, historical, cute—many font foundries and creators design their fonts with such terms in mind. If you find one that isn't perfect but is almost there, don't despair! Customize it so that it is right. Changing the spacing, weight, height, and tilt can have a surprising amount of impact. If you still haven't found it, then gather your research together and draw it from scratch. This is the ultimate luxury of a comic creator,

▲ "Decravia's Diary" is a cute comic strip about a young witch who keeps a diary. The hand-drawn spiky lettering reflects the fantasy setting and the colors give a magical, Hallowe'en-like feel.

to have a totally customized title logo, but this comes with its own problems, such as not having a font to go to for other branded wording.

★ **Use color or outlines for boldness:**
It is a good idea to check your title against white, black, gray, and brightly colored backgrounds to see if it stands out sufficiently. Companies often have

Cover design

Covers are designed and laid out flat, to be printed and wrapped around the inner pages. Here are the key elements to consider when working on each part of the cover.

Front cover

You must have enough space for a large title and any additional by-lines. When thinking about a cover image, you need to account for an area at the top or bottom of the image where nothing really important gets obscured by the wording. Think about glossy fashion magazines and the way the model isn't covered up—the title and feature wording seem to fit around them. It is why cover images are often composites, where the background is separate from the character, so that you can shift things around until it works.

The top of the book's front cover is the most important place. Not only is it where the reader will look first, but when arranged in tiered shelves in book stores amongst other books, it is sometimes the only section that is visible. Most creators put the title there. Others put the creator by-lines there, if the name carries more weight than a new comic series, for example. Then there are a few who put the main focus of the artwork there. It is up to you!

Spine

If your manga is printed in perfect-bound book format, you need to design the spine so that it is clear to read and gives enough visual cues to the type of book it is. Many manga volumes are stored and displayed in bookstores with only their spines facing out. Choose your colors and fonts carefully. Make the title and logos easy to see. Display some artwork to attract the reader.

Back cover

Many elements of a typical back cover are optional, as it depends on how you market and sell your manga. A short paragraph summarizing the story (the blurb) is useful for the reader to get a quick idea of what the book is about. If selling through official channels and if your book has an ISBN, you'll need to include the barcode, which must be pure black ink against a white background. Having a price, genre tag, and age rating can also be very helpful.

▲ "Love Stuffing" is a romantic comedy about the stuffing in soft toys. The font is cute and puffy with stitches incorporated into the design.

▲ "FujoFujo" is a web comic about geeky girls. The blocky design matches the tone of the comic and is easy to read and recognize even at small pixel sizes.

▲ "Once Upon A Time" is a contemporary drama. The colored, bold outlines help to make the delicate font stand out on both light and dark backgrounds.

several versions of their logo to work on different backgrounds. It may be a simple matter of reversing your design from black to white, or vice versa. If you use outlines or borders as part of your font design, you may find that it pops out nicely on more backgrounds.

★ **Legibility:** Don't be tempted to go for a font or design that is overly elaborate in the quest to be unique. It is better to have a simple logo than to have one that can't be read or understood by most of your audience. If you must have a complicated element in your title logo, be sensible; perhaps only decorate the first or last letters and keep the rest plain. Also consider the formats of your manga—if it is going to be printed very small or distributed online or electronically, the design has to be simple and clear to read at all sizes, and has to scale up or down without difficulty. Test out your logo on as many of your friends as possible to see if they are able to read it.

Publishing:
Marketing your manga

The Internet allows you to get exposure for your work and share information with anyone, but it also means that you are competing for attention with many others like you. Don't neglect face-to-face relationships and focus on marketing to the right people, in the right manner.

Using the Internet effectively

It is very easy to get sucked into the many distractions the Internet has to offer. Set aside some quality working time to invest in these important activities:

Make sure you have an online presence so that when people search for your name (or pen name) and manga, there is some information on you. Make a dedicated website or blog, or online portfolio with a short, catchy name that is easy for people to spell and remember. Describe it accurately with the right keywords and tags—mention your name, the style of artwork you create, maybe the country in which you are based, and any genre you specialize in. You can do much of this for free or relatively cheaply.

Selected advertising

Always consider the audience you are trying to reach before spending money on advertising and whether the cost is worth the gain. Having a very expensive advertisement on a national newspaper's website would reach millions of people, but only a very small proportion of them would be interested in manga, so the pay-off is low. Buying a large banner on a comic reviewing website aimed at people who love comics would be much more effective for the price. You don't always have to spend money either—have a link exchange agreement with other manga artists, or offer to do some artwork for a website owner in exchange for a link.

Social networking

There are many websites and applications that link us to our friends, relatives, colleagues, and like-minded people. Well-known examples include Facebook, Twitter, Tumblr, and LinkedIn. You can easily update everyone with your latest works and where to buy them from, and they in turn can share this information with their friends. All of this can be done for free or at low cost, aside from investing your time to produce good write-ups, images, and remembering to post regular updates.

Web comics

These can make a massive impact on the sales of your manga. It's great for readers to preview your work and to get into the stories and characters. You can also upload pages a little at a time to showcase your work gradually. Uploading regularly will keep you at the foremost of everyone's radar. Some argue that putting your comic online will mean some readers will choose not to buy your comic in print if they can read it for free online, but most of these readers are unlikely to buy an independently published comic anyway. Practice making comics to a certain schedule and do your best to upload regularly and consistently.

Researching opportunities

The Internet is an invaluable resource for seeking information. Check artist forums, social websites, creator's blogs, and publisher's websites to find out about any opportunities. Look for upcoming events and mark them on your calendar. Even if you have just missed one, remember it for next year and see if you

▶ This is a professional manga artist's website: easy navigation along the top, plenty of thumbnail images for viewers to click through and see in full-view, along with information about upcoming events.

can attend. Competitions are held regularly by art communities, magazines, and event organizers. Publishers hold talent contests and sometimes have open periods of submissions. Take note of any such announcements and if you have the time and think you can deliver, it can be a great way to directly introduce your artwork to the people in charge. Even if you don't win, your work will have been seen. You may even be able to get feedback. If you enter next time, they may remember you and notice your improvements.

Meeting customers and colleagues

For all the benefits of marketing online, it is meetings in person that readers and clients remember most. A friendly, approachable artist that you can shake hands with, chat to, and have autograph your book is an experience all comic fans appreciate. An artist is also much more likely to recommend a fellow artist if they have met face-to-face, as it distinguishes them from all the artwork that can be seen online.

Fairs, festivals, conventions

If there is a comic convention, a craft fair, or a literature festival nearby, do your best to attend it. Better still, see if you can book a table so that you can showcase your artwork and sell your work there. Attendees to such events are self-selecting and are most likely to be interested in buying your manga. It is also a great way to make friends with other artists who will be doing the same thing as you! Swap prints or comics, talk about your techniques, where you get things printed, and share information about upcoming

▲ Anime and comic conventions are held all over the world, ranging in size from a few hundred attendees to over 100,000! They are a great place to sell your work to fans such as these cosplayers.

events. Word-of-mouth and reputation is a powerful force in getting your work seen.

Trade shows

These are geared toward those employed in the industry, not directly selling to the consumer. Publishers talk with wholesalers, studios franchise their books to different publishers, technology companies offer their products to help with publishing, and so on. The aim of

➡

▲ When putting together a physical portfolio, always think about who your audience is and who you are pitching to. This is geared toward publishers, so shows a ranged of abilities and experience linked to creating manga for publishing.

attending these events is to talk with editors, publishers, printers, and wholesalers of manga. This is about selling yourself to potential employers and partners, so treat the entire experience like a non-stop interview. You are not selling your manga to a fan, you are either selling the rights to your manga to a publisher so they can print it and sell it to fans, or you are selling bulk volumes of your manga to a distributor so they can sell it to fans. Try to arrange meetings with potential contacts beforehand, or attend any talks they give, or sign up for a portfolio review.

Talks and workshops
Attending any presentation by colleagues or industry contacts you admire is great for getting insider knowledge and provides a good starting point for a memorable conversation with them. You can also offer to give talks and workshops yourself! Start off small— why not offer to give a short talk at your local school, library, or book club about your manga and what was involved in making it? If you can draw in public, many events love having someone give a live drawing demonstration or draw sketches of attendees. Everyone will remember you and your work and you can often get perks like advertising or a free table to sell your stuff.

Bookstores
Getting your manga into bookstores requires some financial investment, patience, and a fair amount of luck. A formal requirement is that your book needs to be registered under an official publisher, designated an ISBN, and copies sent to your country's legal copyright libraries. You can use online open publishing services for a small fee, but you lose out on complete customization and control. Conversely, you can buy a publisher's license and reserve a list of ISBNs, allowing you to do whatever you want, but it can be very expensive. Once you have an ISBN, any bookstore in the world can order and stock your manga if customers or staff request it. This is where you need to be patient and lucky—talk to your local bookstore staff or chat to booksellers attending comic conventions and find out if they would be willing to stock a few copies. You may also want to look up comic distributors who buy manga at wholesale amounts to redistribute to various comic stores. Be careful when using all these channels, though, as they often expect a discount of 10–50 percent off the cover price, so consider your costs and choices carefully.

Marketing tools
Whether you are in a meeting with a publisher or you've just met a new-found fan at your event booth, you should try to give them something to remember you and your artwork. Make sure what you give them is attractive, memorable, and has all the correct information.

▲ This an example of a small promotional flyer. It has attractive images in keeping with the artist's branding and all the public information a fan would need if they wanted to get more information or products.

Business cards

Think of these as something you only give to industry contacts, so you can afford to make them to a high quality. A business card has to have all your important contact details in a legible font and size. It is best to use your own artwork but, failing that, pick a design that works with your style.

Flyers and samples

You can give these out for free at events or to casual fans. It should show off your artwork, give information about where to obtain your work, and include a link to your website. It should not contain personal details or contact information. It is most cost-effective if you get a large number of small flyers printed on thinner paper stock.

Portfolio

Beginners make a lot of mistakes with their portfolio. Always bring it or some examples of your work to every event or meeting as you never know who you will meet at any time. Do not use pages and pages of work—twenty examples is the maximum. Use only your very best work and don't make excuses for older pieces, even if it means just three images make the cut. An editor would much rather look at and critique three pieces, than get increasingly bored and frustrated looking through a folder of apologetic work. Distribute your best pieces evenly throughout so that there isn't a gradual drop-off in quality. Finally, tailor your portfolio to the occasion—if pitching to a children's publisher, bring your brightly colored and cute pieces, not pages of your gory, sci-fi action series.

▲ Putting a webcomic online for all to see is a great way to garner interest for your work and to promote the comic itself before you start selling physical copies.

Resources

Manga publishers

VIZ Media
www.viz.com

Tokyopop
www.tokyopop.com

Dark Horse
www.darkhorse.com

Seven Seas Entertainment
www.gomanga.com

Kodansha
www.kodanshacomics.com

Digital Manga Publishing
www.digitalmanga.com

Vertical Inc
www.vertical-inc.com

Yen Press
www.yenpress.com

Art product manufacturers

Letraset
www.letraset.com

Deleter
www.deleter.com

Copic
www.copicmarker.com

Kuretake
www.kuretake.co.uk

Wacom
www.wacom.com

Comic fonts

Blambot
www.blambot.com

Comic Book Fonts
www.comicbookfonts.com

Art supplies online

Akadot
www.akadot.com

Cult Pens
www.cultpens.com

Dinkybox
www.dinkybox.co.uk

Blue Line Pro
www.bluelinepro.com

Software

Adobe Photoshop
www.adobe.com

Corel Painter
www.corel.com

Paint Shop Pro
www.jasc.com

OpenCanvas
www.portalgraphics.net/en/oc/

GIMP
www.gimp.org

Deleter CG Illust
www.cgillust.com

PaintTool SAI
www.systemax.jp/en/sai/

Manga Studio
www.manga.smithmicro.com

Image hosting galleries

SheezyArt
www.sheezyart.com

DeviantArt
www.deviantart.com

Artist and Image Database
www.artwanted.com

Galleries Online
www.galleries-online.co.uk

Photobucket
www.photobucket.com

Flickr
www.flickr.com

Tumblr
www.tumblr.com

Web comic hosting

Comic Genesis
www.comicgenesis.com

The Duck Webcomics
www.drunkduck.com

Smack Jeeves
www.smackjeeves.com

ComicFury
www.comicfury.com

WordPress
www.wordpress.com

Art communities

Sweatdrop Forum
www.sweatdrop.com/forum

DeviantArt Forum
www.forum.deviantart.com

Gaia Online
www.gaiaonline.com

Cgtalk
www.cgtalk.com

Conceptart.org
www.conceptart.org

Anime series online streaming

Crunchyroll
www.crunchyroll.com

FUNimation
www.funimation.com

The Anime Network
www.theanimenetwork.com

Anime, manga, and comic events

Animecons.com List
www.animecons.com/events/

Convention Scene
www.conventionscene.com

How-to movie Web links

Clip 1 Drawing the head: Front view
http://qr.quartobooks.com/bgad/clip1.html

Clip 2 Drawing the head: Side view
http://qr.quartobooks.com/bgad/clip2.html

Clip 3 Drawing the head: Three-quarter view
http://qr.quartobooks.com/bgad/clip3.html

Clip 4 Drawing the head: Looking up
http://qr.quartobooks.com/bgad/clip4.html

Clip 5 Drawing the head: Looking down
http://qr.quartobooks.com/bgad/clip5.html

Clip 6 Drawing eyes and eyebrows
http://qr.quartobooks.com/bgad/clip6.html

Clip 7 Drawing expressions: Happy and sad
http://qr.quartobooks.com/bgad/clip7.html

Clip 8 Drawing expressions: Angry, embarrassed, suspicious
http://qr.quartobooks.com/bgad/clip8.html

Clip 9 Drawing hairstyles: Pigtails, short, spiky
http://qr.quartobooks.com/bgad/clip9.html

Clip 10 Drawing hairstyles: Bob, braid, ringlets
http://qr.quartobooks.com/bgad/clip10.html

Clip 11 Drawing limb proportions
http://qr.quartobooks.com/bgad/clip11.html

Clip 12 Drawing action poses
http://qr.quartobooks.com/bgad/clip12.html

Clip 13 Drawing hands: Palm and back of hand
http://qr.quartobooks.com/bgad/clip13.html

Clip 14 Drawing hands: Fist and peace sign
http://qr.quartobooks.com/bgad/clip14.html

Clip 15 Drawing feet: Front and back view
http://qr.quartobooks.com/bgad/clip15.html

Clip 16 Drawing feet: With shoes
http://qr.quartobooks.com/bgad/clip16.html

Clip 17 Drawing weapons: Gun
http://qr.quartobooks.com/bgad/clip17.html

Clip 18 Drawing weapons: Sword
http://qr.quartobooks.com/bgad/clip18.html

Clip 19 Drawing animals: Cat
http://qr.quartobooks.com/bgad/clip19.html

Clip 20 Drawing animals: Dog
http://qr.quartobooks.com/bgad/clip20.html

Clip 21 Inking demo
http://qr.quartobooks.com/bgad/clip21.html

Clip 22 Colored pencil demo
http://qr.quartobooks.com/bgad/clip22.html

Clip 23 Watercolor demo: Part 1
http://qr.quartobooks.com/bgad/clip23.html

Clip 24 Watercolor demo: Part 2
http://qr.quartobooks.com/bgad/clip24.html

Clip 25 Watercolor demo: Part 3
http://qr.quartobooks.com/bgad/clip25.html

Clip 26 Markers demo
http://qr.quartobooks.com/bgad/clip26.html

Clip 27 Screentone demo: Part 1
http://qr.quartobooks.com/bgad/clip27.html

Clip 28 Screentone demo: Part 2
http://qr.quartobooks.com/bgad/clip28.html

Index

Credits

Quarto would like to thank the following for supplying images for inclusion in this book:

* **ATOMix, Shutterstock.com**, pp.1, 4, 10tl, 10cl, 84r, 86
* **Baker, Fez,** fez.windflowerstudio.com, pp.121, 122t
* **Deedl, Shutterstock.com**, p.48b
* **Fedoseeva, Valeriya,** hoshino-arashi. deviantart.com, 112l
* **Fitzpatrick, Anna,** annafitzpatrickart. co.uk, 112br
* **Headtilts,** POSEMANIACS, www. posemaniacs.com, p.27
* **Ho, Louise,** naniiebimhbd.co.uk, p.249tr
* **Kang Chen, Kuo,** p.161
* **Kutsuwada, Chie,** chitan-garden. blogspot.com, p.79
* **Li, Karen,** happypuppy000.deviantart. com, p.123t
* **Li, Yishan,** liyishan.com, p.216r
* **Nyuuness, Shutterstock.com,** pp.8otl, 84l, 94, 251, 255
* **portalgraphics.net © 2013,** p.162b
* **Sjostrom, Conny, Shutterstock.com,** p.247
* **Smith Micro Software Inc. © 2013,** All Rights Reserved, p.163
* **The GIMP Team © 2001–2013,** p.162t
* **Valentin, Marta,** martavalentin.es, pp.5cl, 5cr, 71r, 256
* **Vieceli, Emma,** emmavieceli.com, p.184l

* **Yong, Faye,** fayeyong.com, pp.8ocl, 216l
* **Zhou, Johanna,** chocolatepixels.com, pp.4r, 25r, 88, 110br, 111bl

The text and images on page 85 were first published in *The Complete Guide to Figure Drawing for Comics and Graphic Novels* by **Daniel Cooney**.

The step-by-step sequences on pages 24, 45, 96–103, and 106–109 are by **Chie Kutsuwada**.

The artworks in the character library are by:
* **Aggs, John,** johnaggs.com, pp.212–215
* **Ai Takita-Lucas, Inko,** inko-redible. blogspot.co.uk, pp.196–199
* **Ho, Louise,** naniiebimhbd.co.uk, pp.188–191
* **Kutsuwada, Chie,** chitan-garden. blogspot.com, pp.200–203
* **Li, Yishan,** liyishan.com, pp.192–195
* **Strauch, Aileen,** kiwichameleon.com, pp.204–211

All other artworks are by Sonia Leong.